MEXICO'S DAY OF THE DEAD

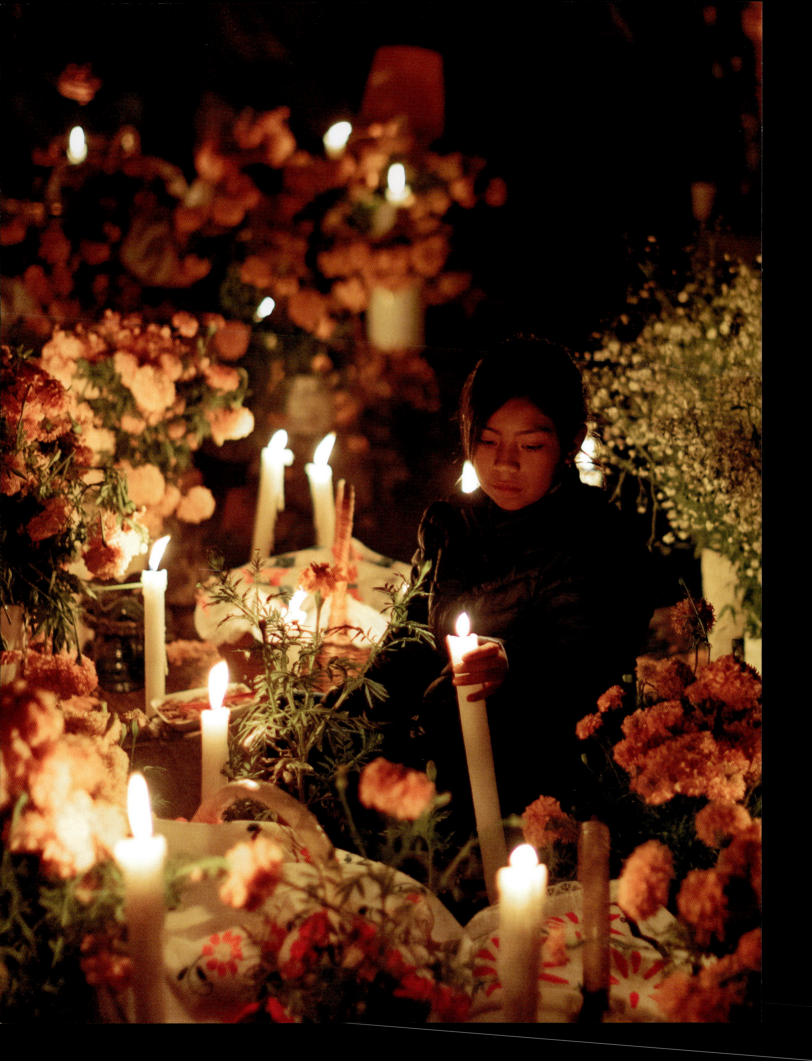

MEXICO'S DAY OF THE DEAD

A Celebration of Life Through Stories and Photos

LUISA NAVARRO

Photography by Christine Chitnis
Illustrations by Goodish Studio

Hardie Grant
NORTH AMERICA

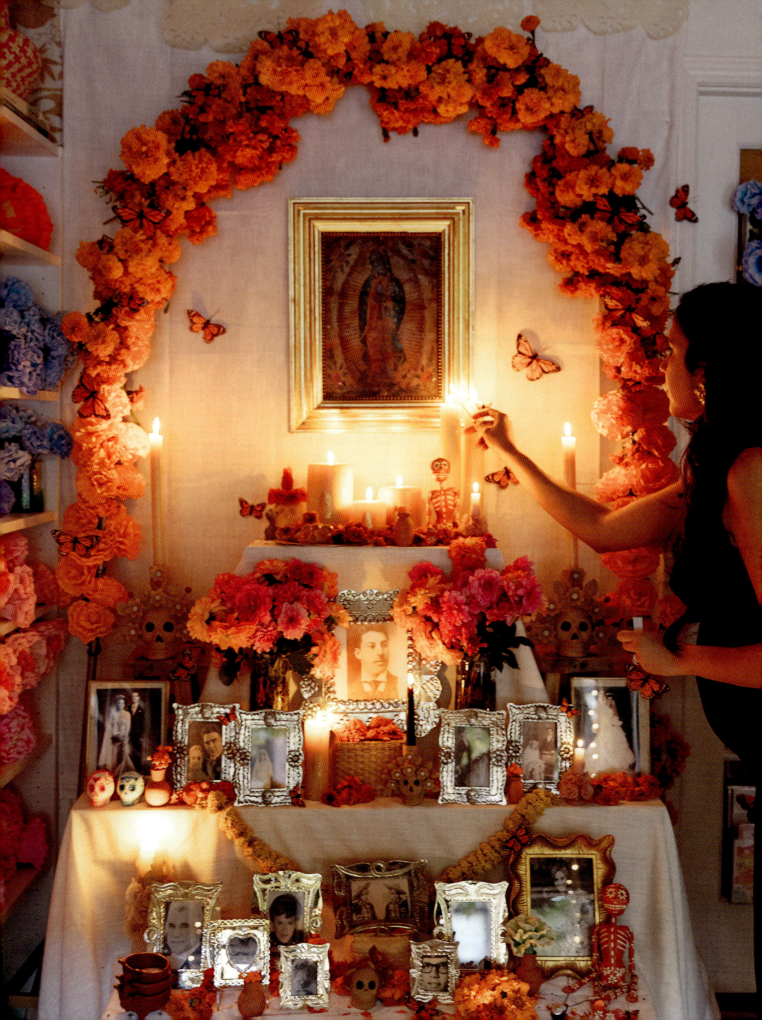

To all the generations to come:
This book is for you.

May you never forget your ancestors.
May you honor and celebrate their stories.

"La muerte es democrática, ya que, a fin de cuentas, güera, morena, rica o pobre, toda la gente acaba siendo calavera."

"Death is democratic, since in the end,
white or brown, rich or poor,
all people end up being skeletons."

—SOURCE UNKNOWN

CONTENTS

PROLOGUE: A LETTER TO MY GREAT-GREAT-GRANDCHILDREN
9

INTRODUCTION
20

Meeting La Catrina and the Goddess of Death 23

Why We Should Talk About Death 45

THE OFRENDA AND THE ALTAR
48

The Elements of the Ofrenda 66

Pan de Muerto 128

The Colors of Day of the Dead 150

The Ofrenda Basket 159

Creating an Altar of Your Own 178

CELEBRATING DAY OF THE DEAD AT HOME
186

Day of the Dead Calendar **188**

Catrina Papel Picado **190**

Calaveritas de Azúcar (Sugar Skulls) **194**

Pan de Muerto with Charred Corn Husk **198**

OTHER TRADITIONS TO HONOR THE DECEASED
200

Visiting the Panteones **203**

Tito Santiago and the Skeleton **227**

INDEX **232**
ACKNOWLEDGMENTS **234**
BIBLIOGRAPHY **236**

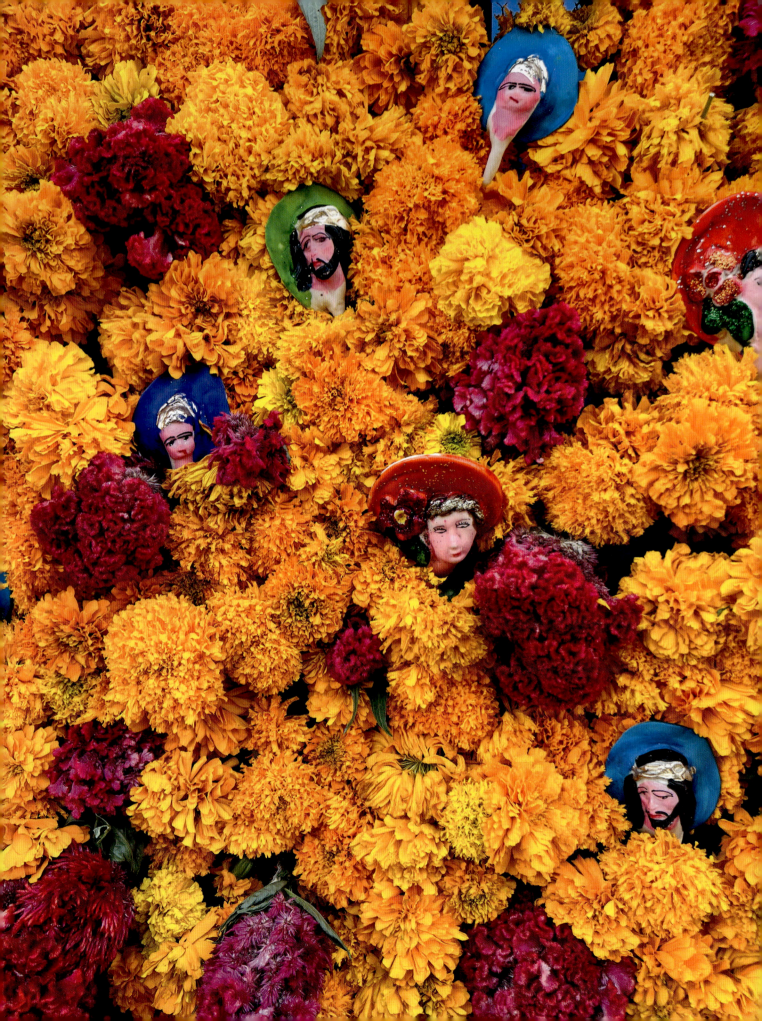

PROLOGUE

A LETTER TO MY GREAT-GREAT-GRANDCHILDREN

Querida Familia,

If you're reading this, you're old enough to understand that death is inevitable. And though it's bleak, it's a truth we must face gracefully and with our whole hearts.

We can choose to never talk about the pain and bury our loved ones, their memories, and their stories. Or we can honor them—both when they come to mind and more formally, by building an altar in their memory.

But to celebrate our lost ancestors, we must preserve their stories so that their memories live on.

I have learned about my great-great-grandparents through anecdotes told by my grandparents and parents, but I would have loved to receive a letter with their own thoughts and observations. Which is why I've decided to write one to you.

So I'll tell you about our family, and I'll tell you about me. Some of it, I hope, you will already know; other things will be new. All of it is yours as much as it is mine.

First: I am so proud to be your *tatarabuela*, and as your great-great-grandmother, there are some things I would like for you to know about my story.

I am a first-generation Mexican-American born and raised in Dallas—as we like to say in Texas, I'm a Texican.

I live a block away from my small shop in the beautiful Brooklyn neighborhood of Carroll Gardens. I am surrounded by amazing people, including my friend Andrea Romeo (my "Brooklyn mom"), who helped me open the store.

My shop is adorable, with hand-painted Talavera-style art and a faux *bugambilia* (bougainvillea) thanks to my friend Yulio Rondon.

As a professional, I am hardworking and tenacious.

As a human being, I am loud and silly, and I love to dance.

Telling stories is my passion, and making people laugh brings me the greatest joy.

One time I took a group of fifteen people to Oaxaca and injured my leg pretty badly, needing six stitches. On the way to the hospital, my anxiety got the better of me, and I started crying. The group assured me that I wouldn't get a scar and that everything would be okay.

I yelled back, "I don't care about a scar! I just want to dance again." The van roared with laughter. I didn't tell them, but it was one of my proudest moments: even in my angst, I was able to make people laugh.

I wear my heart on my sleeve. I love my family and my dog, Holly, more than anything, and even though I haven't met you, I know that I will love you.

Speaking of our family: you come from an extraordinary lineage! You are a Feloni, a Navarro, a Rodriguez, a Flores, a Garcia. And I imagine that, by the time you read this, we've added more *chingones* (badasses) to that list.

My husband—your great-great-grandfather—is Richard (Rich) Feloni. He has never stopped cheering me on. We met at Boston College, where he found me annoying and I found him obnoxious. When we got in to Columbia University's graduate journalism program, we started dating. He claims that, on the first day of orientation, I looked at him and said, "You're so lucky! When you get to school, you'll already have a girlfriend!" I don't remember that, but I do know I found my best friend for life. He is the best writer I know. He writes me the sweetest notes, and I save all of them. We are complete opposites, but he always knows exactly what I need, and I am so grateful that he is mine.

❈

My parents (your great-great-great-grandparents) look like movie stars! I'm not joking; they really do.

My mom, Lulu, is the reason I value culture, craft, music, and celebration. Her home is filled with artisan crafts and *retablos* from Mexico. When she drove me to school, she played Diana Ross, the Beatles, the Jackson 5, and Luis Miguel. She is one of the most beautiful women in the world and always dresses impeccably. Christmas and Thanksgiving at her house are always legendary! When I think of her, I think of the color red: she wears it well, and she always rocks a bright lip. She gives me a hard time if I don't look *arreglada* (put together). We talk every day—news, fashion, gossip: whatever's on our minds. She has always emphasized the importance of an education. At one point in her career, she was a Spanish teacher and insisted all of her kids' first language should be Spanish, not English. Her persistence is the reason we all speak Spanish fluently, and I am so grateful. When I told her I wanted to be a journalist, she was the first to encourage me. She has always supported me in all my professional decisions. Her essence is inimitable and should be celebrated for years to come.

My dad, Carlos, is the reason I am both an entrepreneur and good at problem-solving. When he was ten years old, his mom's friend mentioned that her employee didn't show up to sell flowers at the *panteones* (cemeteries) for Día de Muertos. It was the weekend, and instead of playing with friends, he offered to help. To his mom's surprise, he came home with piles of cash: Instead of just selling flowers, he had rallied a team to gather more flowers and sell them—basically starting a business on the spot. He believes that when life gives you limes, you make margaritas. He loves to put his own spin on things, coining catchphrases like "Have a mockingbird day!" (focus on the positive, a reference to mockingbirds singing endlessly). As an orthodontist (and inventor of orthodontic appliances), he loves helping people achieve a beautiful smile. He is the best person to call in an emergency. He has a charming, thick Mexican accent that we love. At seventy, he still has a full head of jet-black hair. People say he looks like Robert De Niro, but our family thinks he's a lot more handsome. He has a fantastic sense of humor. He is one of the most generous, tenacious people I know, with the wisdom to see that adversity is a gift we must use wisely! If you want to understand his essence, he would give you the jacket off his back, no questions asked.

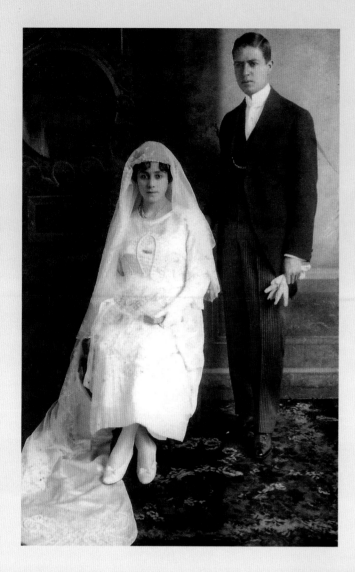

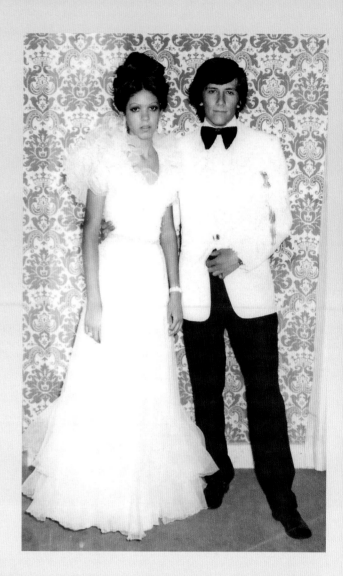

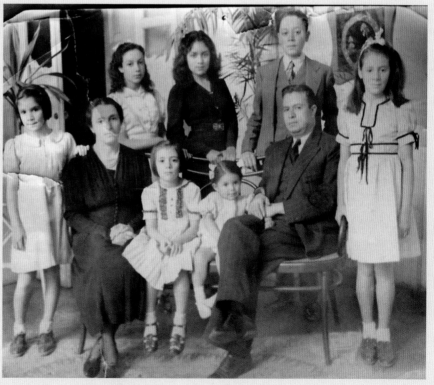

CLOCKWISE FROM TOP LEFT:

My great-grandparents Arturo and Luz María Mercado de Flores on their wedding day in Pátzcuaro, Michoacán.

My mom and dad dressed up for El Baile Blanco y Negro at the Casino de Saltillo in Coahuila, 1973.

My maternal grandparents, Tita Lupita and Tito Santiago, on their wedding day in Saltillo, Coahuila, June 9, 1955.

My paternal grandparents, Tita Susana and Tito Carlos, on their wedding day in Morelia, Michoacán, April 19, 1952.

My favorite picture of my cousin, Lila Cuevas, that I place on my altar every year in her honor.

The Flores Family in Pátzcuaro, Michoacán.

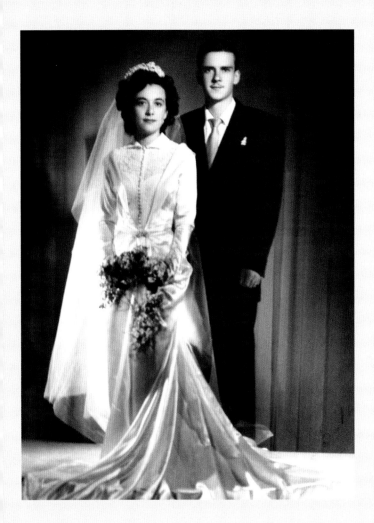
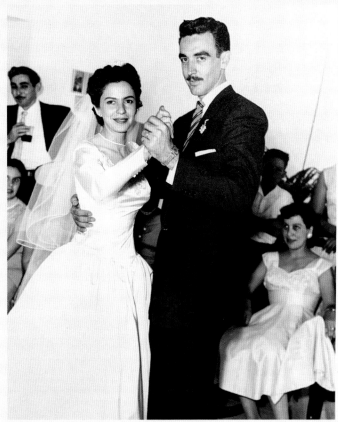
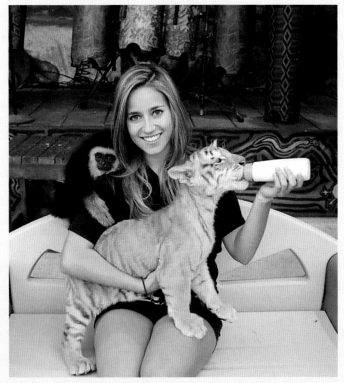

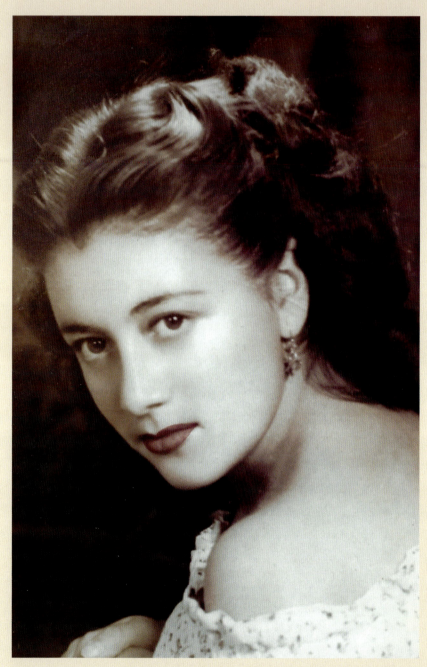

A glamour shot of Tita Susana that she gifted to my grandfather when they were dating. She slowly saved up money to pay for the photograph because she didn't want her brother to find out about it.

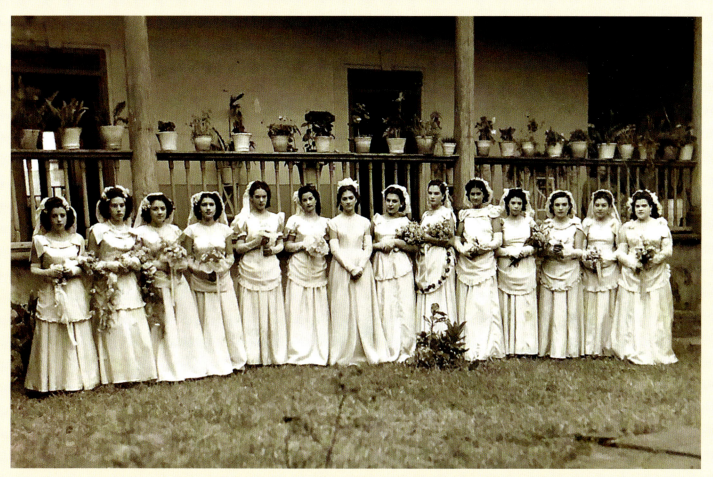
Tita Susana, third from left, dressed in a white gown for a Catholic May Crowning ceremony. This photo was taken in the house that once belonged to my great-uncle Maurilio Flores, which is now Colegio Silviano Carrillo in Pátzcuaro.

My parents immigrated to the United States in 1979. My mom was twenty-two and my dad was twenty-six, and they left their entire family in Mexico. I know it wasn't easy, but I am grateful.

I have three siblings, each unique, special, and talented.

Karla, the oldest, is very beautiful. She has olive skin and large brown eyes with a playful twinkle that always suggest she's up to something. She's utterly eloquent in both Spanish and English. She has been a prosecutor, a fitness instructor, and a stylist. She loves beautiful design and takes great pride in how she decorates her home and how she dresses. But no matter what role she takes on, her true purpose is in helping others believe that they are capable of achieving their heart's desires. I am most grateful to her for instilling confidence in me from a young age. Nine years older than me, she is protective like a mother but encouraging like a friend. I adore her and thank God every day for her.

My brother, Carlos, is six years older than me and is the funniest person I know. A natural born leader, he is the first to lend a helping hand in times of need. He was there for me when I experienced my first heartbreak, and when I lost my job, he called and offered me money. Watching him become a father recently has been a true joy. His son, Charlie, is the luckiest to call him Dad.

I am the third child and very proud to be so. If you're a middle child, too, never forget that we're the best! After me comes the baby, Andrea, who I call my twin because we are thirteen months apart (the irony is that we don't look much alike, and our personalities are polar opposites). She has beautiful auburn hair and a doll's face. A talented artist and designer, she can paint, bake, make jewelry, and beat you in any race. As much as I want to hate her because she's so talented, I love her so much it hurts. She always knows when something is wrong (we often joke about our telepathic abilities), and she has been my closest friend since birth.

My mom grew up in Saltillo, Coahuila, in northern Mexico. Home to the famous sarape textiles, it was also once the capital of Texas! Her father, Santiago Rodriguez (your great-great-great-great-grandfather), was an ophthalmologist. His patients included notable politicians and religious figures, and he was even selected to be the eye doctor for the

1986 World Cup in Mexico. But when I asked him about his proudest accomplishment, he told me it was performing life-saving surgery on children who had eye cancer.

My mom's mom, Guadalupe Garcia, was a lawyer. A female lawyer at that time was uncommon, to say the least. (Her father, Papá Pancho, who was also a lawyer, did not approve.) But as I mentioned, you come from a lineage of chingones, so after my grandmother's fifth child was born, she decided to return to law school. When she asked her father, the director of the school, if she could come back, he responded, "Women don't have the ability to become lawyers, only men do."

So my grandmother went to speak to the president of the university, who gave her permission to proceed. My grandmother, who taught me to never take no for an answer, then showed up to a class where her father was the professor. During roll call, he read her name, "Garcia Fuentes, Guadalupe," aloud and looked up in shock to see his daughter. My grandmother casually responded, "Presente, maestro."

Her father, apparently giving up, didn't say anything, and my grandmother, being the badass that she was, not only redid her first and second years but finished her degree and went on to become a lawyer. In the end, my great-grandfather—who was one of the founders of the law school, treasurer of the state of Coahuila, and interim governor seven times—was very proud of her. And so am I.

My grandmother's story helped me believe I was capable of doing anything I set my mind to, including writing this book.

But it wasn't always easy.

Growing up Mexican-American in the United States had its challenges. In preschool, I struggled to make friends because I didn't speak English.

Some classmates even bullied me, and I must say, discovering racism at five years old was confusing, and it hurt.

I would often hear children say horrible things about Mexicans, and I started resenting my Mexican heritage. I even tried to change my name from Luisa Fernanda to Hannah.

Luckily, my parents and grandparents taught me to fall in love with Mexican culture—so much so that I eventually started my blog, *Mexico In My Pocket*, where I write about the most beautiful cities in Mexico and about the traditions of our culture.

Eventually, my writing brought me to Pátzcuaro, Michoacán, the hometown of my other grandmother, Tita Susana, and a region famous for celebrating Day of the Dead. When I was growing up, my grandmother would tell me stories about how her hometown

was a magical place. I dreamed of visiting but never did until after she was gone. I was always very close with my grandmother, but unfortunately, there were parts of her story that I never knew. I always wondered why she didn't talk about her family. So I decided to visit her hometown to see if I could meet her relatives and find out why.

I'm so glad I did because it connected me to her life before I met her, and helped bring Día de Muertos alive for me in so many new ways. Writing this brings tears to my eyes because I miss her so much.

I yearn for my grandmother Susana's spirit. Her freshly cut-up fruit with sugar sprinkled on top. Her tight hugs, and the way she smiled at my shenanigans. We often laughed so hard it hurt. I am grateful I had a grandmother who loved us fiercely and unconditionally.

Like us, my grandmother lived in Dallas, Texas. She spoiled us with home-cooked meals, including my absolute favorite, *enfrijoladas* (like enchiladas except they're smothered in beans and cheese!). My brother loved her *bacalao*, and my sister Karla loved her potato soup with ham and peas. My dad loved her *bistecs empanizados* (breaded steaks) and *alubias* (bean stew).

Shortly before my plane touched down in Tita Susana's hometown, I said a little prayer. My grandmother had been active in her church, and she always taught me to pray. So I asked her to send me a sign to help me find clues about our family.

In the airport bathroom, an older woman touched my shoulder and said, "I heard you say that you were going to Pátzcuaro."

"Yes," I said. "I'm visiting my grandmother Susana Flores's hometown."

The woman exclaimed, "I knew Susa!"

She said my grandmother's nickname! I was shocked, and still skeptical—until she said, "Your grandmother was *chiquita* and *muy bonita*."

Now I started to believe her.

She asked me if I had a picture; I showed her a photo on my phone.

"Yes!" she exclaimed. "That's her! She was very beautiful."

I jotted down her information, and when I got settled in my hotel, I got in touch. When we met, I showed her an old photo of my grandmother dressed in a white gown

in a hacienda-style house with wooden columns. My grandmother's friend told me that this home had once belonged to my great-uncle Maurilio Flores. Today it's a school called Colegio Silviano Carrillo. A teacher at the school helped me find my aunt, Susana Flores (who has the same name as my grandmother and is a second cousin of my father), in the local shoe shop she owns. It was a beautiful moment!

Susana invited me to a gathering at her home, and her brothers were able to tell me more about our family, including where my grandmother lived and how my great-grandfather died. His name was Arturo Flores, and he was an incredibly successful businessman. His wife, my great-grandmother, came from the distinguished Mercado family, and her sister, Maria del Carmen, married into the family that owned a famous mansion in Pátzcuaro called La Casa del Gigante.

I also learned more about how my grandmother's life changed when her father died from cancer at the age of forty-five. Upon his death, rumors spread, and tragically, the family became divided. The fate of the family inheritance was unclear. Some say that my abuela's older brother spent it all while others say that her uncle Maurilio inherited everything of her father's, leaving my grandmother's family with nothing.

Visiting my grandmother's hometown made me realize how easy it is for family stories to get lost. Although it was bittersweet to learn more about the tragedies of the past, I hope that sharing this story will help you understand why we need to keep our memories alive. No matter how painful, I've realized how important it is for us to continue sharing our stories so that the future generations never lose touch of where they came from.

My descendants, I offer you this gift of story, memory, and celebration. I know that by now you will have many more stories and keepsakes to add to mine. My hope is that this letter, and this book, will encourage you to learn more about your ancestors and inspire you to create beautiful altars that honor our memories and stories.

With all my love and admiration,
Tu tatarabuela,
Luisa

INTRODUCTION

Day of the Dead is my favorite family tradition. Every year, I look forward to setting aside time to reflect and honor my relatives who have passed away. I fill my shop with fresh marigolds and old family photographs, and I share stories about my ancestors with anyone who will listen. It is a practice that I hope more people around the world will learn to embrace.

While Day of the Dead is a deeply Mexican tradition, death itself is universal, and it is a topic that connects all of us as human beings. No matter who we are, or where we come from, we will all experience the loss of a loved one. Over time, I've come to realize that people of all backgrounds, not just Mexicans, are looking for ways to celebrate their loved ones who have passed away. Unfortunately, not every culture chooses to pay tribute to the those who have died. So, every year, I help members of my community and customers learn more about Día de Muertos traditions.

Outside of Mexico, there is some confusion surrounding what Day of the Dead is and what it means. Contrary to what many people assume, Day of the Dead is not Mexico's version of Halloween. Unlike Halloween, which is often associated with spooky imagery, and which originates from pagan and Christian traditions, Día de Muertos has indigenous roots and is playful, celebratory, and very colorful.

This book includes personal stories, interviews, recipes, tutorials, and photography from different regions in Mexico. By sharing this information, I hope more people around the world will understand and recognize this beautiful indigenous custom.

This is not a handbook for how to celebrate Day of the Dead, and I am not an expert on the subject. But I have spent the last decade traveling to Mexico and studying the traditions of our culture and our ancestors.

Think of me as a guide and companion as I share my stories and experiences from these trips, what I have learned about the history and origins of Day of the Dead, how to build an altar, and what each element of the altar means and why they should be included. If you do decide to make an altar and celebrate Day of the Dead, purchasing handmade crafts made by indigenous artisans from Mexico is one of the best ways you can help support the origins of this holiday. I believe that no one honors the dead like Mexican people, and I hope that my travels and stories will inspire you to take time to pause, honor, and celebrate the deceased no matter how busy life gets.

Above all, I hope you remember to never lose touch with your roots, because the stories of your ancestors contain wisdom that may be useful in your own journey.

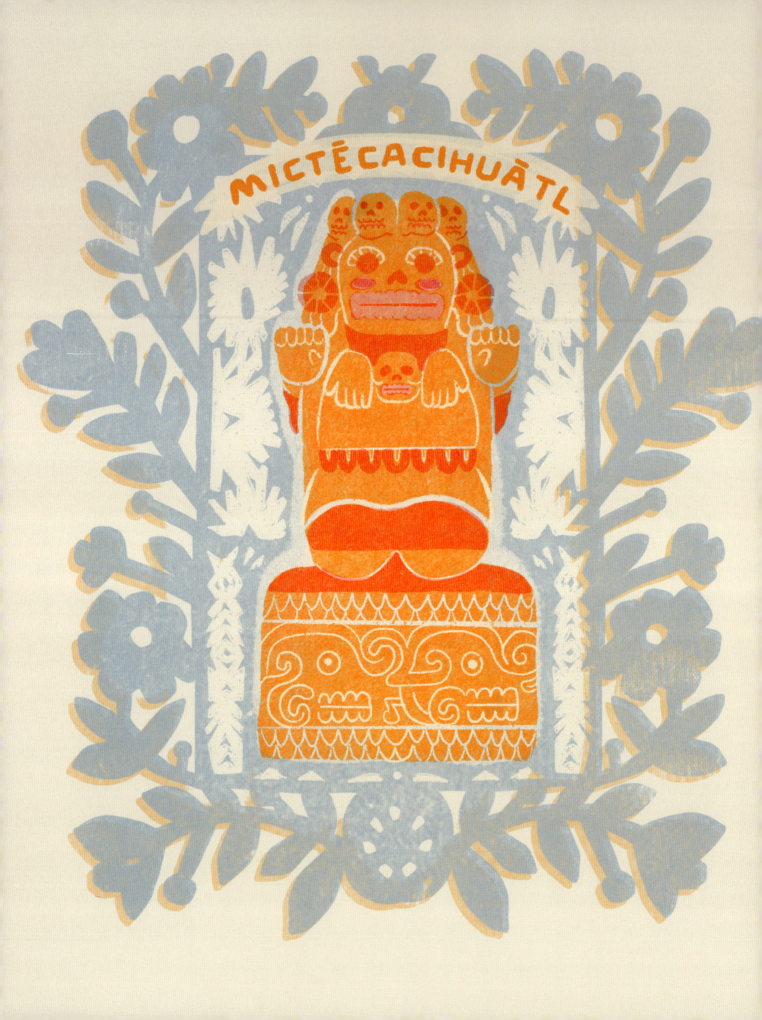

MEETING LA CATRINA AND THE GODDESS OF DEATH

When I was growing up, my mom decorated the house with shadow boxes filled with skeletons that poked fun at death. They scared me so much I would pretend not to see them. At the time, I didn't realize that my mom loved these little skeletons because they brought back memories of her home. And, unlike me, she was accustomed to seeing dancing skeletons. It was simply a part of her culture.

As a child, I was terrified of death. It would sometimes consume my thoughts, and I would worry obsessively about someone close to me dying. I agonized over losing my parents or grandparents. But my perspective changed after I lost my twenty-four-year-old cousin. After this first loss, I finally understood how necessary it was to celebrate and share the stories of my loved ones. Suddenly, my mom's skeletons did not feel so scary to me (though I could still see why displaying papier-mâché skulls and talking about death might seem strange to someone outside the tradition). I began to feel more comfortable with death.

Day of the Dead is not a day to celebrate death, and it is not intended to frighten us. Instead it is a day of festivity when families come together and commemorate the lives of loved ones who have died. When my husband's grandparents passed away, I wanted to add their picture to my altar for Day of the Dead. My husband, who is not Mexican and had never celebrated the holiday, was hesitant; he also worried because his pain was so fresh. I could understand his trepidation—when I built my first altar, I too hesitated, and I worried I might cry the whole time.

But I felt strange not adding his grammy and grampy, so I snuck in a picture at the last minute and was relieved when I saw he was happy I included them. Seeing his grandparents honored on the altar, he felt comforted that our deceased relatives were being celebrated together. That evening, we exchanged stories and looked at old photographs. As his wife, I felt grateful that even though he did not grow up Mexican, he finally understood the beauty of Day of the Dead.

✳

Many people have asked me, "Can I celebrate Day of the Dead if I am not Mexican?"

Of course, I say. Anyone can celebrate Day of the Dead; death does not discriminate. But before participating, it is important to know more about the tradition—how it began and how it became one of Mexico's most famous and cherished holidays.

The truth is, Day of the Dead did not become deeply meaningful to me until I experienced the death of someone I loved. Desperate for solace, I began to research the holiday. I became curious why my culture is so comfortable with death and why we see Día de Muertos as a time of celebration instead of mourning.

During Day of the Dead, it's common to see Mexico filled with papier-mâché skeletons dancing, riding bicycles, singing in a mariachi band, or even dressed as Frida Kahlo. Mexicans avoid mournful colors like black and, instead, decorate sugar skulls with vibrant colored icing. We choose to accept death as a natural part of life and to remember our loved ones with joy.

✳

I had always been curious to learn why Mexicans are fascinated by skeletons. My research led me to discover that some skull imagery can be traced back to the Aztecs' reverence for Mictēcacihuātl, the goddess of death. Pre-Hispanic statues often depict her with a skeletal face and breasts (differentiating her from her male counterpart and consort, Mictlāntēcutli, the Aztec god of death). In fact, if you visit Mexico City's Museo Nacional de Antropología, you'll find various pre-Hispanic artifacts involving skulls. One example is the *tzompantli*, which is a rack made of wood on which Mesoamerican peoples publicly displayed the skulls of their enemies.

As the *reina de la muerte* (queen of death), Mictēcacihuātl's duties include presiding over the festivals of the dead and guarding their bones. According to Aztec mythology, the dead must complete a nine-level journey to Mictlān (the underworld), which takes four years to complete. During this time, the spirits face obstacles testing their strength before reaching their final resting place where they are then greeted by Mictēcacihuātl and Mictlāntēcutli.

Mictlān is not a good or bad place for punishment but is rather the "land of the dead," where the souls of most people rest for eternity. And unlike Catholicism, which has heaven and hell, the Aztecs believed that the destiny of the soul was determined by

a person's manner of death, instead of their behavior in life. For example, those who died by drowning were sent to Tlālōcān, the paradise of the rain gods. Infants who died would be sent to Chichihuacuauhco, a place with a nursing tree providing babies with breast milk to suckle on. Warriors who died in battle were sent to the realm of the sun god, Tonatiuh, and were eventually reborn as hummingbirds.

When the Spanish arrived, Mictēcacihuātl was a widely recognized goddess. She was celebrated during the ninth month of the Aztec calendar, in late July and early August. The conquistadors, including Hernán Cortés, punished indigenous peoples for worshiping their gods and forced them to convert to Catholicism. Though archaeologists do not have a complete picture of the traditions of the Aztecs' original summer celebration of Mictēcacihuātl, they believe customs included burning copal incense, making tamales and flower garlands, singing, dancing—and, sometimes, human sacrifice.

The best records we have for the feasts of the dead—known as Miccailhuitontli (Little Feast of the Dead or Feast of the Little Dead) and Miccaihuitl (Great Feast of the Dead or Feast of the Adults)—come from late sixteenth-century writings by Spanish Franciscan missionary Bernardino de Sahagún and Dominican friar Diego Durán and from the pre-Hispanic Codex Telleriano-Remensis.

In their writings, Sahagún and Durán describe the ceremonies honoring the dead as festive times, for which people went without sleep to prepare. According to Sahagún, the Aztecs placed images of the deceased on altars and offered them tamales, sang songs of praise, drank pulque, and recited prayers in their honor.

These sixteenth-century texts provide insight into how indigenous traditions evolved since Spanish conquest. For example, the Codex Telleriano-Remensis reveals that the feast of the dead originally did not take place in November: "The feast of all the dead begins on the third of August. During this feast they made offerings to the dead, placing food and drink on the tombs; this they did for four years because they believed that in all that time the souls did not reach their place of rest."

Note that the name of the celebration is Día de Muertos, not Día de los Muertos. While the latter is common in English-speaking countries, Día de Muertos is the grammatically correct, proper Mexican term.

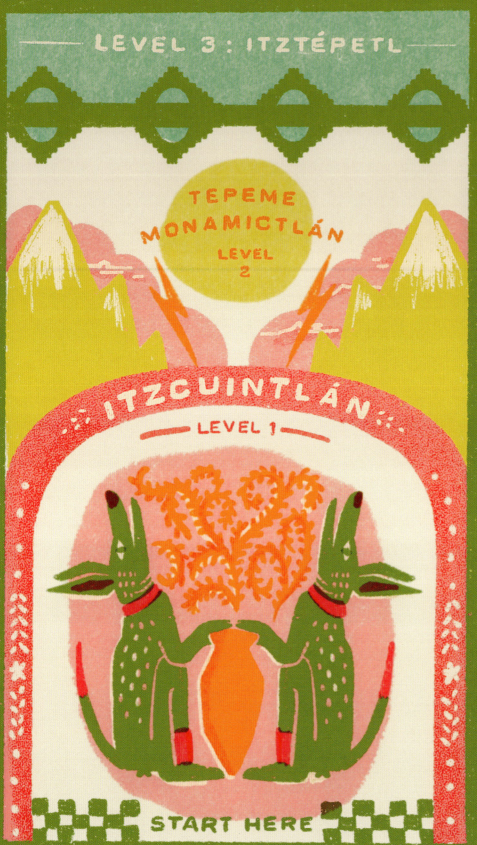
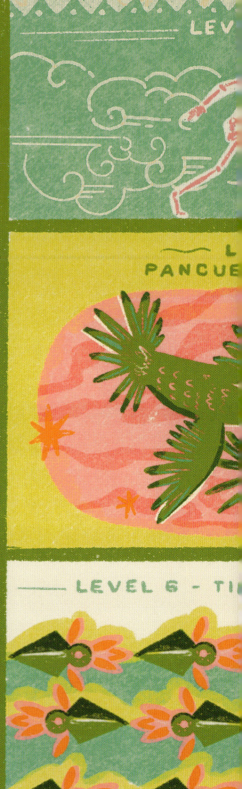

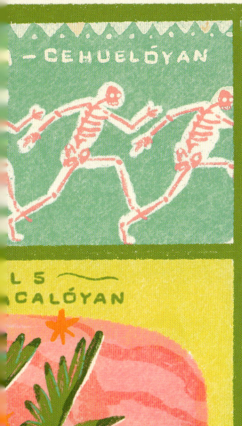

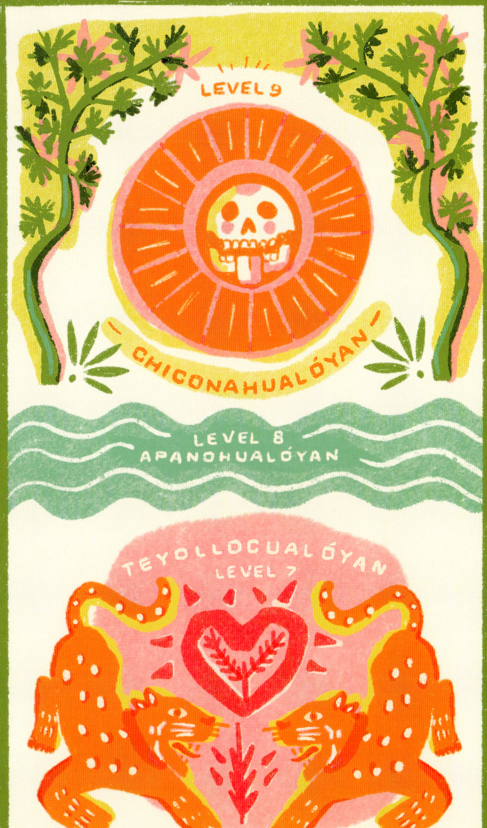

9 LEVELS OF MICTLÁN, THE UNDERWORLD

According to Aztec mythology, the deceased must pass through these nine regions to reach eternal rest.

LEVEL 1
ITZCUINTLÁN

Place of the Dogs

Souls cross the Apanohuacalhuia River, the boundary between the living and the dead, with the help of a Xoloitzcuintle dog.

LEVEL 2
TEPEME MONAMICTLÁN

Place Where Mountains Meet

These souls must figure out a way to cross between two colliding mountains without being crushed.

LEVEL 3
ITZTÉPETL

Obsidian Mountain

The deceased must ascend a mountain covered with obsidian blades.

LEVEL 4
CEHUELÓYAN

Place of Lots of Snow

The deceased must cross a desolate, frozen land while enduring freezing winds.

LEVEL 5
PANCUETLACALÓYAN

Place Where People Float Like Flags

Intense winds cause the deceased to float wildly.

LEVEL 6
TIMIMINALÓYAN

Place Where Arrows Are Shot

The souls must pass through a trail without being hit by obsidian arrows thrown by invisible hands.

LEVEL 7
TEYOLLOCUALÓYAN

Place Where Jaguars Devour Hearts

Jaguars eat the hearts of the deceased, marking the end of their worldly attachments.

LEVEL 8
APANOHUALÓYAN

Place Where Water Must Be Crossed

The deceased cross through black waters to complete the process of resting their souls and getting rid of what was left of their bodies.

LEVEL 9
CHICONAHUALÓYAN

Place with Nine Waters

After passing through nine mist-covered rivers, the souls are greeted by the god and goddess of death, Mictlāntēcutli and Mictēcacihuātl, and they are rewarded with eternal rest.

Durán's writings show that, following the Spanish conquest, indigenous celebrations were adjusted to coincide with the Christian calendar. The Miccailhuitontli tradition of preparing offerings for dead children was moved to All Saints' Day (November 1) and the Miccaihuitl tradition of preparing offerings for dead adults was shifted to All Souls' Day (November 2).

Durán was troubled to discover that indigenous people continued to secretly observe their pagan holidays alongside Catholic feast days. While the Spanish disapproved of both the Aztecs' worship of Mictēcacihuātl and their festivals honoring the dead, they were unable to completely eradicate these practices. Instead, the influence of the goddess's celebrations was so strong that indigenous people found a way to subtly honor the dead during Catholic remembrance days. This syncretism was eventually used by the Spanish as a tool to convert the indigenous people to Catholicism. Today, this celebration is known as modern-day Día de Muertos—blending indigenous and Catholic traditions, which is why Mexicans today often include Catholic saints, crosses, and statues of La Virgen de Guadalupe on their altars.

Long after the Aztecs were conquered, the images of skeletons and Mictēcacihuātl continued to evolve. Eventually this gave rise to one of Mexico's most famous cultural icons, the elegant skeleton known as La Catrina. But before there was La Catrina, there was La Calavera Garbancera.

In the early twentieth century, Porfirio Díaz was the long-standing, controversial president of Mexico, who would eventually resign during the Mexican Revolution. Though his grandmother was an indigenous Mixtec woman, he preferred and championed his European heritage over his native side. In this era, known as the Porfiriato, it was common for many upper and middle class Mexican people to deny their indigenous ancestry, dressing and acting more European and powdering their faces white. These people were referred to as *empolvadas*, or "covered in powder." Even street vendors, instead of selling traditional Mexican foods like corn and beans, hawked chickpeas, which were introduced by the Spanish. Díaz's authoritarian influence promoted assimilation with Europeans and disdain for aspects of indigenous and mestizo culture, resulting in damage to and even partial erasure of some of Mexico's rich native customs.

It was in this context that lithographer José Guadalupe Posada created *La Calavera Garbancera* (The Chickpea Skeleton) around 1910. His illustration poked fun at Mexican women who denied their indigenous roots by dressing in European clothing. Through all of his work his message to the people of Mexico, especially to those who clung to classism and discriminatory behavior, was clear—so much so that the popular quote "Death

is democratic, since in the end, white or brown, rich or poor, all people end up being skeletons" is often misattributed to him around Día de Muertos.

Even though she was just a caricature, Posada's La Calavera Garbancera and her deep, urgent cultural message is why she eventually became so popular. Sadly, Posada would never see his elegant skeleton go on to become Day of the Dead's most famous symbol. Shortly after creating her, he died penniless and was buried in an unmarked pauper's grave, and his contributions as a cartoonist were, for a time, forgotten.

Thirty years after his death, Posada's La Calavera Garbancera would make a serious splash when Mexican muralist Diego Rivera, one of Posada's most famous fans, would create his own version and dub her "La Catrina."

During the early twentieth century, upper-class men often dressed in tailcoats, pinstripe pants, and bowler hats and carried canes. The Spanish referred to such a man as a *Catrín*, or "dandy." In keeping with Posada's mission to poke fun at Mexican women who denied their indigenous roots, Diego Rivera called his skeleton dressed in an ostrich feather hat and European dress "La Catrina," the female equivalent of a Catrín.

Diego Rivera was influential and popular, and his decision to place La Catrina front and center in one of his most famous murals—among notable figures like Hernán Cortés, Frida Kahlo, Porfirio Díaz, Benito Juárez, and the creator of La Catrina, José Guadalupe Posada—transformed the lady of death into a cultural icon.

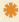

In spite of attempts to eradicate Mictēcacihuātl's festival during colonization, the pre-Hispanic goddess of death's image and influence have flourished into modern Día de Muertos celebrations. Today, La Catrina can be seen all over Mexico during Day of the Dead celebrations. Featured in art, movies, costumes, artisan crafts, and parades, many have come to celebrate and idolize La Catrina, as the Aztecs honored Mictēcacihuātl. People also dress up as her, painting their faces with heavy sugar-skull-style makeup and wearing fancy dresses and ostrich feather hats. But contrary to what many tourists might think, people in Mexico aren't dressing up for Halloween; they are paying tribute to one of Mexico's most famous cultural icons, who serves as a comforting reminder that death is simply a natural progression of life that everyone experiences. Because in the end, we all become skeletons.

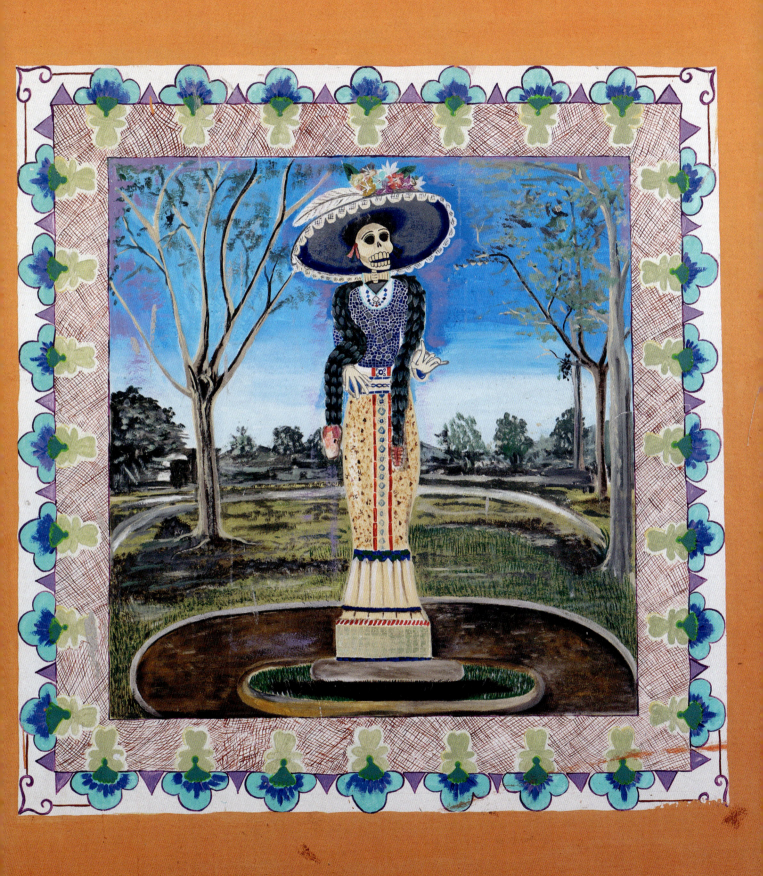

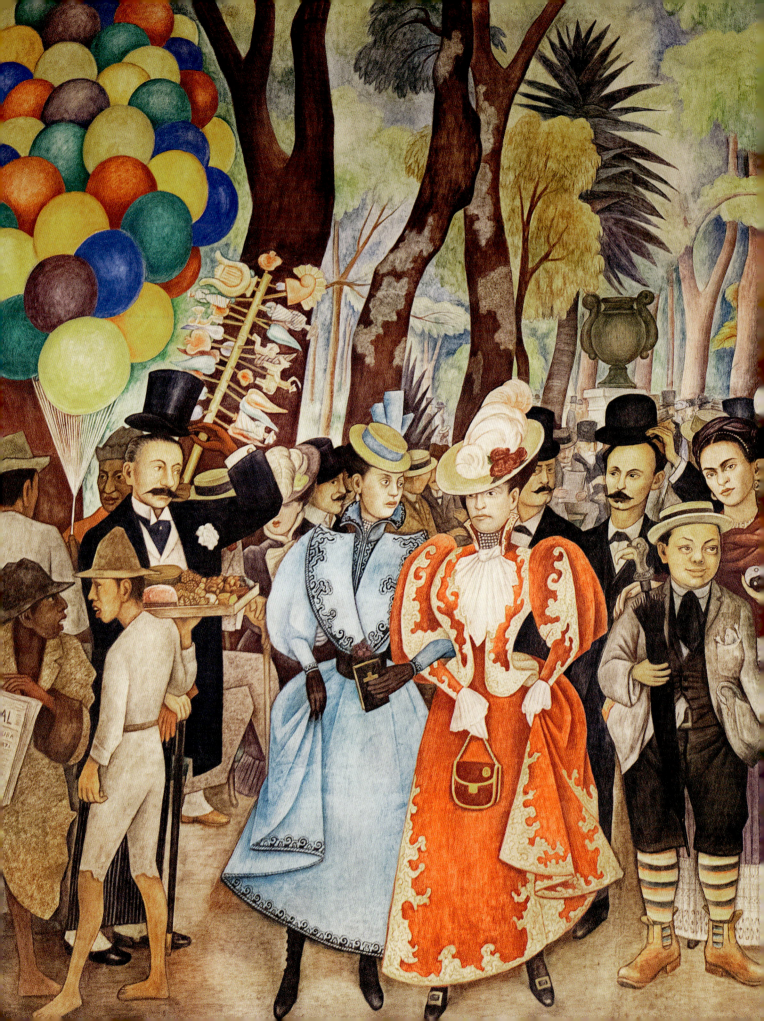

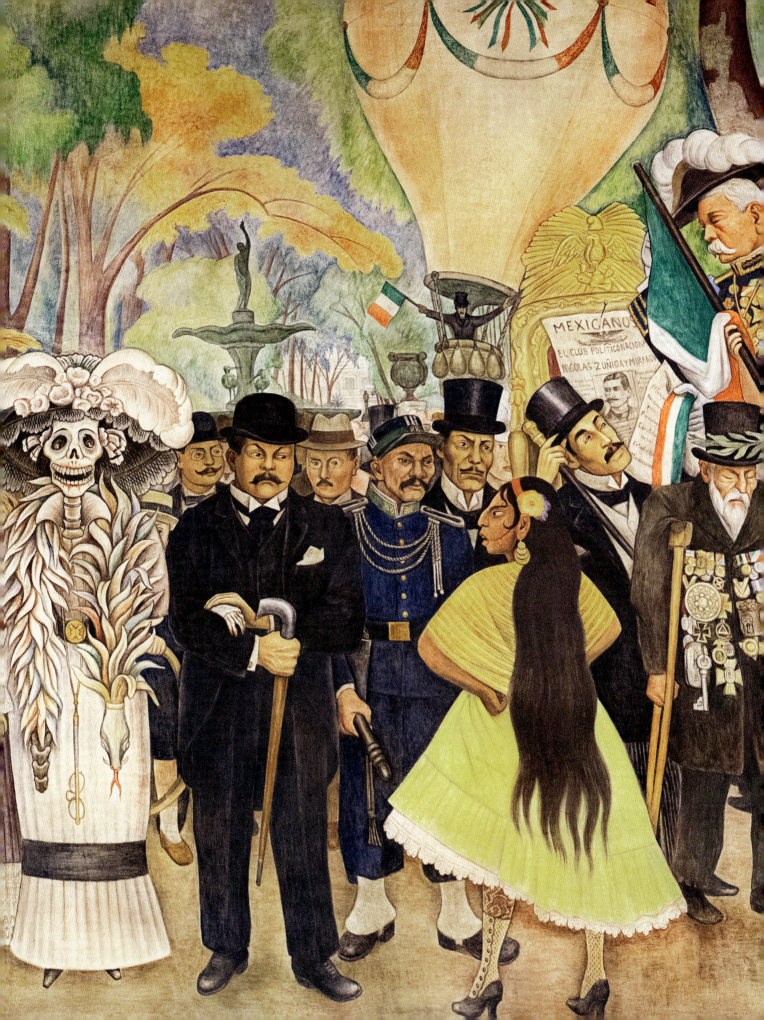

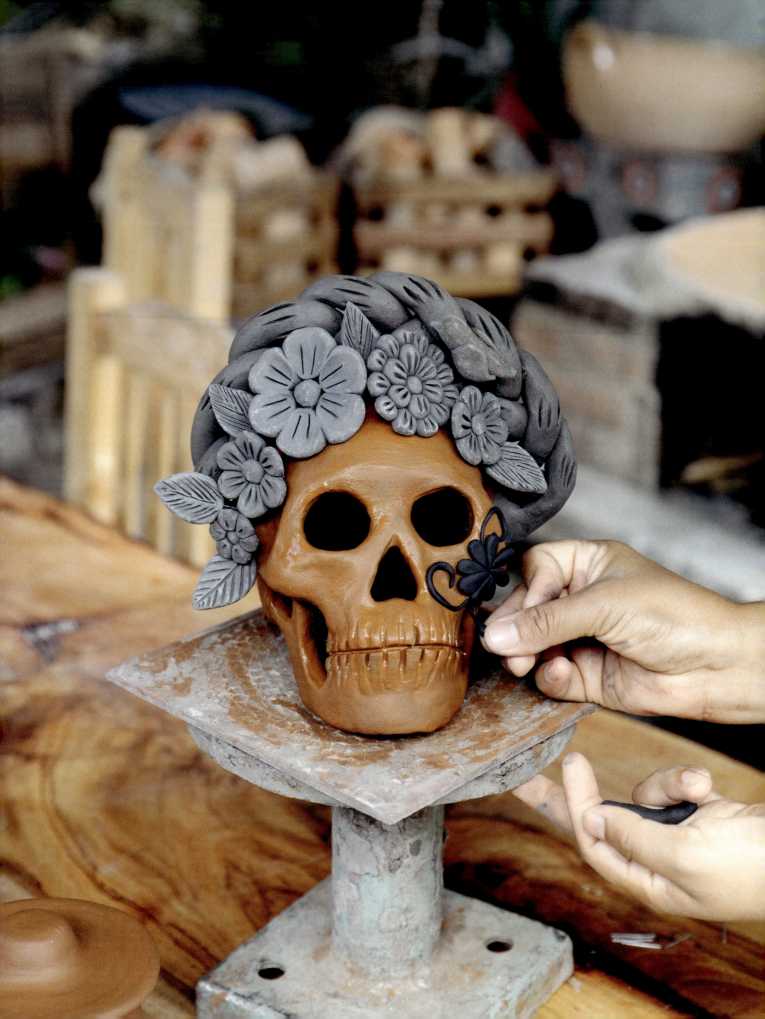

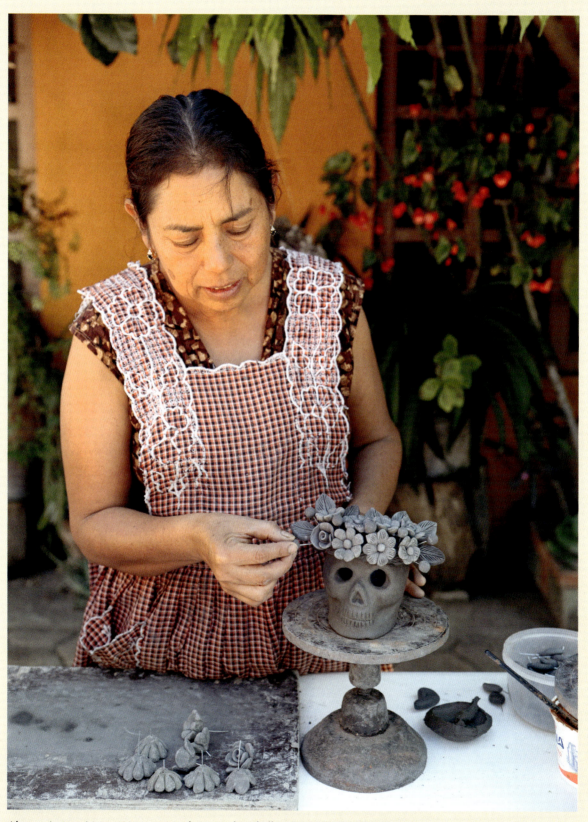

Above: Artisan Noemí Vasquez works on a clay skull in Santa María Atzompa, Oaxaca. Each skull takes 3 to 4 days to complete.

Opposite: Handmade floral clay skull made by master artisan Patricia Gaytán in Santa María Atzompa, Oaxaca.

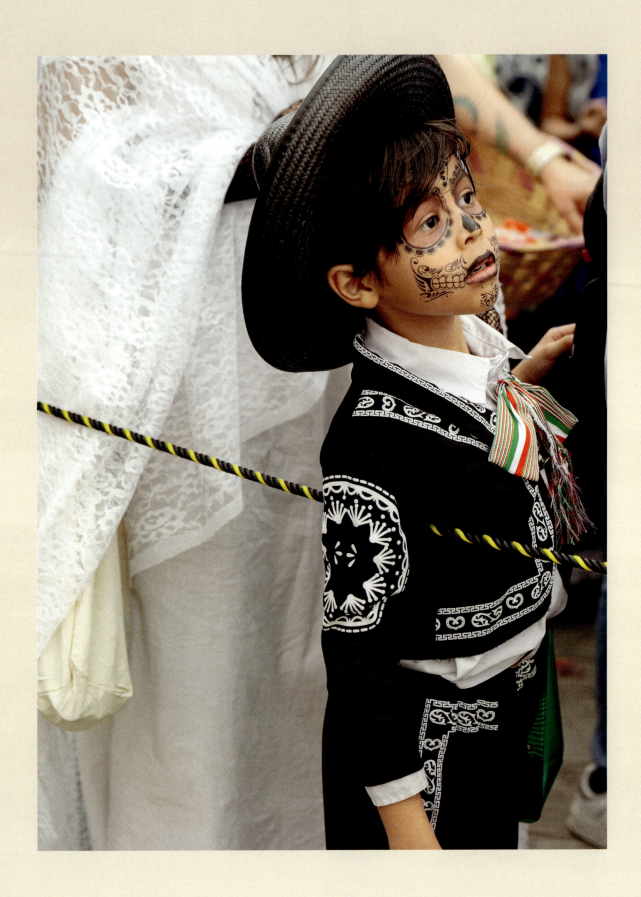

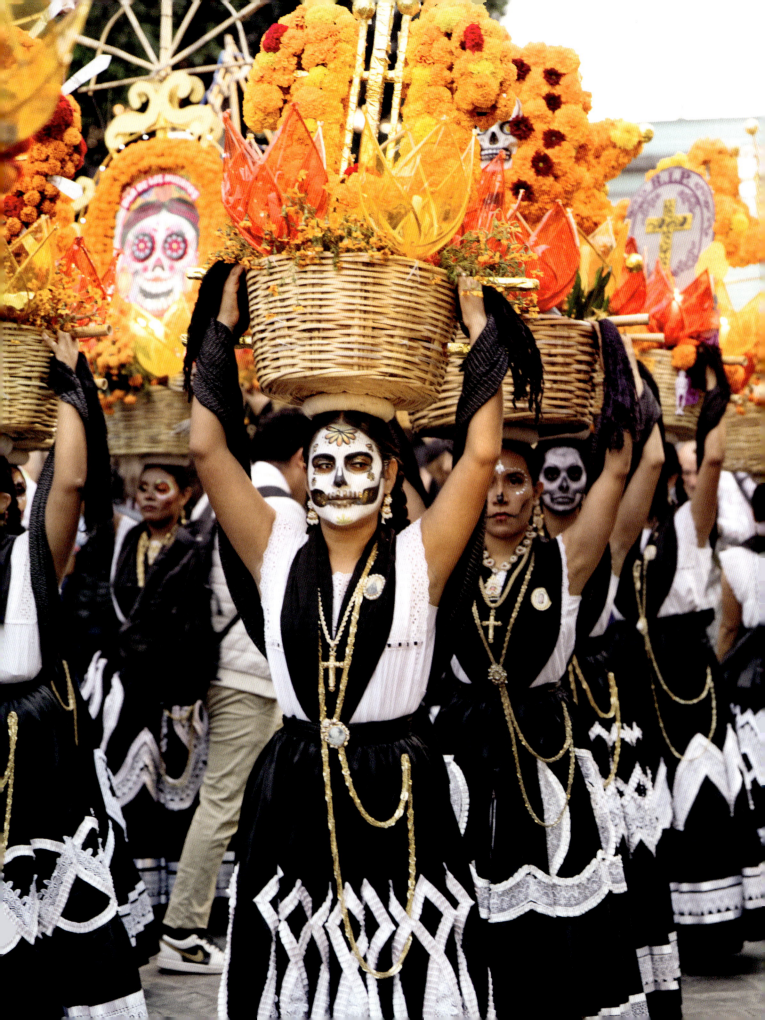

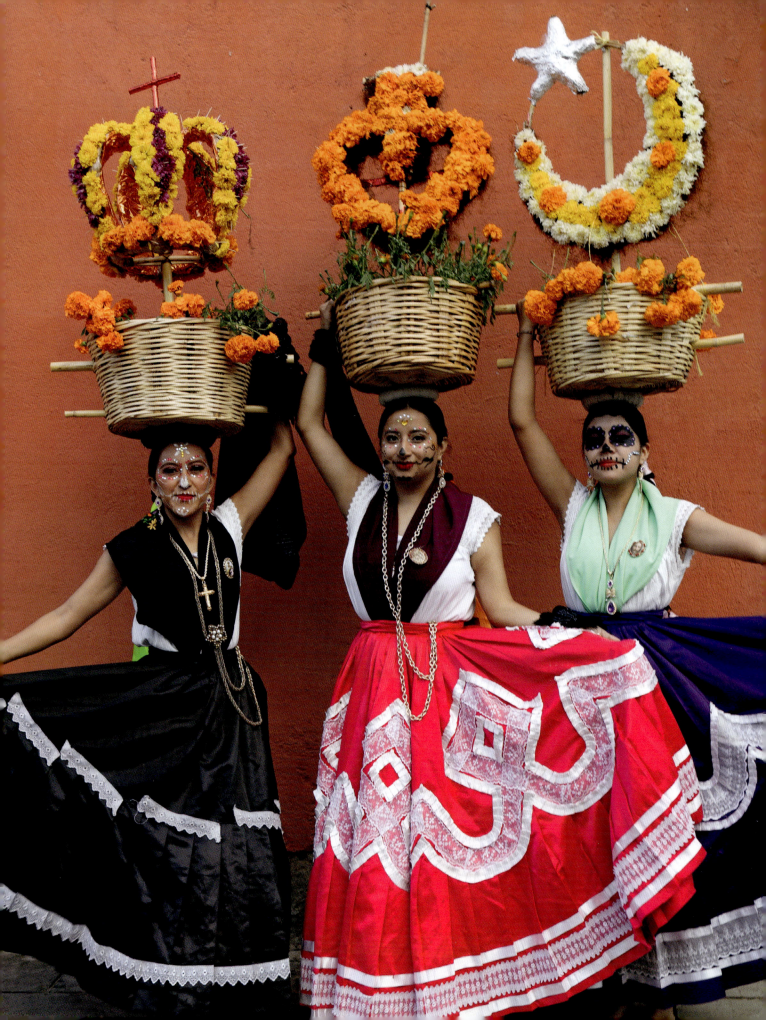

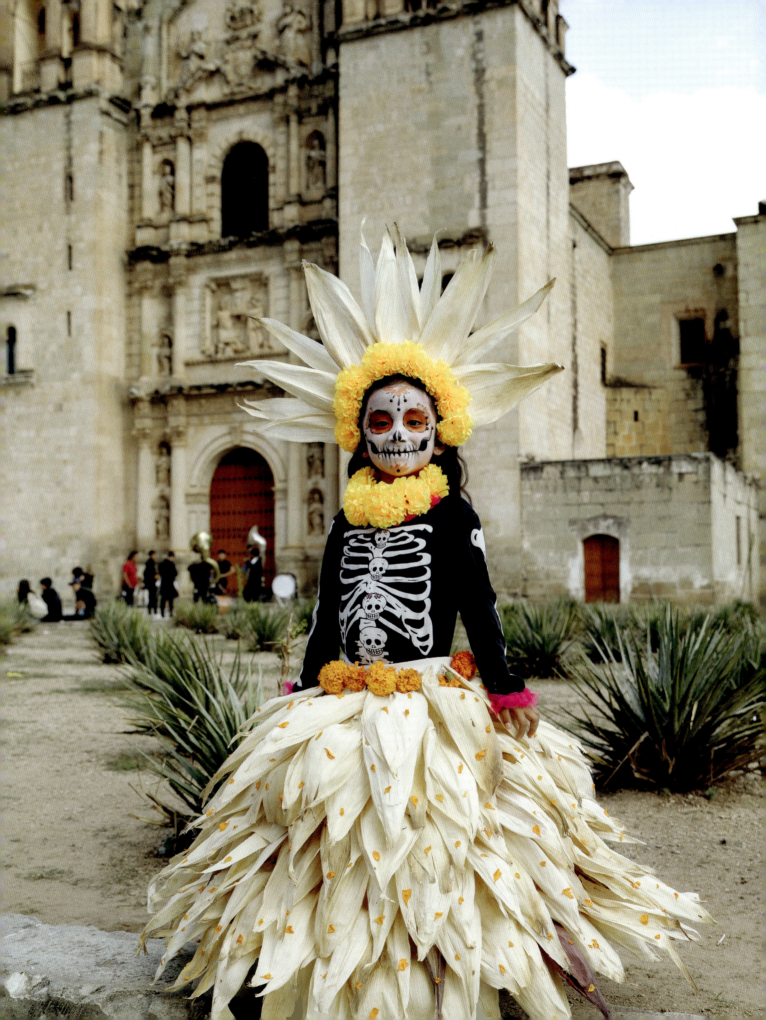

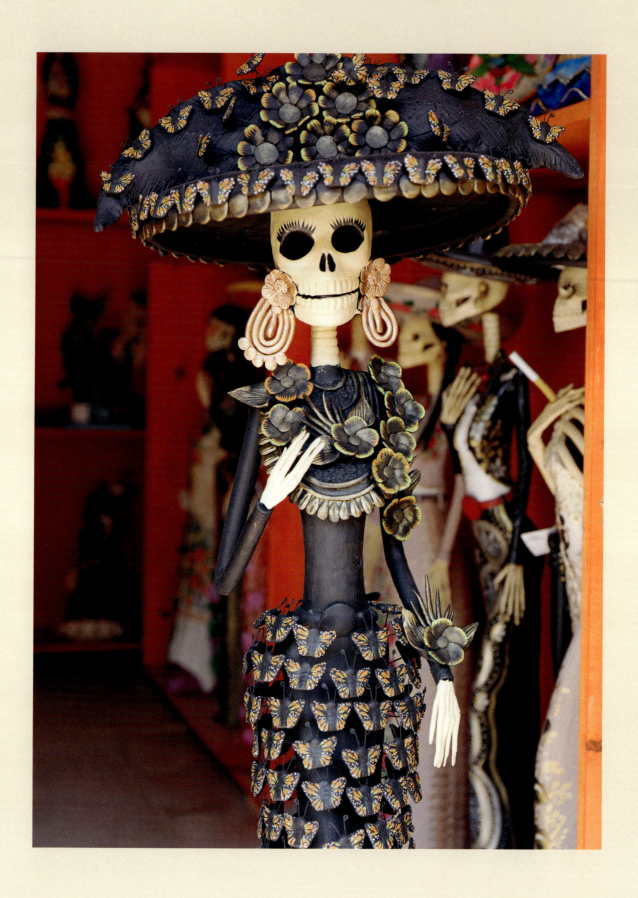

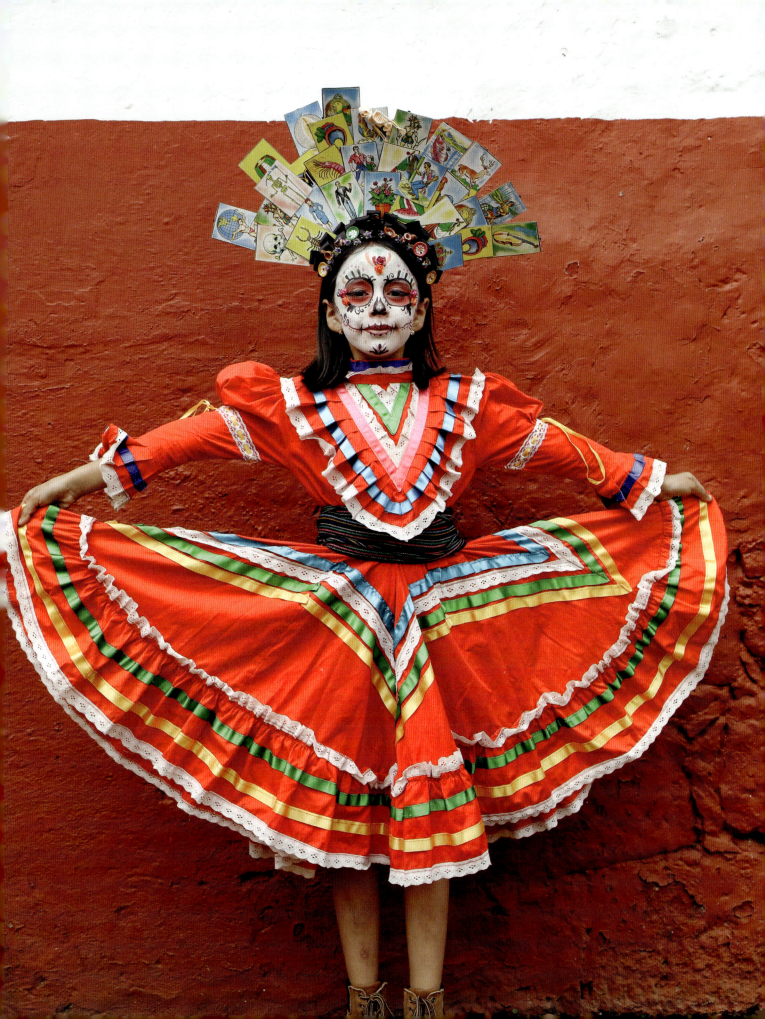

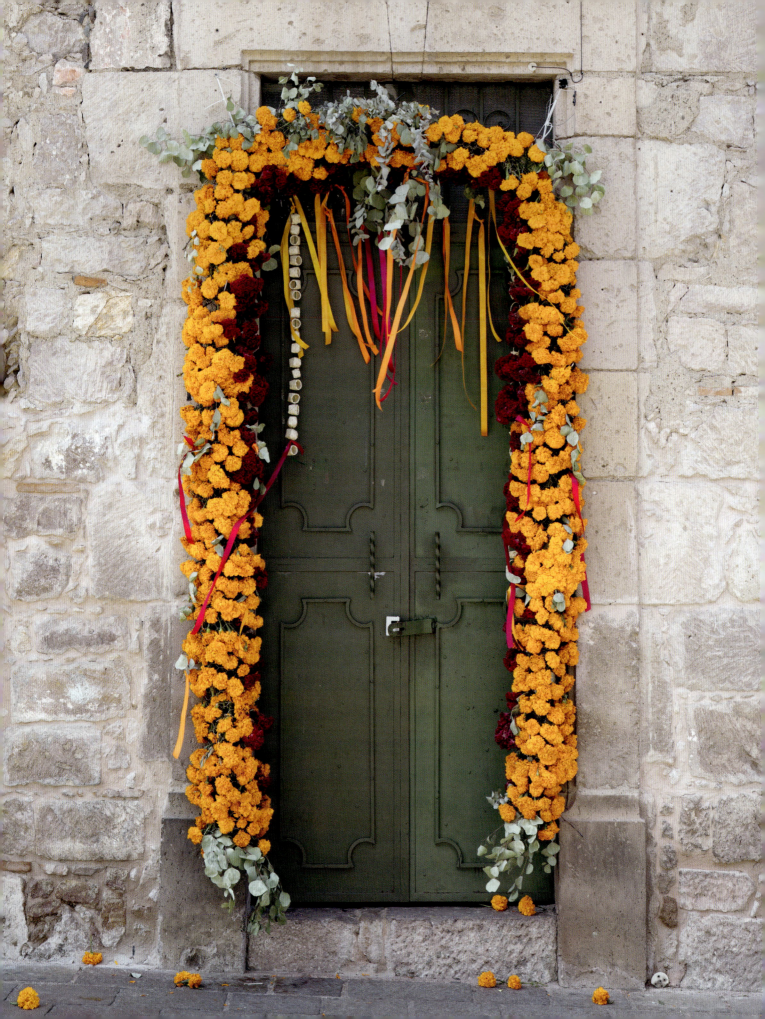

WHY WE SHOULD TALK ABOUT DEATH

Nothing in life can prepare you for the passing of a young soul. An untimely death knocks you off your feet, making you agonize over the fantasy of what could have been.

Saying goodbye to my cousin Lila was something I never imagined we would have to do in our twenties. Fifteen years later, I still struggle to make sense of how she died so suddenly, from a stroke. But I'll always be grateful that I made it to the hospital to see her one last time. During those final moments, I held her hand and fought back the tears so we could end the way she wanted, with positivity. I didn't want to let go, but I was able to promise her that she would never be forgotten.

From the time I was a little girl, I felt a strong desire to be close to Lila. Lila made me feel safe. When we spent the night at each other's houses, we talked until the sun came up the next day. When my heart raced from anxiety, she would wake up in the middle of the night to help me breathe. Our conversations were like therapy. She was my buddy, my confidante, and, later on, the cousin I could count on to go dancing at Billy Bob's, the Fort Worth honky-tonk.

It was always exciting to see the world from my older cousin's perspective. Everywhere we went, she turned heads. When men catcalled in her direction, I would scold them, saying, "Do you know she's only seventeen?" Lila would giggle and tell me not to worry, but it infuriated me when they ogled. Her looks were on par with Marilyn Monroe. She had a gorgeous, voluptuous figure and enchanting blue eyes. But Lila was more than just physical beauty. She was the kindest soul I ever met. She was never selfish. Never jealous. Never boastful. She was my biggest cheerleader—she would have been so proud of me for writing this book.

Lila also taught me I could do anything I set my mind to. She made things look easy, even when they weren't. When she was in her teens, she was determined to find a job so she could pay for her first car. In college, she first studied medicine before transferring to law.

Lila was magic. She loved animals and wasn't afraid to hold snakes and pet monkeys or even tigers. In fact, her photo on my altar shows her feeding milk to a baby tiger while a monkey hugs her (pictured on page 13). I love that photo because it captures her essence so perfectly.

✳

Months before Lila passed away, we happened to have a conversation about death. We talked about what we would want at our funerals, and she revealed to me her wish was for everyone to read her favorite book, *Captivating: Unveiling the Mystery of a Woman's Soul*. She asked me if we could read each other's favorite books, and, although I politely told her it was a great idea, I confess I never had any plans to read it—it wasn't my style. She was so annoyed with me when she found out that I didn't read it that she went to my house to retrieve it. Luckily, she couldn't find it, and when I returned home from college, I discovered it was still there, tucked away on my bookshelf. I was relieved to be able to grant her wish by sharing the book in the eulogy I wrote for her funeral.

Today, I treasure this book and keep it on my nightstand because it expresses so much of her wisdom, including handwritten notes and underlined passages. One of my favorite quotes in the book is from the author C.S. Lewis: "To love at all is to be vulnerable. Love anything and your heart will be wrung and possibly broken."

Lila was one of the greatest loves of my life, and although her death broke my heart, it also gave me a perspective I never realized I needed. It gave me permission to start living—to take risks, become an entrepreneur, travel the world, and put myself out there, even if it meant being susceptible to criticism. Her death made me a braver version of myself because it made the words "you only live once" feel real.

Losing Lila also taught me that death can be extremely isolating. After her funeral, it felt like I couldn't talk about her anymore. My original solution was to pretend she was still alive. When a memory of Lila popped up in my head, I would talk about her in the present tense. At first, it worked well enough. Strangers reacted normally and I was able to share a story. But then it began to feel disingenuous, so I tried telling the same stories, being honest about the fact that she had passed away. Of course, people's demeanor changed; they became uncomfortable, and this made me hesitate to talk about her again.

That was when I discovered there's another element to death that is very painful, aside from the devastating loss of the person. Society makes it clear in so many ways that we shouldn't talk about death. But the thing is, we *should* talk about death. Even though it's devastating, pretending like it didn't happen can lead to even more pain. And although it feels like the agony will never end, eventually, we can accept the wound and learn to live with the grief—choosing to use it for a greater good or, alternatively, allowing it to destroy us.

According to Mexican tradition, death doesn't have to be an isolating experience. In fact, it's perfectly acceptable to talk about death, because death is seen as a natural part of life. I'm so proud to be part of a culture that provides refuge for people who have lost someone. If you've lost someone, whether they're a sibling, parent, child, cousin, friend, or pet—please know, you're not alone, and there are beautiful traditions that can help you honor and celebrate their life.

THE OFRENDA AND THE ALTAR

My Tita Lupita always gave us the best *bienvenida,* or welcome, to her home. For Christmas, she would buy a five-foot-tall piñata of Santa and stuff it with candy and toys. She also loved to plan trips to different parts of Mexico—including Aguascalientes, Oaxaca, Zacatecas, and Guadalajara—and made sure every family trip was filled with celebration. Tita taught me that fiestas with family should always be a part of life, and she encouraged us to play music loudly, dance, and never shy away from saying "*te quiero mucho—*I love you so much."

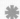

In addition to showing me how to throw a fiesta, my tita taught me to never receive a guest empty-handed. Whether it's a *cafecito, cuernitos de nuez, tacos de carne asada*, or tequila, it's important to always offer your guests a warm welcome. In turn, the guests should also bring something. This concept, which is referred to as *la bienvenida*, has been ingrained in our family since childhood and stems from Mexican traditions. But offering la bienvenida is not just for the living; it's also for the dead. This is why we create an *ofrenda,* or an offering, to welcome our loved ones back home.

We Mexicans believe it is always important to greet guests with delicious food and beverages. So an ofrenda traditionally includes the deceased person's favorite foods and drinks, along with pictures and personal items. It can also contain other elements that have various meanings. Even though the two words, ofrenda and altar, can be interchanged to a degree, the ofrenda refers to the items gathered to welcome the dead and the altar is where the items from the ofrenda are arranged. We place our ofrenda on an altar, which could either be a simple table or a more elaborate tiered structure (see more details on page 178). In this section of the book, I'll share more information regarding what an ofrenda entails, and further on I'll go into detail regarding the different styles of altars and their symbolism.

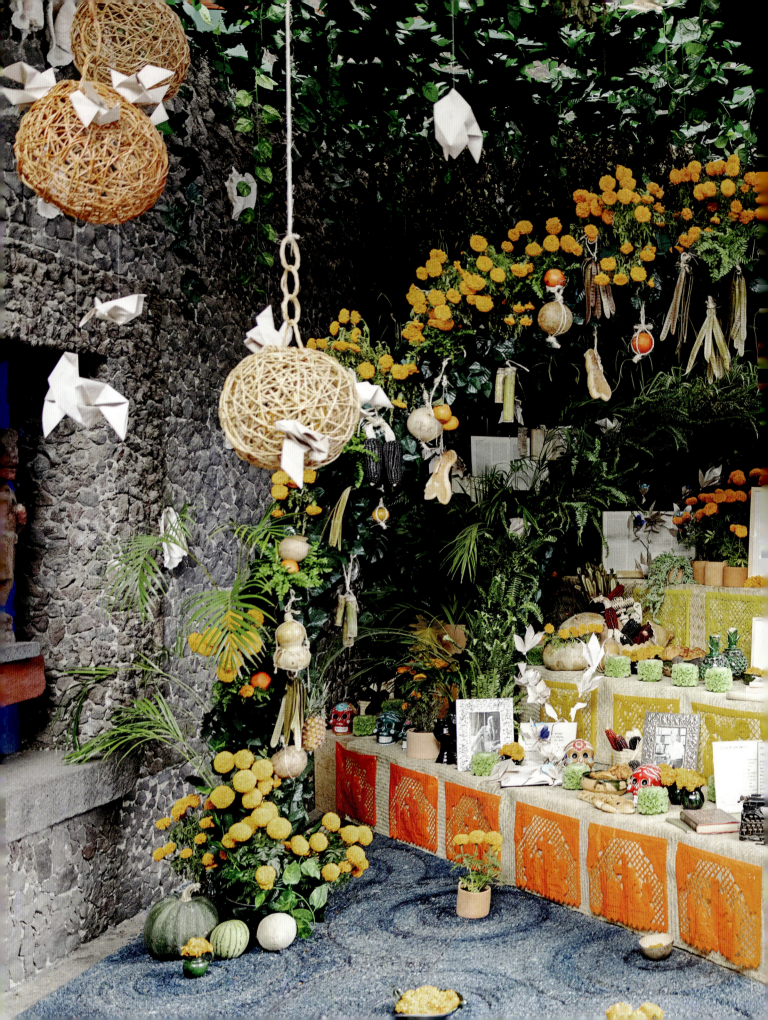

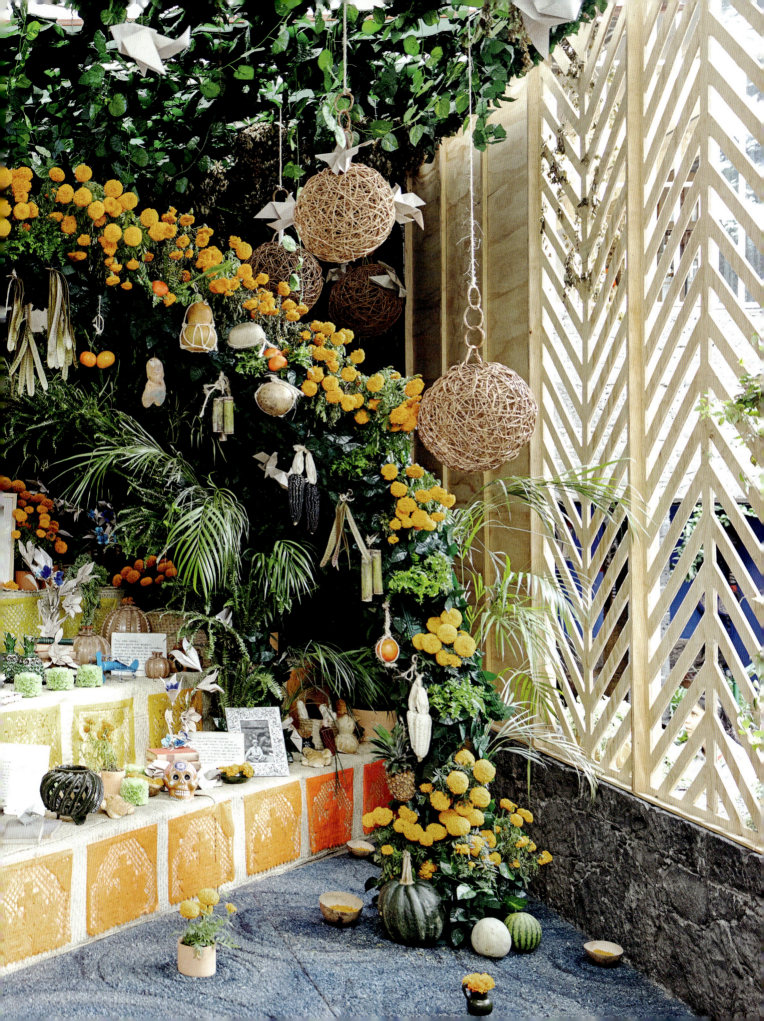

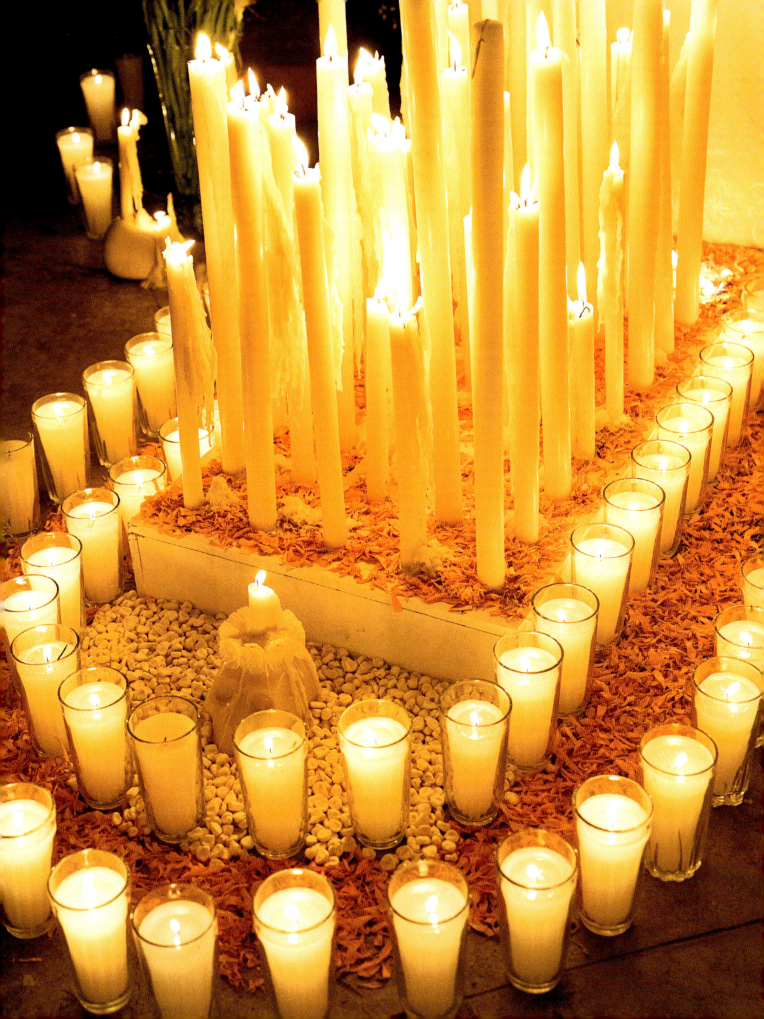

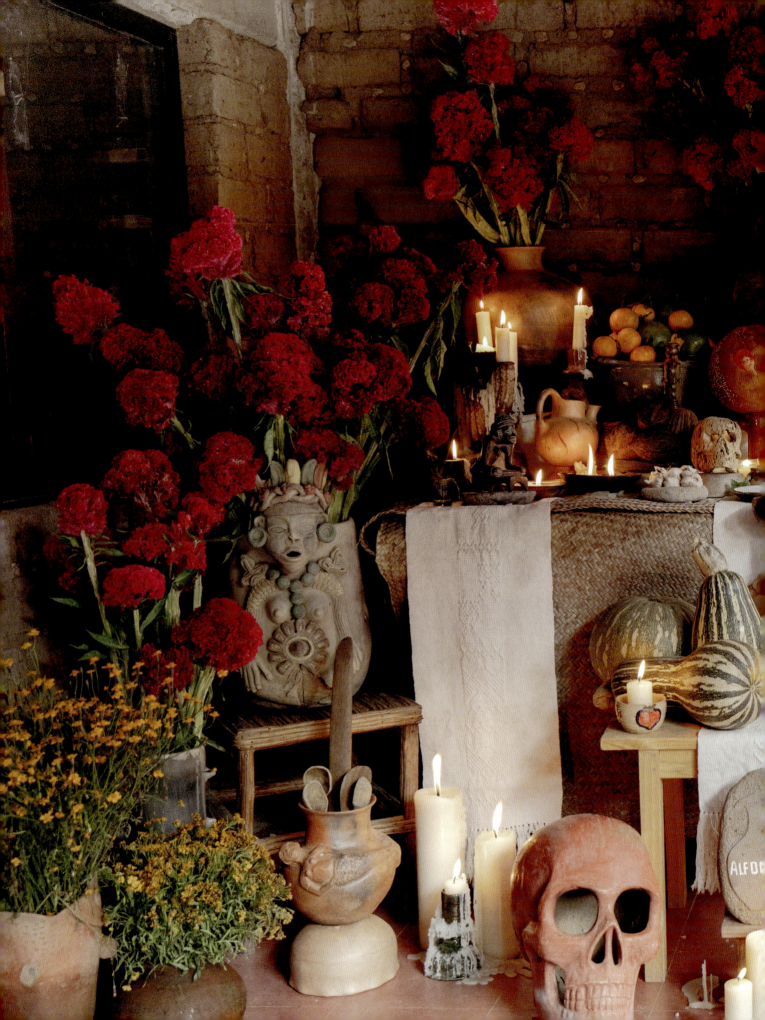

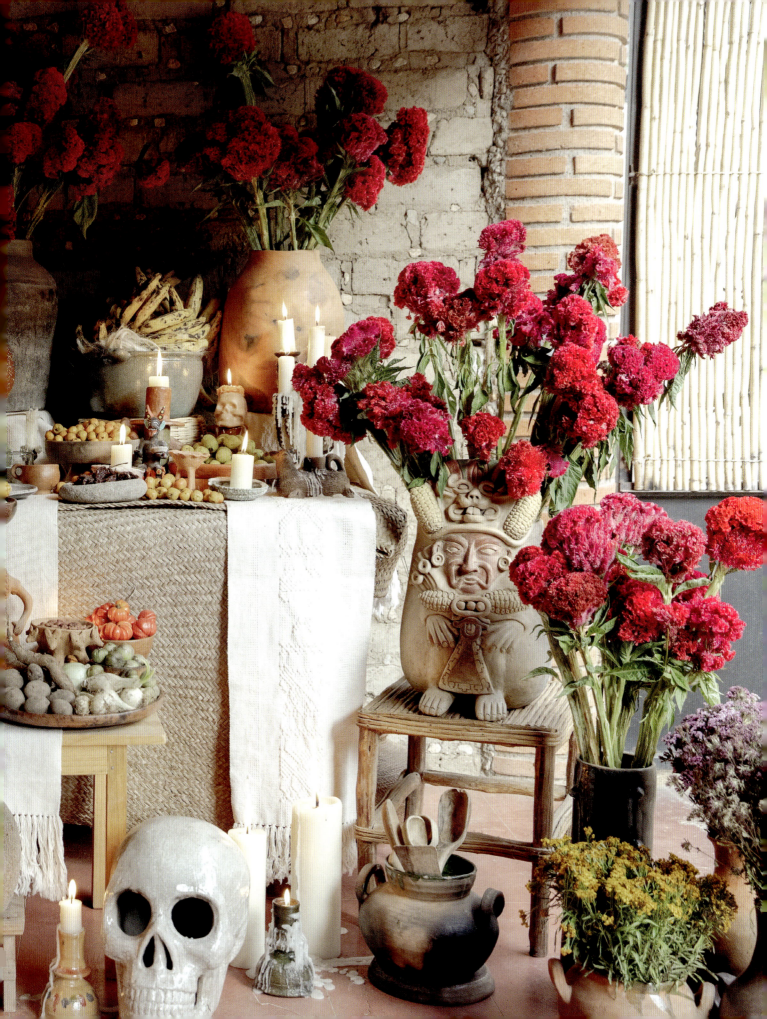

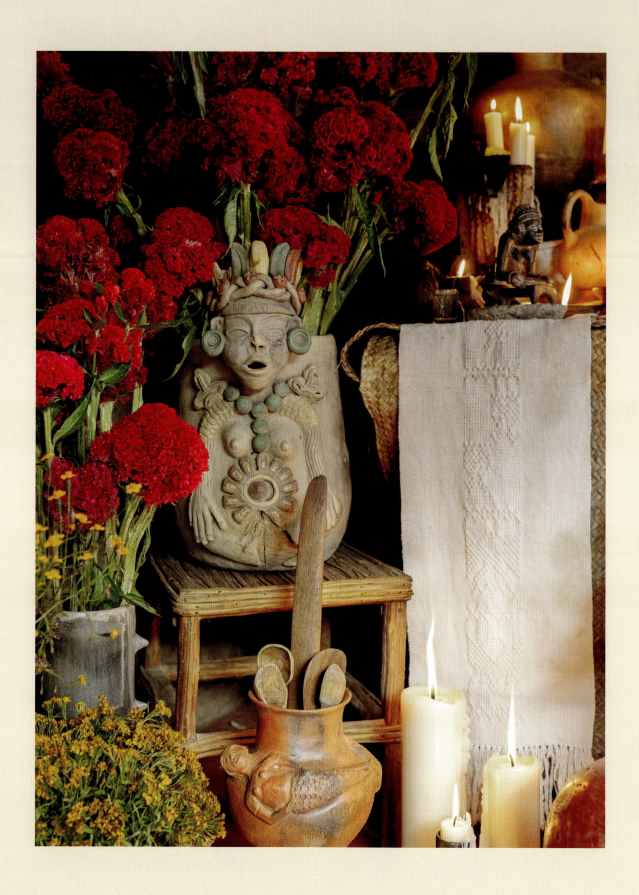

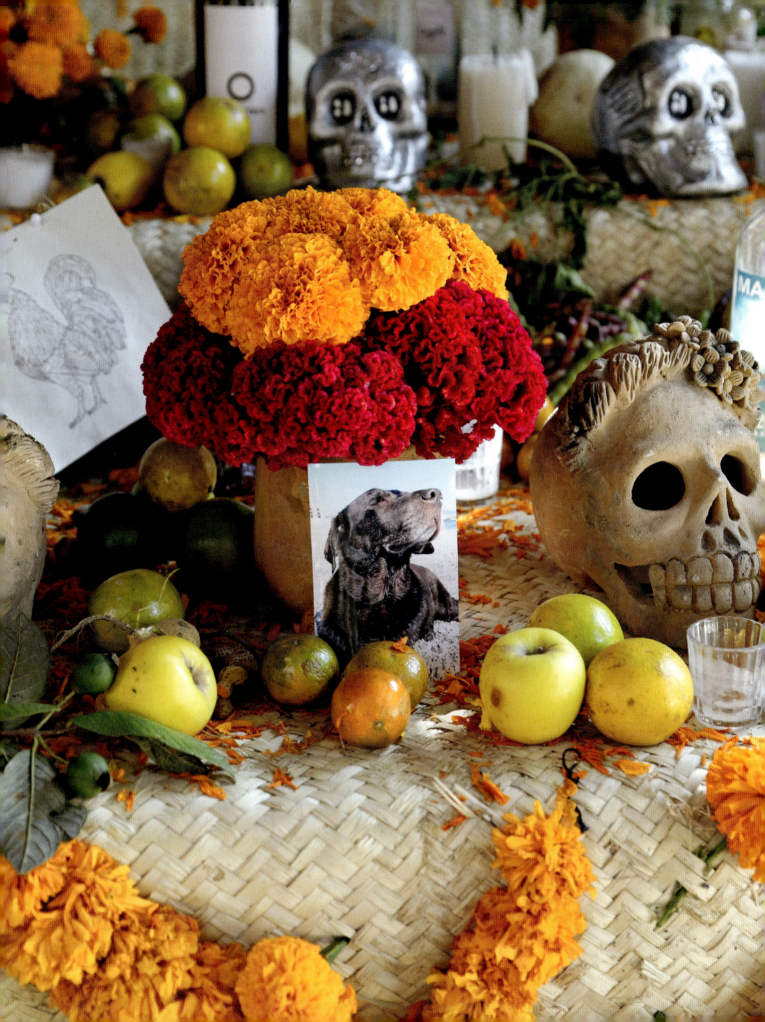

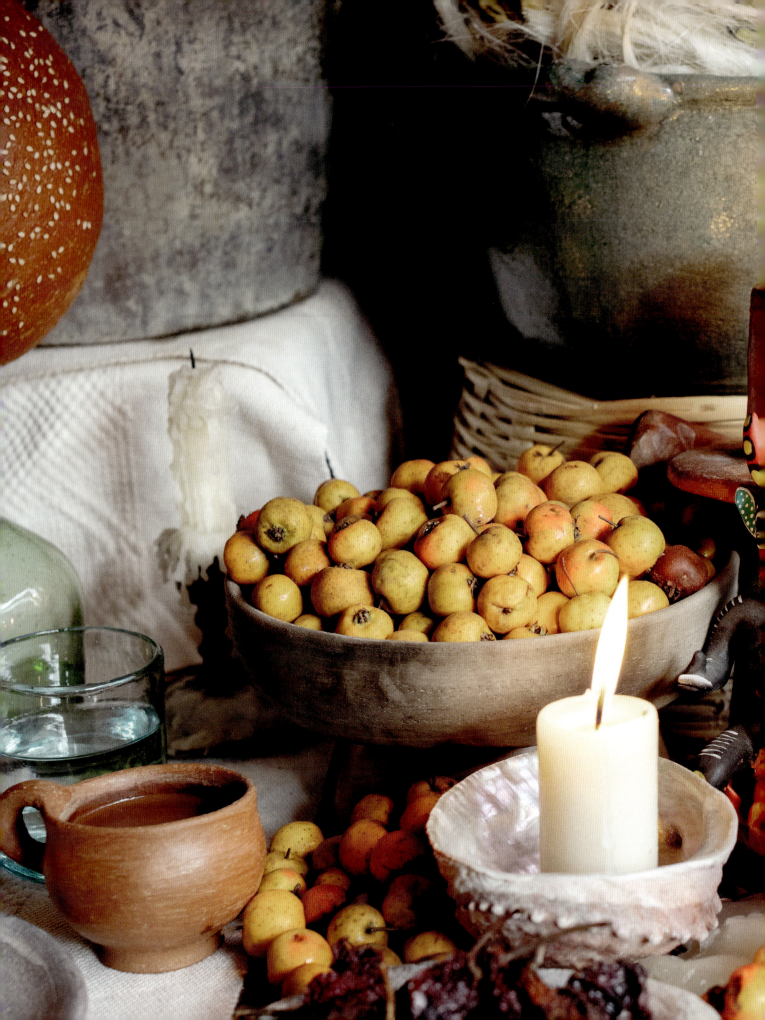

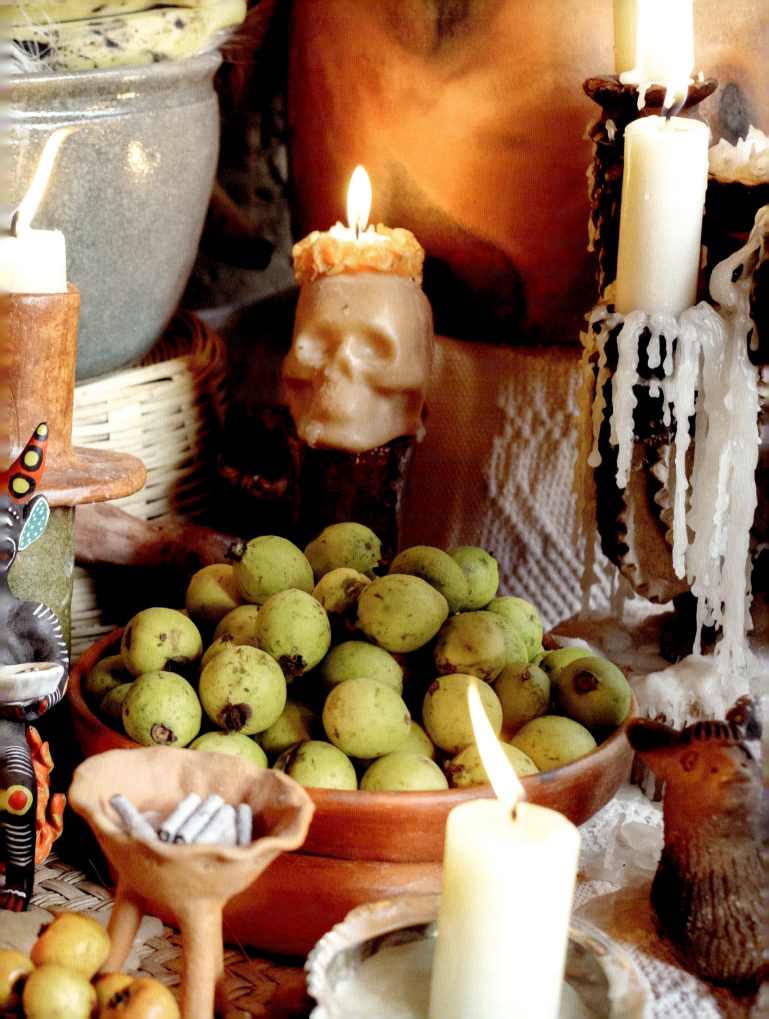

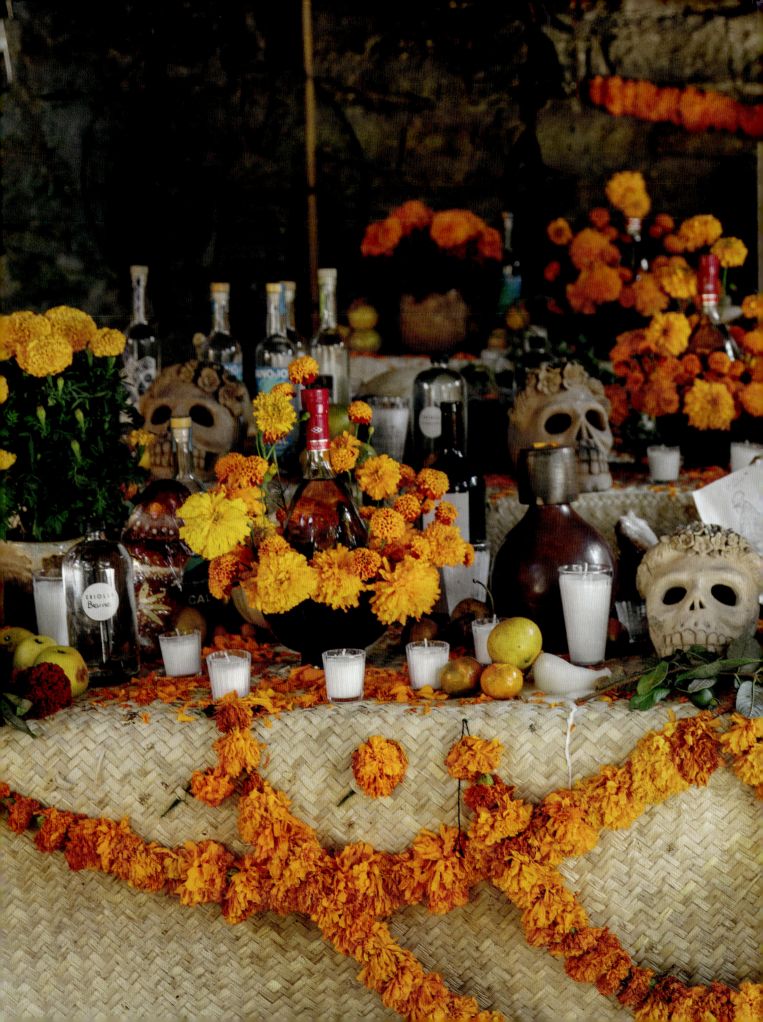

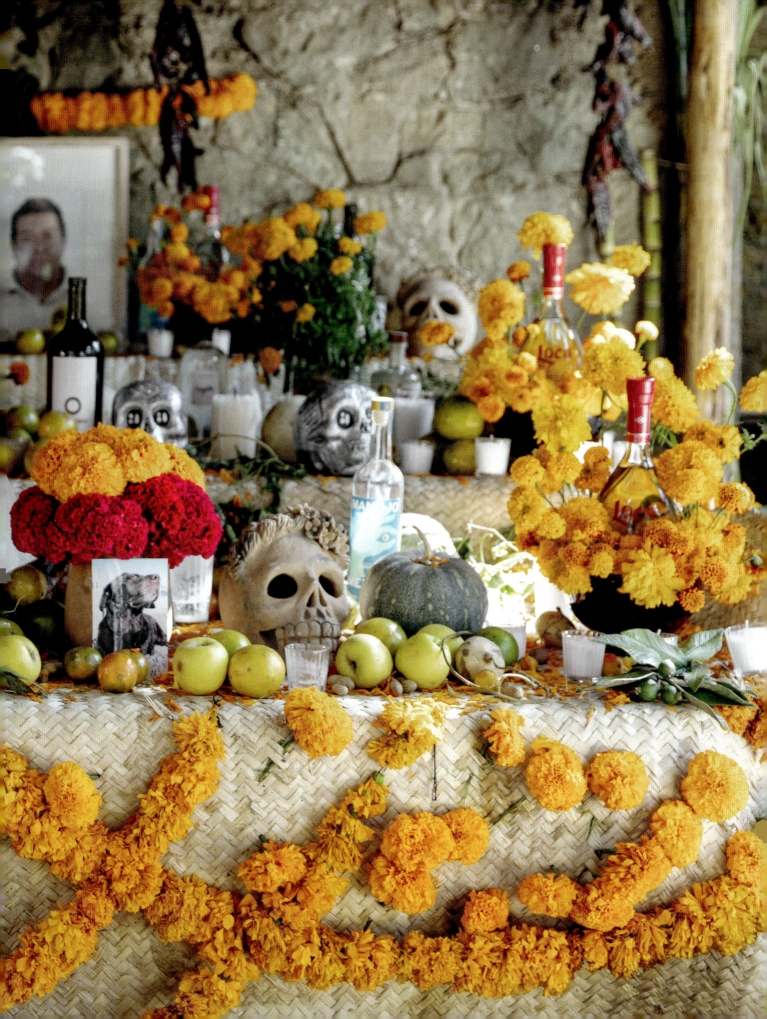

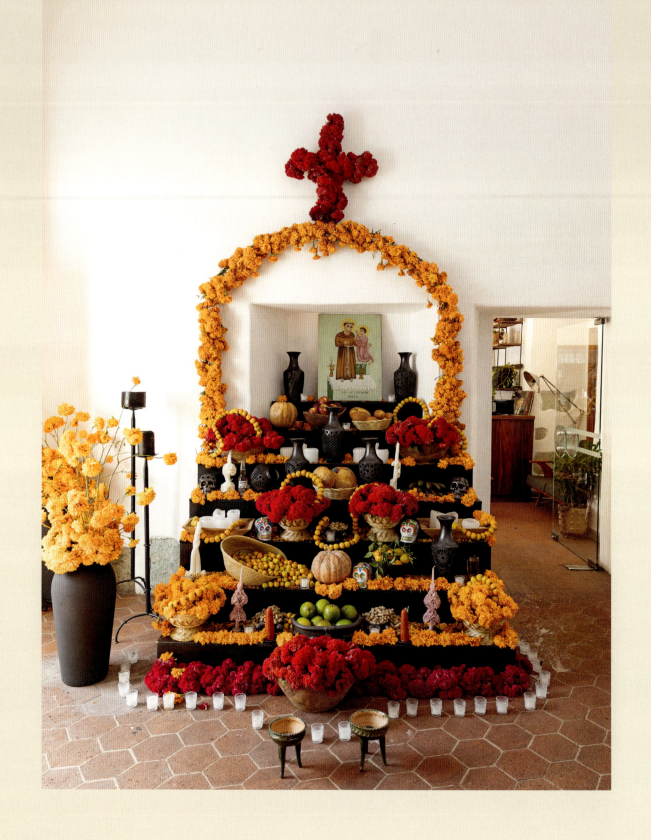

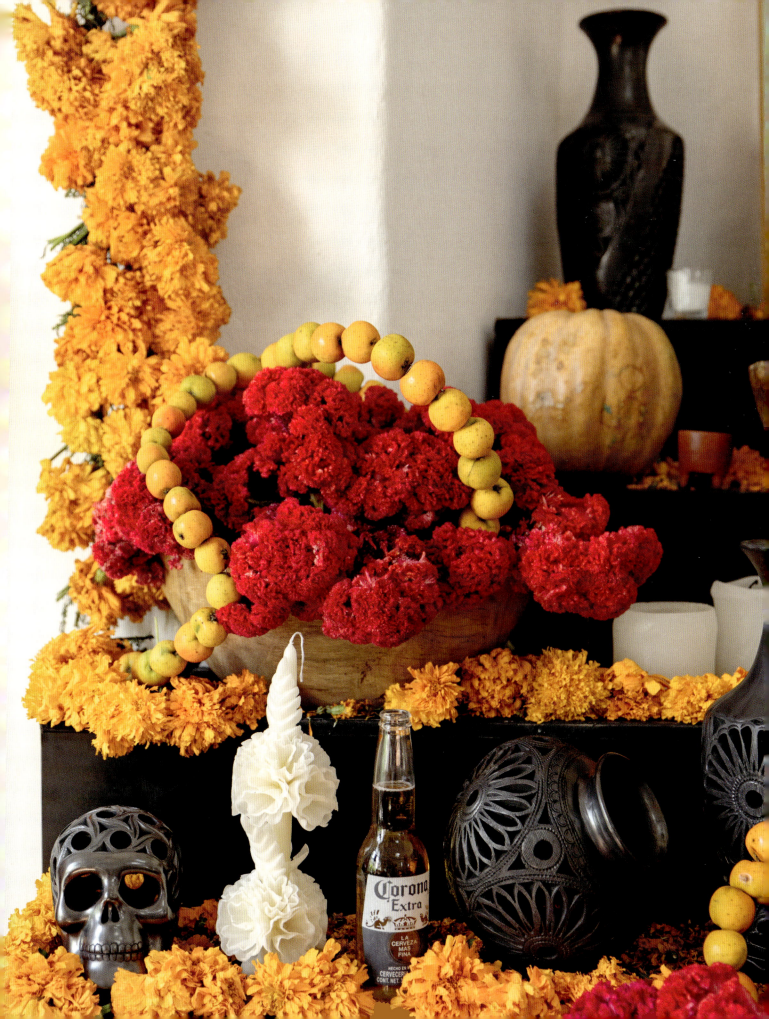

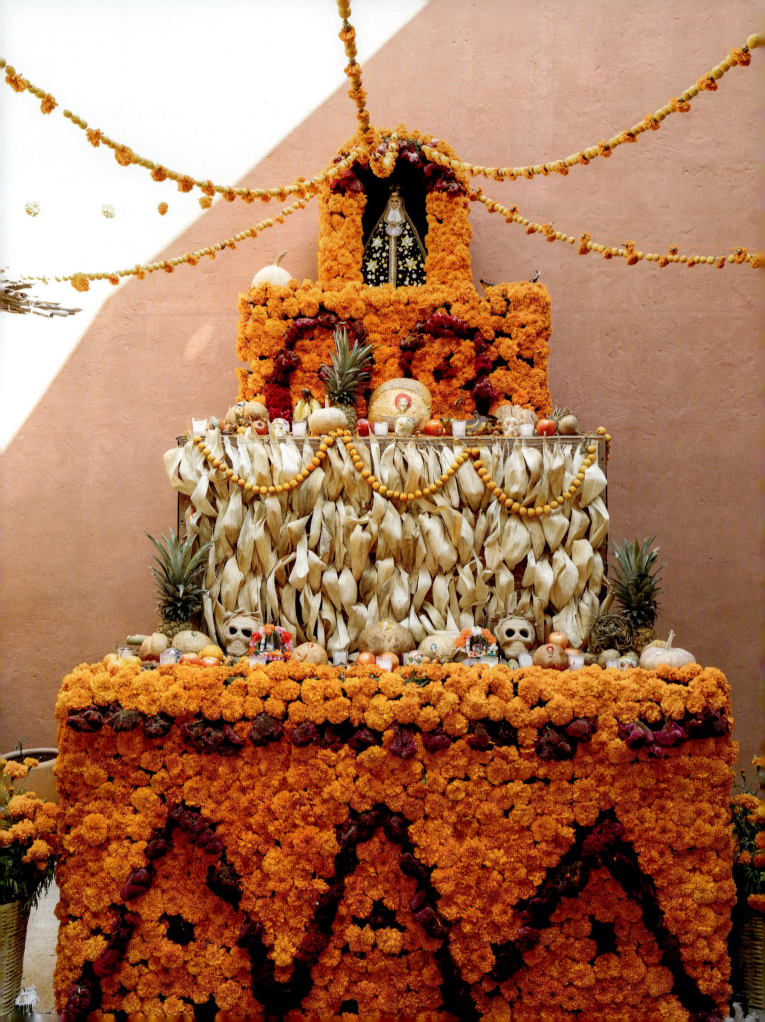

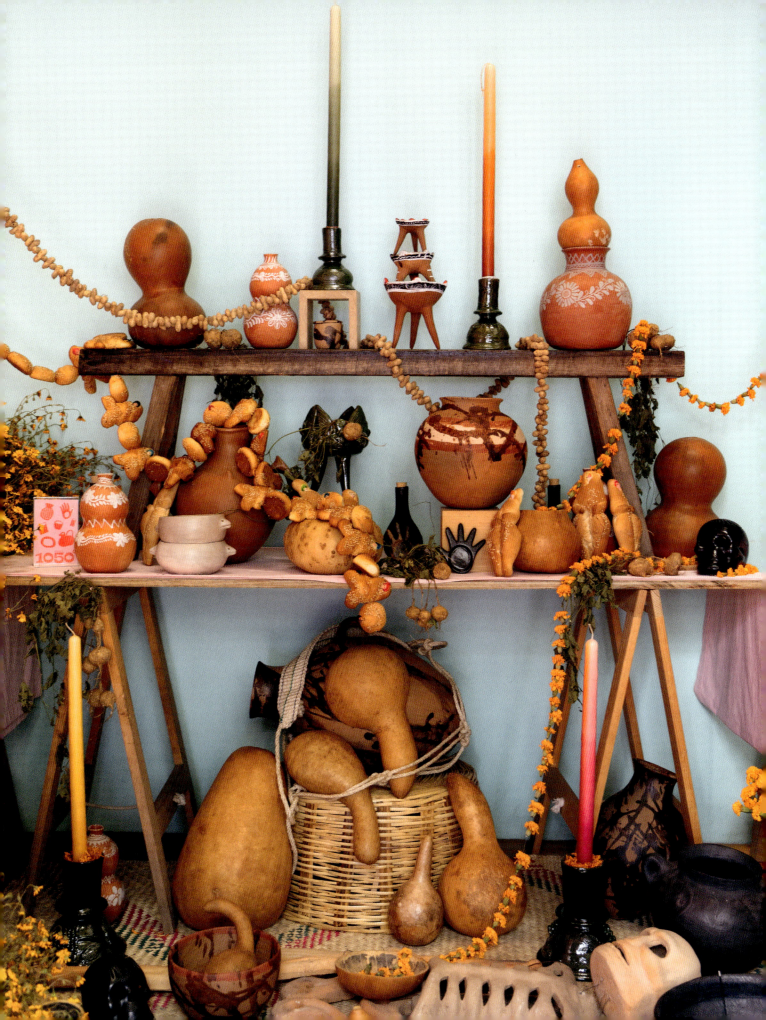

THE ELEMENTS OF THE ALTAR / OFRENDA

I admit that I wasn't so interested in building an altar or creating an ofrenda until my cousin Lila died. Over the years, my ofrendas have become more elaborate, and I've realized that learning customs is like learning anything else: it takes time, practice, study, and attention.

Building an altar is not a one-size-fits-all process. Traditions vary from state to state and between social classes, and people in some parts of Mexico don't even celebrate. Personal items of the deceased add a uniqueness to each altar and every presentation is specific to its creator's vision. In my opinion, as long as you prepare an altar with love, you can't go wrong.

Although customs can vary across Mexico, there are certain elements that every altar should have—including the arch, flowers (marigolds), food, candles, and photos of your loved ones. Some elements, like the arch, marigolds, and copal, help guide the spirits on their journey to visit us. Others have more spiritual and religious meanings, like the pictures of saints and sand cross, while pink candles and *papel picado* are intended to represent the joy in welcoming our relatives back home. Skeletons and sugar skulls represent the reality of death, while photographs and personal items help keep the departed's memory alive.

Even though a few of the elements listed are not traditional, I felt it was important to include them because of their cultural importance.

ALEBRIJES	PAPEL PICADO
ARCH	PERSONAL ITEMS
CANDLES	PHOTOGRAPHS
COPAL	RUG
DIRT OR ASH	SAINTS AND RELIGIOUS SYMBOLS
EMPTY CHAIR	
FLOWERS	SALT
FOOD AND DRINKS	SKELETONS
HUMMINGBIRDS	SUGAR SKULLS
MONARCH BUTTERFLIES	TABLECLOTH
	WATER
PALO SANTO	XOLOITZCUINTLE
PAN DE MUERTO	

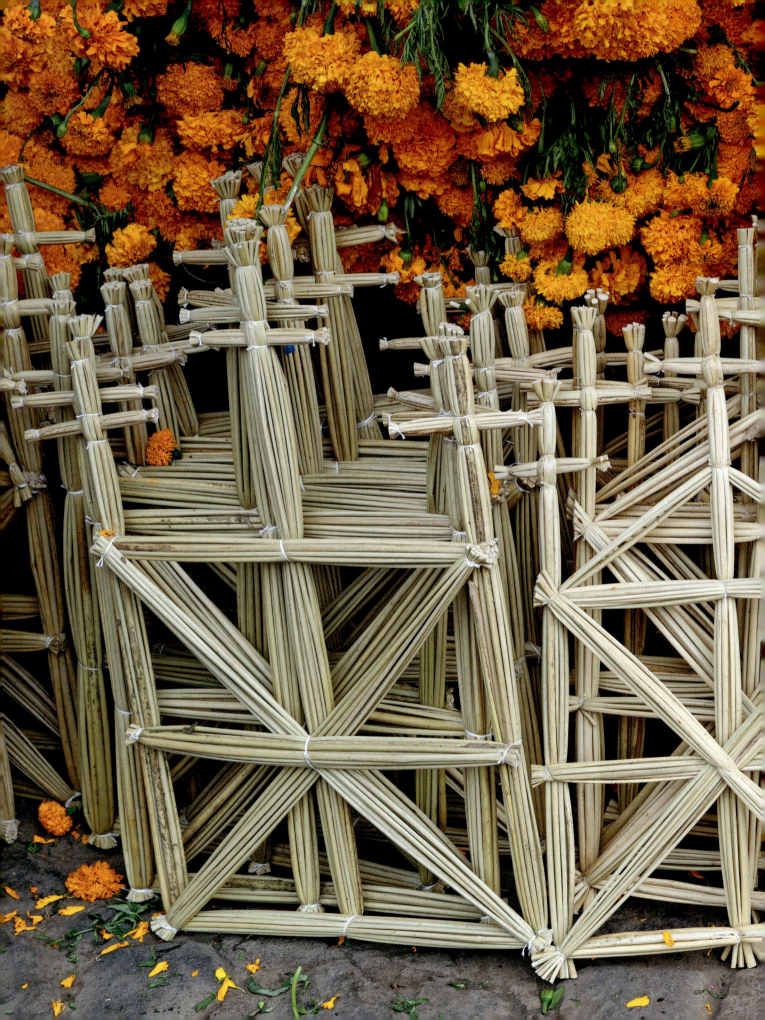

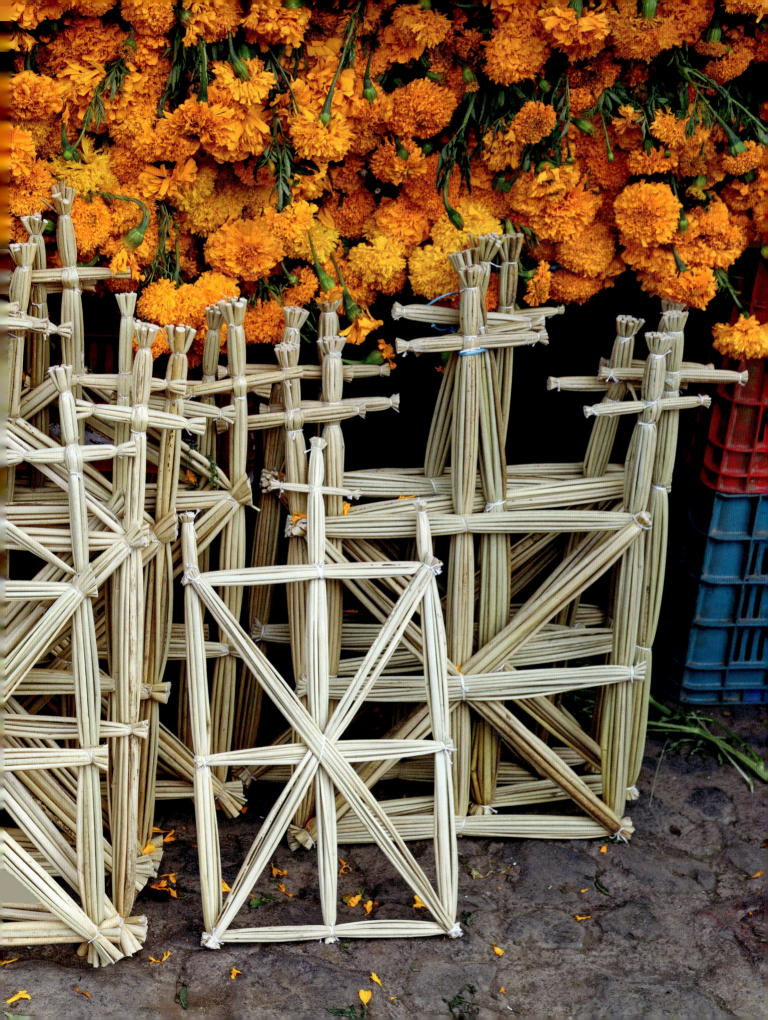

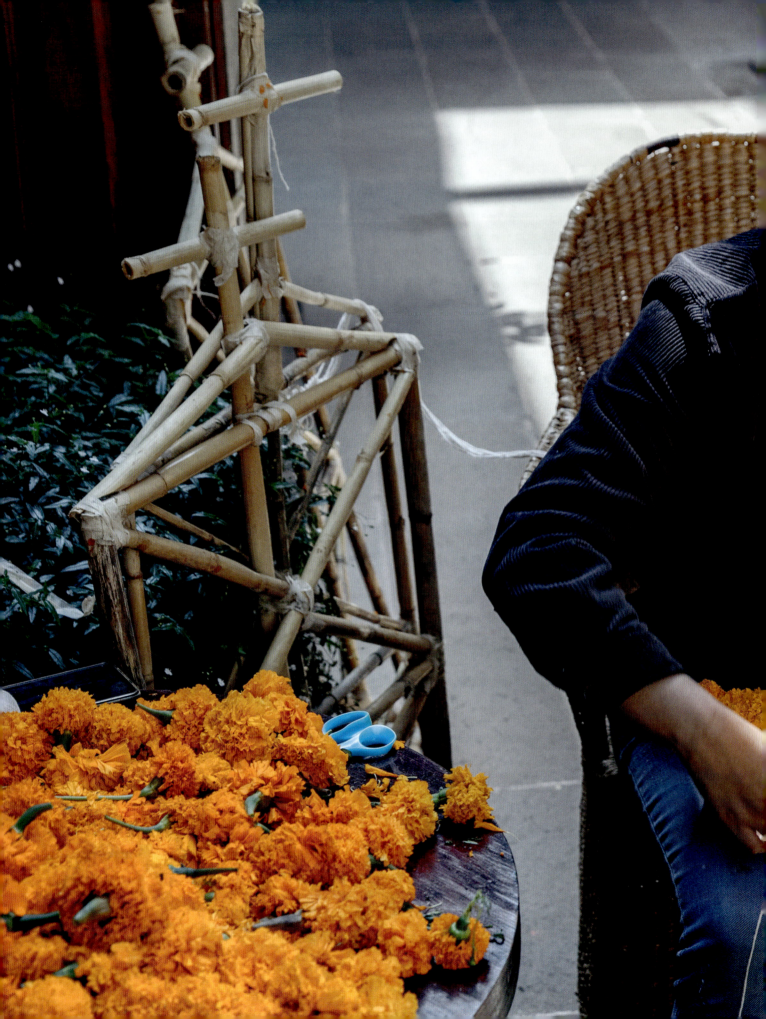

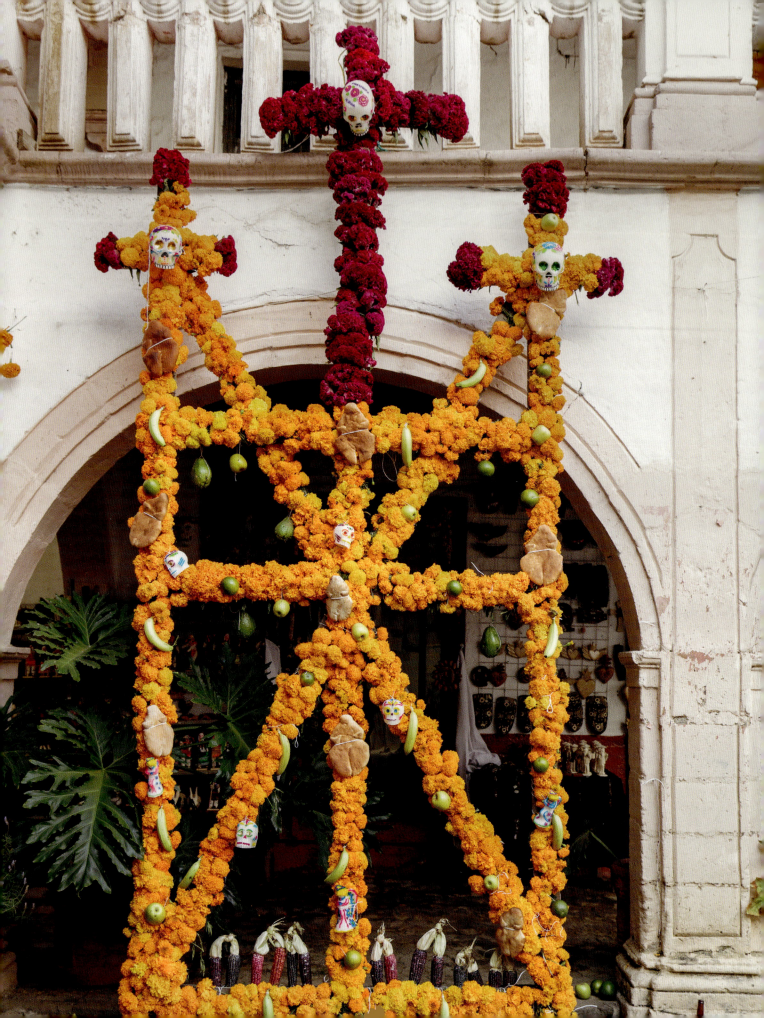

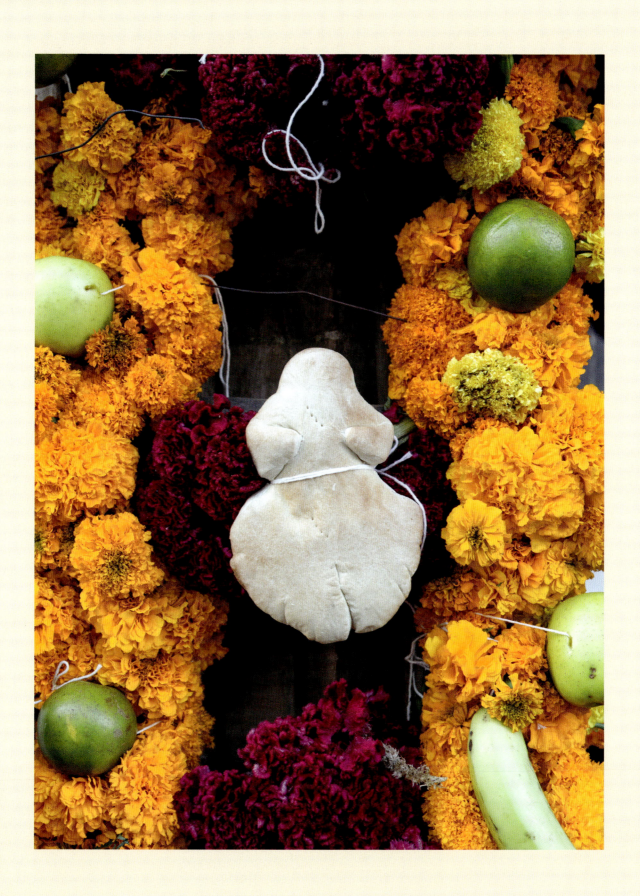

ALEBRIJES

Alebrijes are vibrant hand-painted Mexican spirit animals that have become especially popular around the world thanks to movies like Disney's *Coco*. While it's wonderful that *Coco* shed light on this beautiful Mexican folk art, the movie incorrectly depicts these animals as spirit guides for the afterlife. But alebrijes do not actually stem from Día de Muertos traditions, and they are not a centuries-old piece of Mexican folklore. Instead, alebrijes were invented in 1936 by a thirty-year-old Mexican papier-mâché artist (also known as a *cartonero*) named Pedro Linares.

According to Linares, once during an illness he dreamed of strange animals, including a donkey with wings and a rooster with the body of a frog. In his dream, the animals chanted the nonsense word, *alebrijes*. After waking up from the dream, Linares could not stop thinking about the creatures and the word *alebrijes*. So he brought his dreams to life by recreating the creatures in papier-mâché and sharing them with family and friends. Eventually, Linares's work caught the attention of famous artists Diego Rivera and Frida Kahlo, who commissioned him to create specialized alebrijes for them.

Even though alebrijes are not a Day of the Dead tradition, they can sometimes be found displayed on altars to honor pets or people who loved animals: for example, if someone loved hummingbirds, their family might display a hummingbird alebrije next to their photo. Or in an altar that honors a pet, the owner might include an alebrije that represents their animal.

ARCH

The arch represents the passageway between the world of the living and that of the dead. Located at the top of the altar, the arch is traditionally decorated using marigolds, but its style can vary from state to state.

The most beautiful and intricate arches I've ever seen are located in my grandmother Tita Susana's home state of Michoacán. While arches are traditionally at

the top of an altar, in Michoacán I also saw them placed among the city's buildings, often in front of entryways. Some of the arches are so large that when you walk underneath them it actually feels like you could move between the world of the living and the world of the dead.

Unlike those in some other states, arches in Michoacán are elaborately decorated with marigolds, cockscomb, *pan de muerto*, bananas, sugar skulls, oranges, maize, and sugarcane—and they tend to feature a large cross at the top.

There are many different ways to build an arch. In Michoacán, some locals use plants retrieved from the bottom of Lake Pátzcuaro to create the structure, and tie fresh marigolds on top. In Mexico City, vendors sell premade arches made from scraps of wood. The first time I built an arch by myself, I tied a bunch of marigolds together by the stems, without using a base, but it wasn't the most stable solution and I don't recommend it. The following year, I invested in a metal floral arch, which made the process much easier.

CANDLES

If you're visiting the ofrenda of a loved one, you may want to bring a candle as an offering. Traditionally, white candles are used to light the path of our loved ones back home. Purple candles are used to represent mourning and the connection between the living and the dead. In some indigenous communities, the number of candles on the altar represents the number of souls the family will be receiving.

As Día de Muertos has grown more popular, the candles used have also become more elaborate. For example, in Teotitlán del Valle, Oaxaca, artisans make beeswax candles shaped like skulls decorated with flowers, which can be used in place of sugar skulls.

COPAL

Like amber, copal is a light-yellow tree resin; it has been used as a kind of incense since pre-Hispanic times. The word *copal* comes from the Nahuatl word *copalli*, which means "incense." The aroma is said to attract our loved ones so they can find us on Day of the Dead. Copal is also used as a traditional medicine to heal anxiety, coughs, muscle pains, and other ailments.

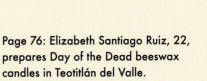

Page 76: Elizabeth Santiago Ruiz, 22, prepares Day of the Dead beeswax candles in Teotitlán del Valle.

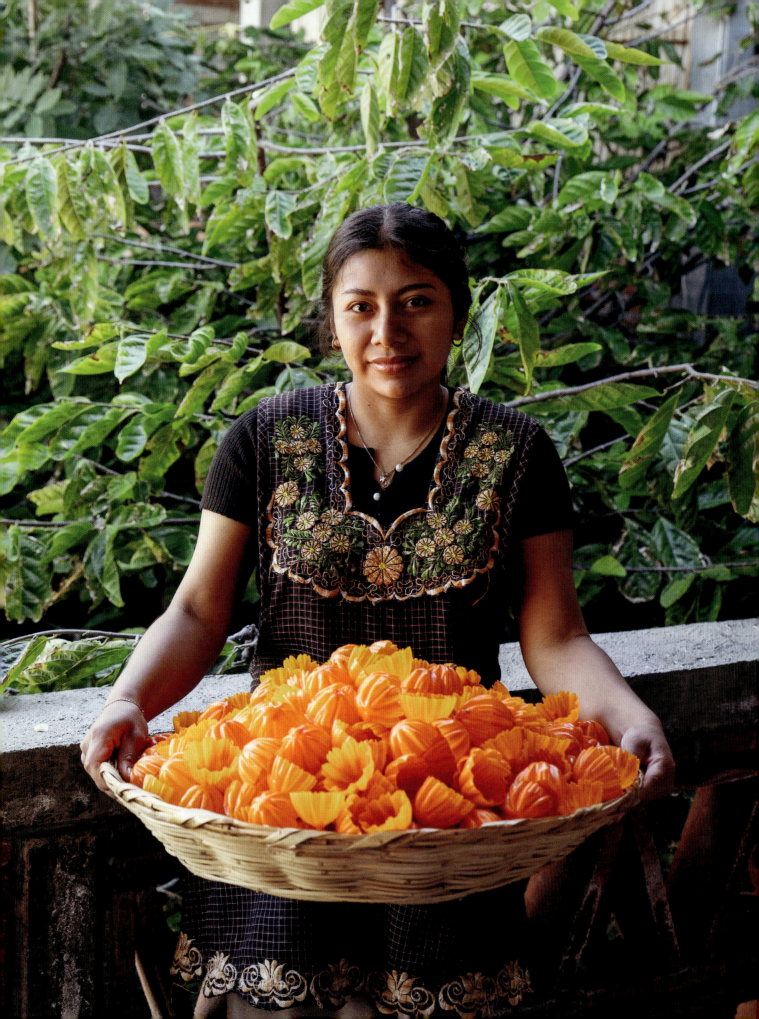

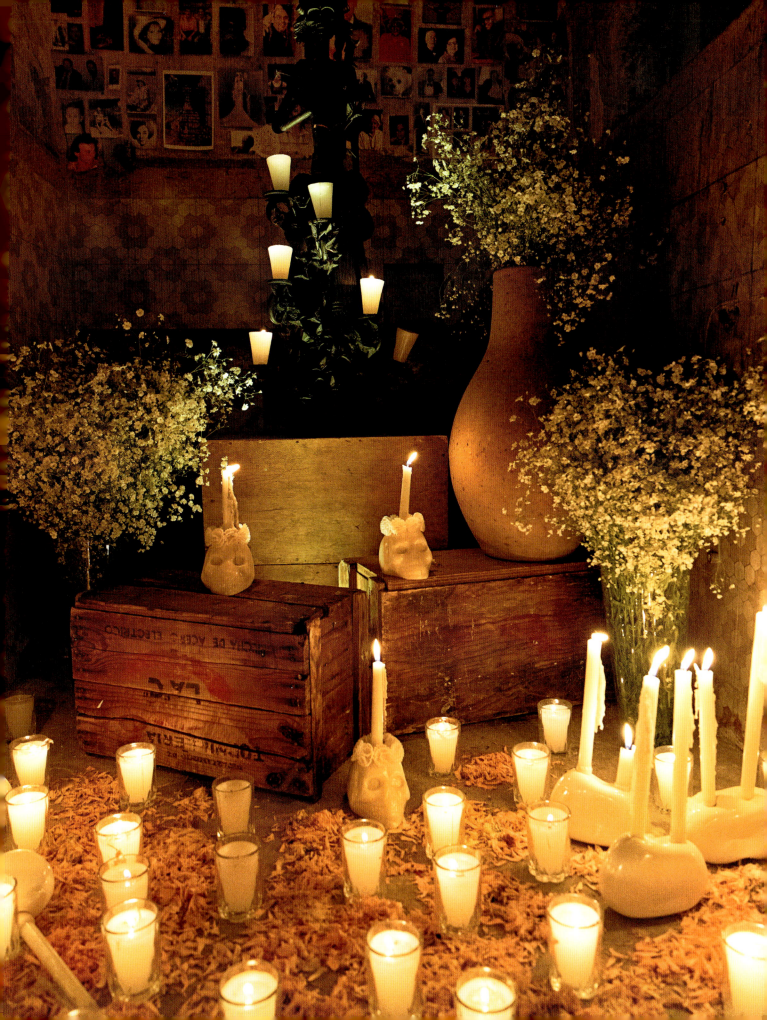

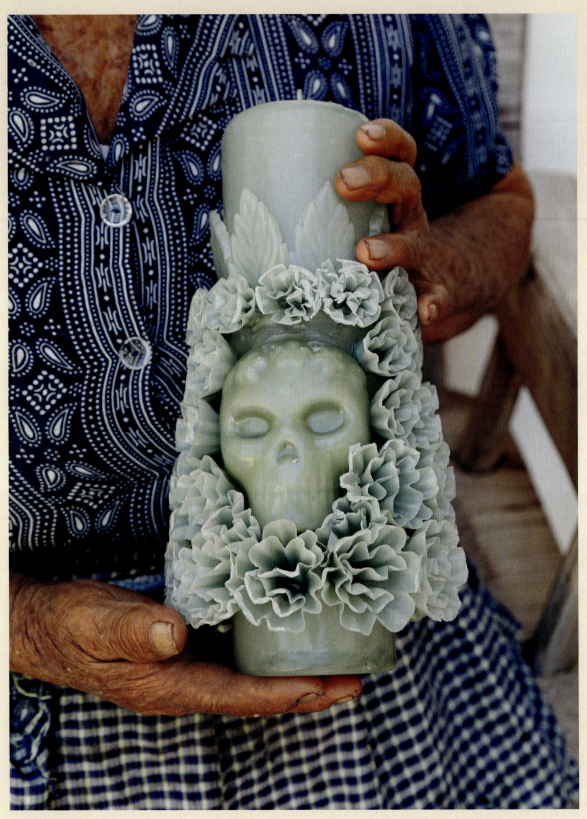
Opposite: Master Artisan Doña Viviana Alávez, 78, shows us her collection of Day of the Dead candles in Teotitlán del Valle.

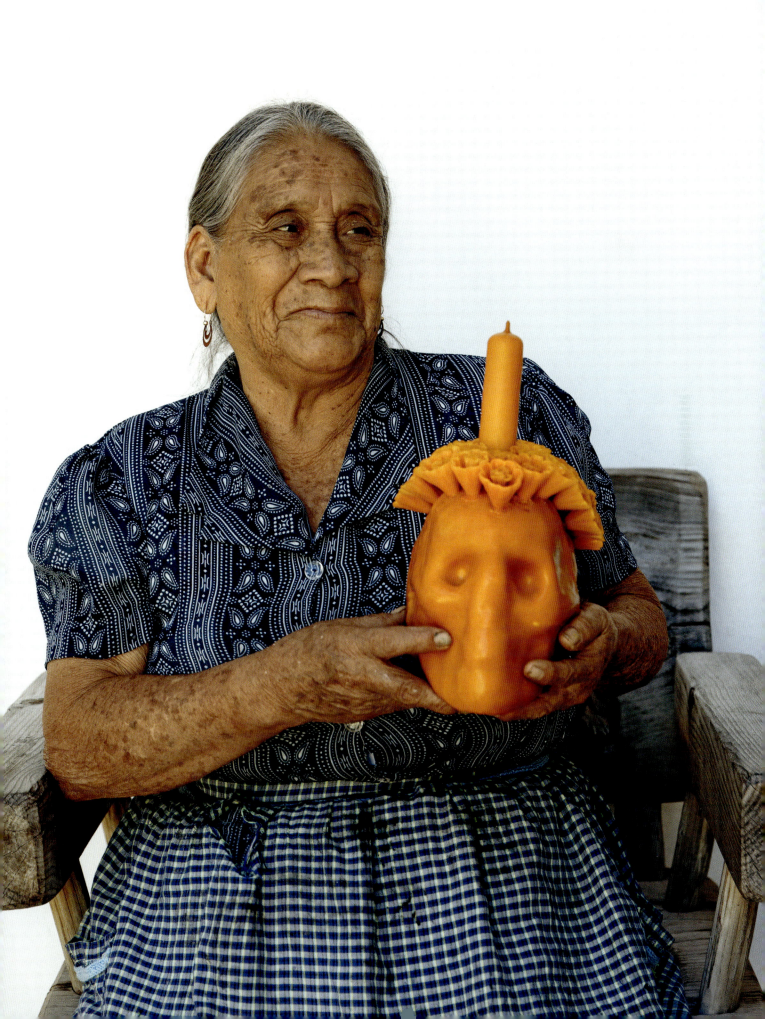

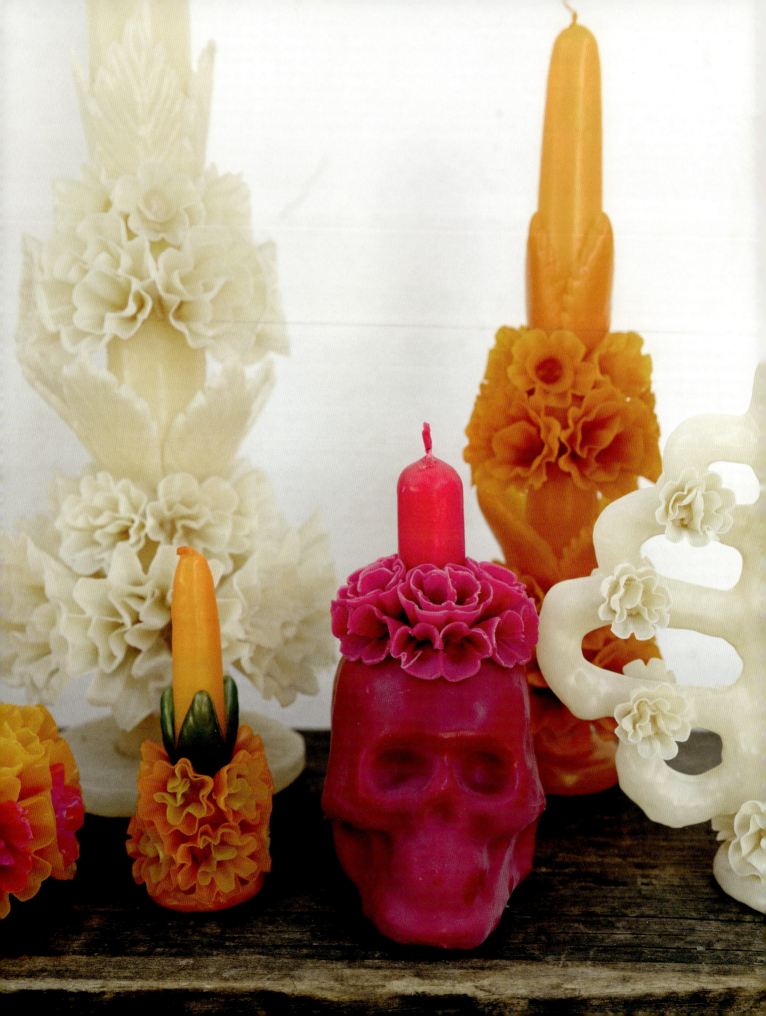

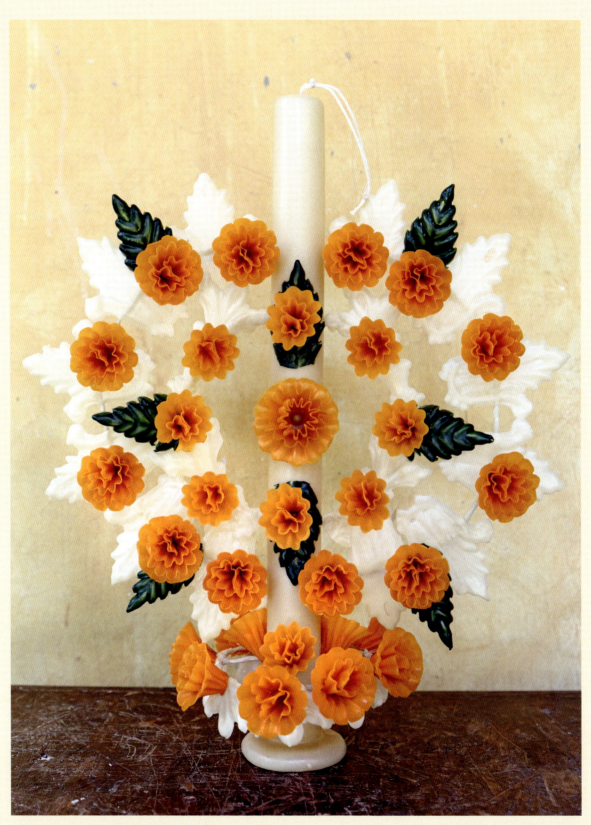

Floral cempasúchil candle handmade by Liliana Ruiz López in Teotitlán del Valle. This candle took 3 days to make.

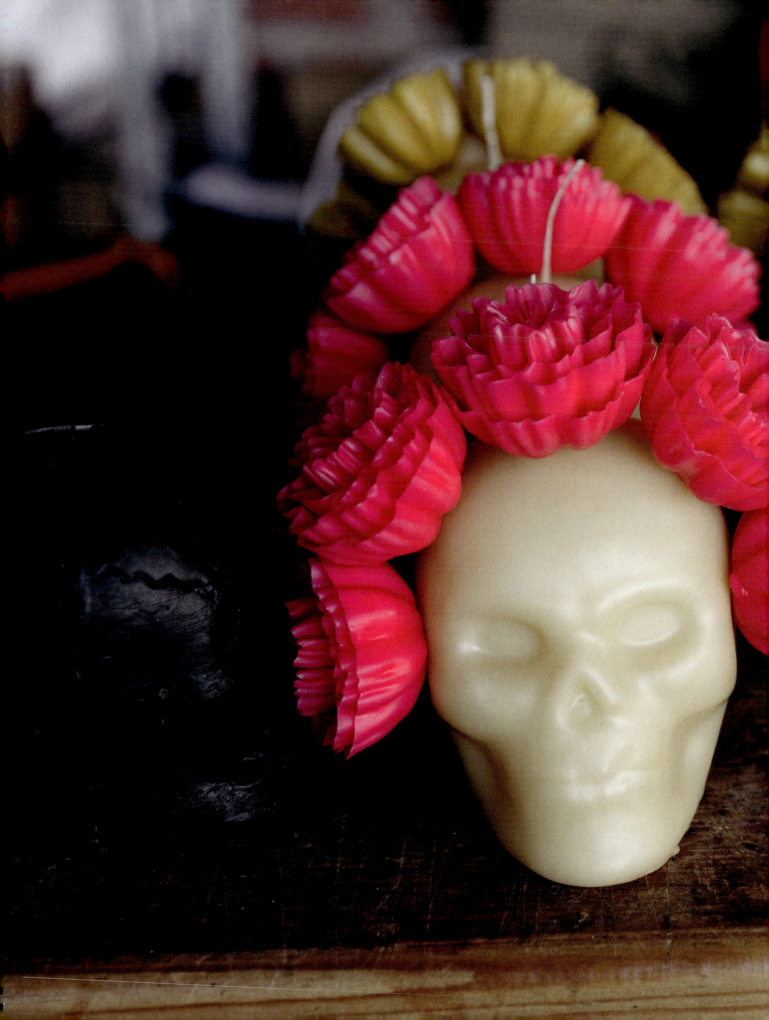

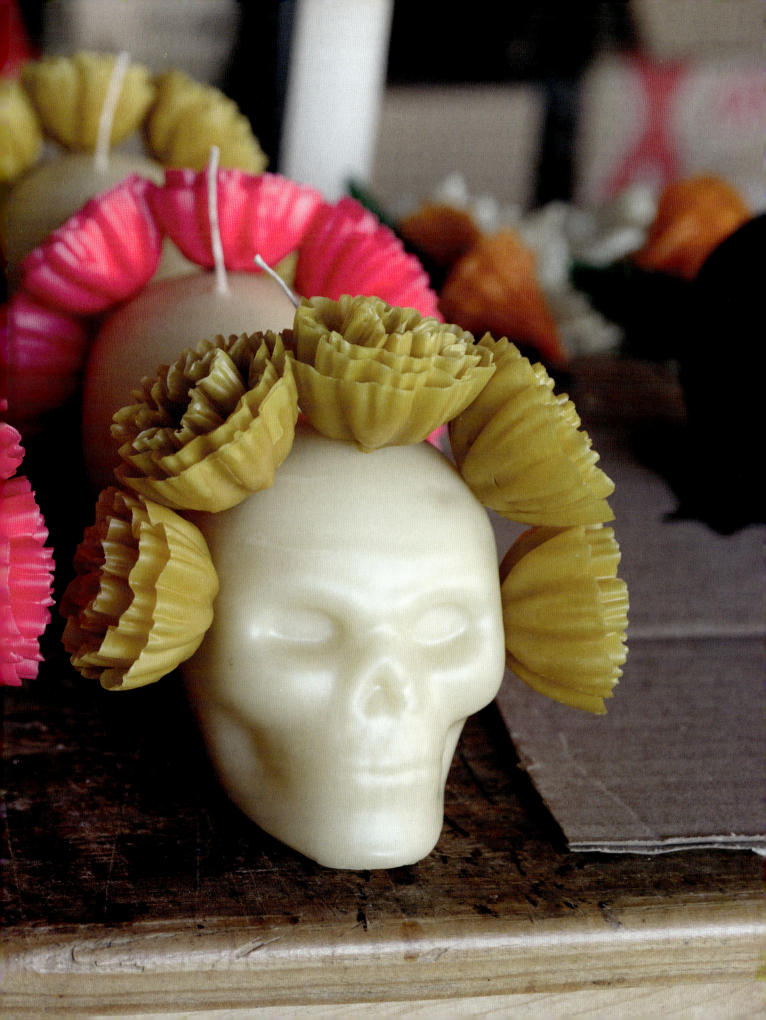

DIRT OR ASH

Dirt or ash elements on the altar represent what God tells Adam in the Book of Genesis: "Remember you are dust, and to dust you shall return." Some altars include a sand cross to represent this idea.

EMPTY CHAIR

Some altars incorporate an empty chair as a place for souls to rest when they arrive. I have found this tradition to be more common in the state of Michoacán than in other places I have traveled.

FLOWERS

Native to Mexico, the *cempasúchil*, or marigold, is recognized as the ceremonial Day of the Dead flower and is an essential on every altar. The word derives from Nahuatl and means "the flower of twenty petals." According to Mexican tradition, the aroma and bright orange color of this flower guides the spirits of our loved ones back home. So we sprinkle a path of petals and abundantly cover our altars with the flowers. In some regions of Mexico, it is common to find a path of marigold petals sprinkled from the entryways of doors all the way to the altar. You may also see a path that guides the spirits toward the cemetery and ensures the spirits don't get lost during their visit.

Unfortunately for me, marigolds are expensive and hard to come by in New York City. A small bunch of six or eight flowers can cost anywhere from $18 to $25, which is frustrating when one is trying to decorate for Día de Muertos. I asked my community where I could find marigolds, and they led me to Luna Family Farm, owned by a Mexican family in Columbus, New Jersey. The Lunas plant marigolds every year to help people in the area celebrate Day of the Dead. Knowing that other people were also struggling to find affordable marigolds, I began to sell them at my shop for $10. People were so excited

they came from all over the tri-state area to purchase them! In order to prepare an altar properly, you truly do need an abundance of marigolds.

Just a few weeks after this coup, I headed to Mexico, where I was shocked to see truckloads of marigolds both at the market in Mexico City and speeding down the highway in Michoacán. The country was painted in bright orange, and my inner child was giddy with excitement! It was incredible to see people carrying double handfuls of marigolds—costing only about 70 to 100 pesos, or $5—in preparation for receiving their loved ones.

Visiting Mercado de Jamaica in Mexico City during Día de Muertos is a memory I'll cherish for years. The market is a one-stop shop where people can find sugar skulls, papier-mâché skeletons, papel picado, and other elements needed for their altars. The energy is exciting and chaotic, as vendors shout "¿Las quiere amarillas o rojas?"—"Do you want them yellow or red?"

There I learned that other flowers can also be used on altars. After the cempasúchil, the second most popular flower is a red blossom known as cockscomb in English and *cresta de gallo* in Spanish. In Mexico, they also call it *flor de terciopelo* or "the velvet flower"; it is soft to touch and is said to bring comfort after the loss of a loved one. This particular flower can be found in deep shades of carmine red, yellow, pink, purple, and orange (and it is edible).

Flor de nube, or baby's breath, can be used in *angelito* or "little angel" altars to honor young children who have passed. The color white symbolizes the innocence of the children's souls, and when combined with marigold, flor de nube creates a lovely aroma.

The vendors at Mercado de Jamaica were also selling *clemolitos* and *siempre vivas*. Clemolitos (*molitos* for short) is a different type of marigold; it's not as fluffy or as orange, looks dry, and has tints of red. This flower is often used in combination with regular marigolds but is less popular. Siempre vivas are purple flowers whose name translates as "always alive." This flower never wilts and is primarily found during autumn; though it's not as popular as the marigolds and the other traditional flowers, it's an option for Día de Muertos altars.

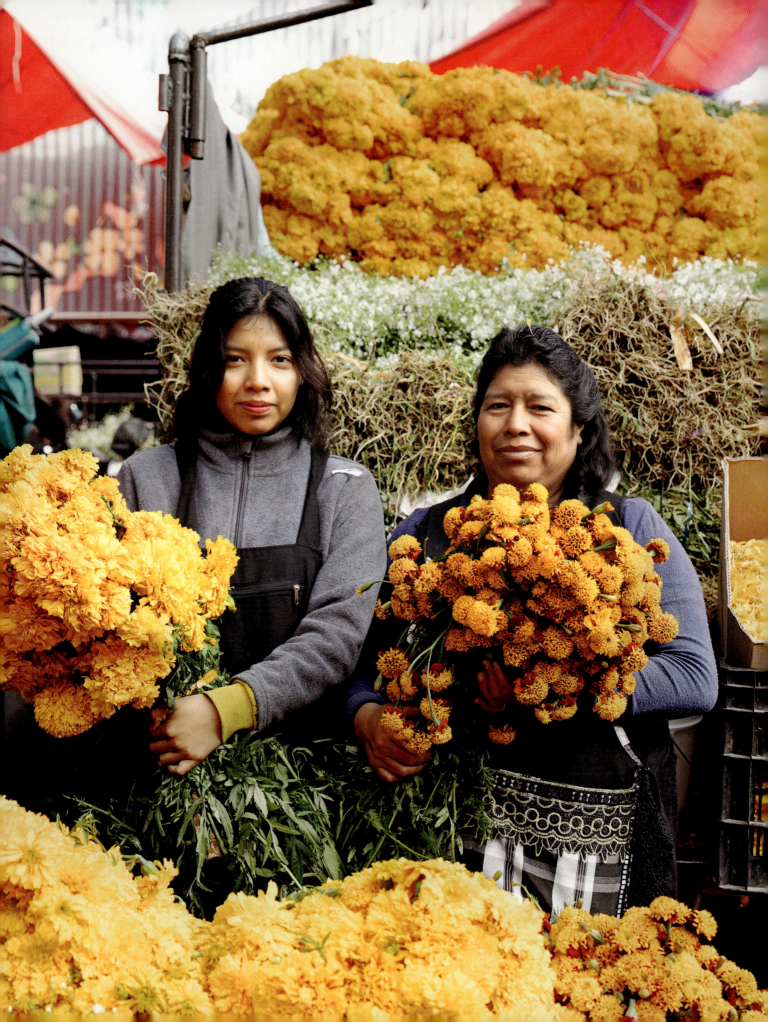

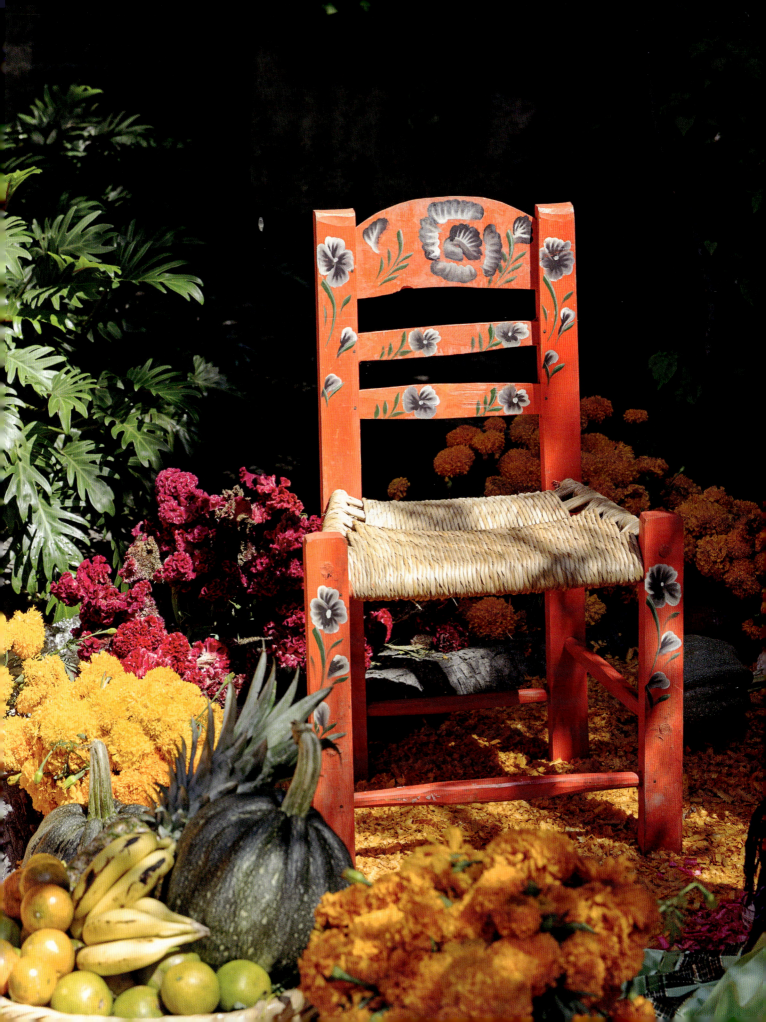

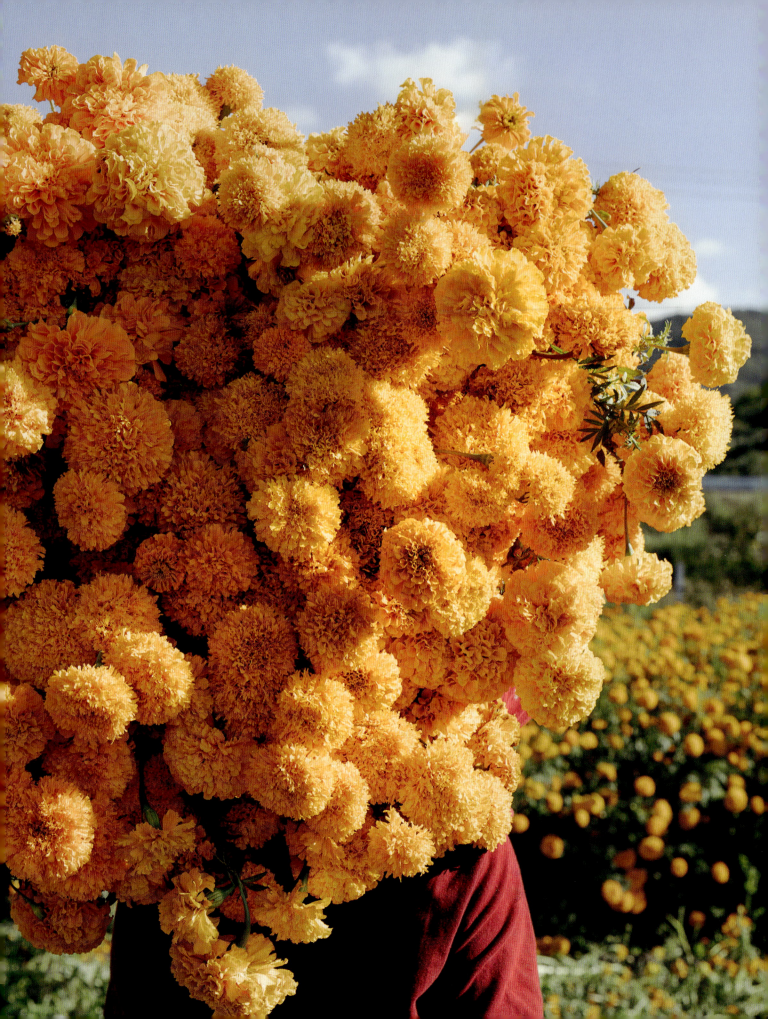

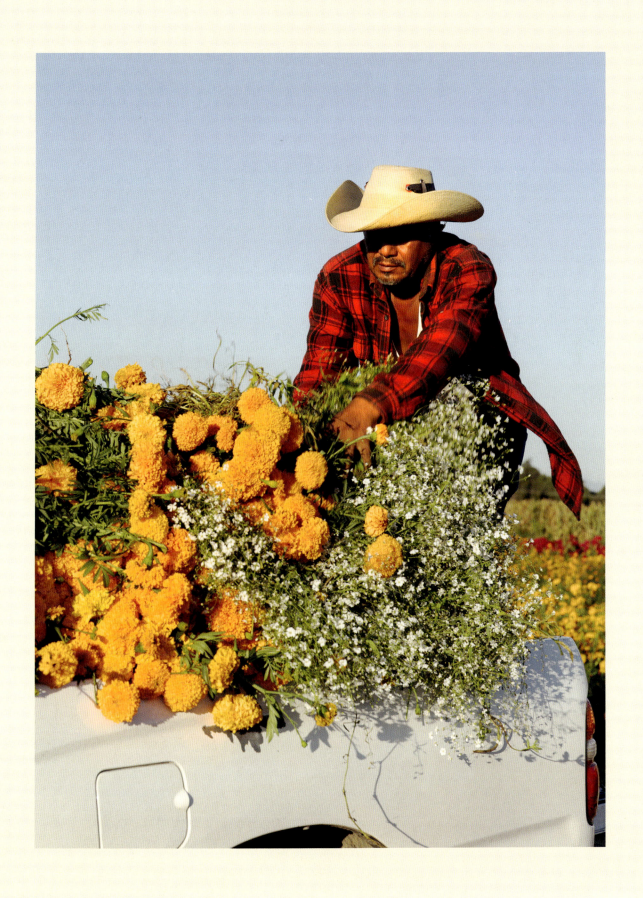

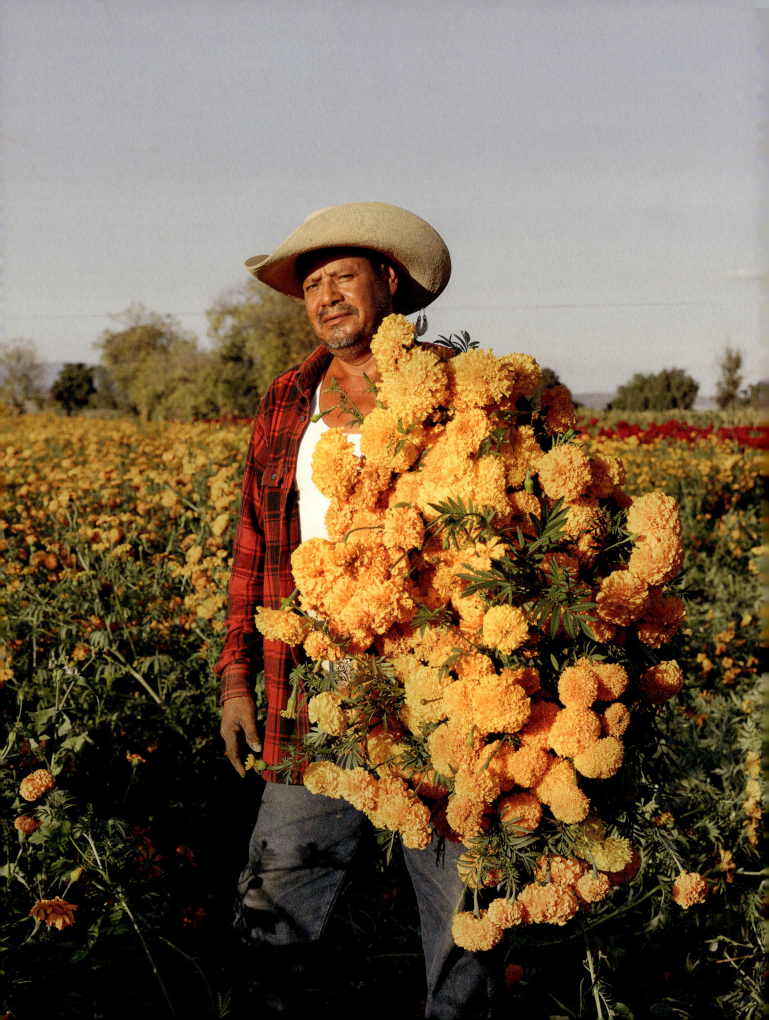

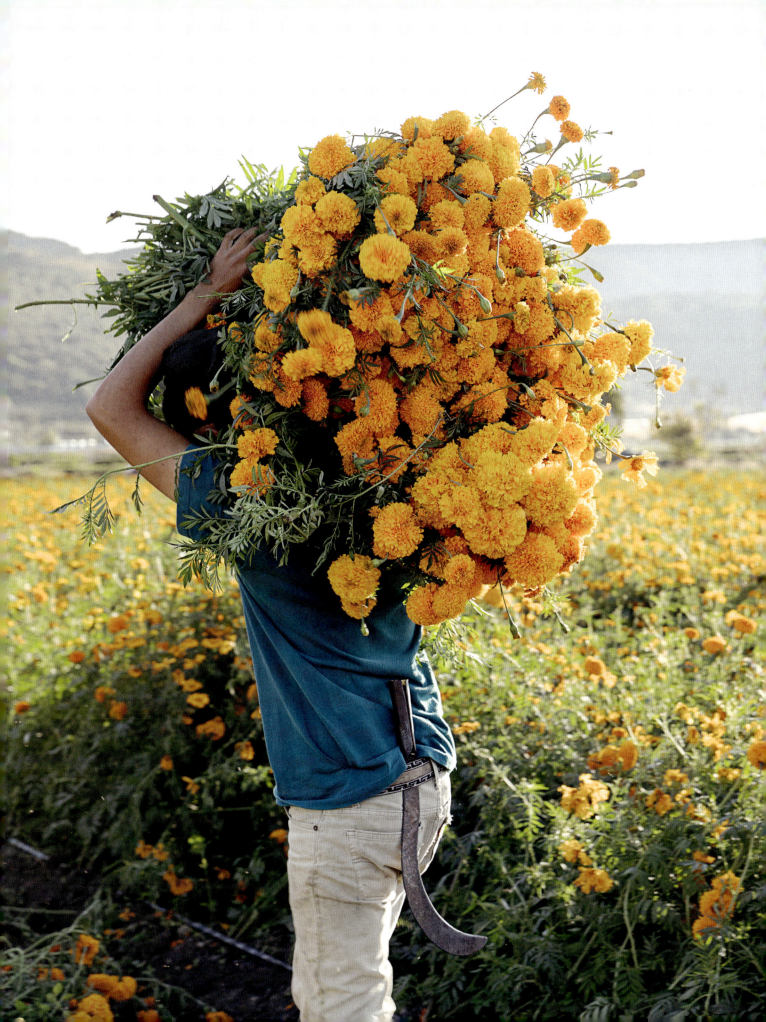

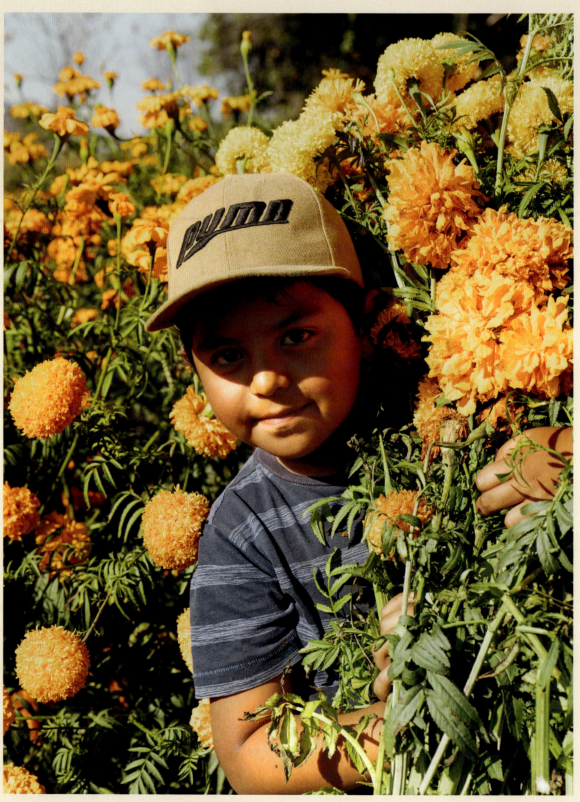

Above: Leo Dante Rodriguez, 7, struggles to lift the bunches of marigolds, but does it with great pride and reassures me that he's got it under control.

Opposite: Rumaldo Acosta, 70, tells me "This tradition will never end. It's a beautiful tradition full of joy where we remember our loved ones who have left us."

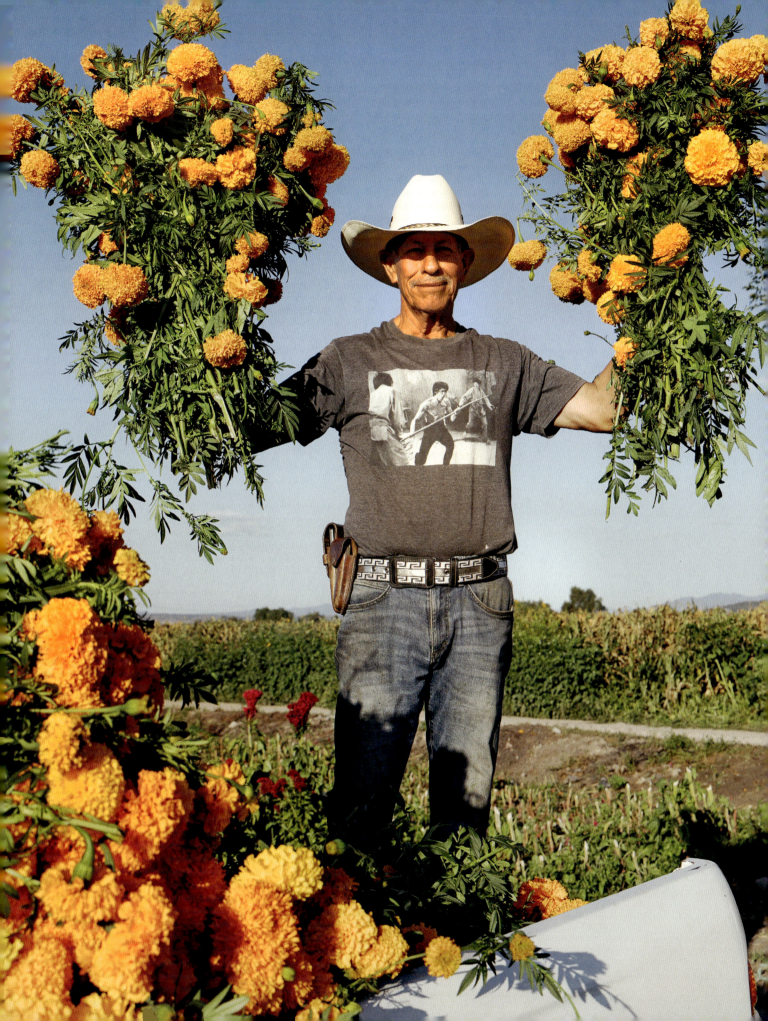

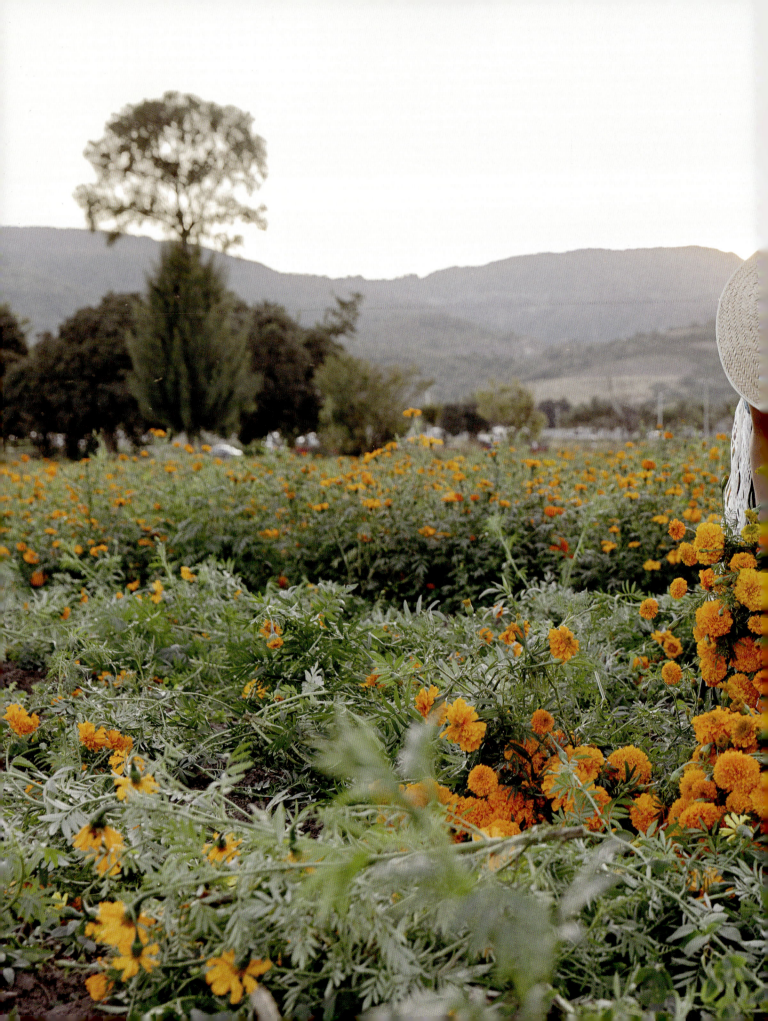

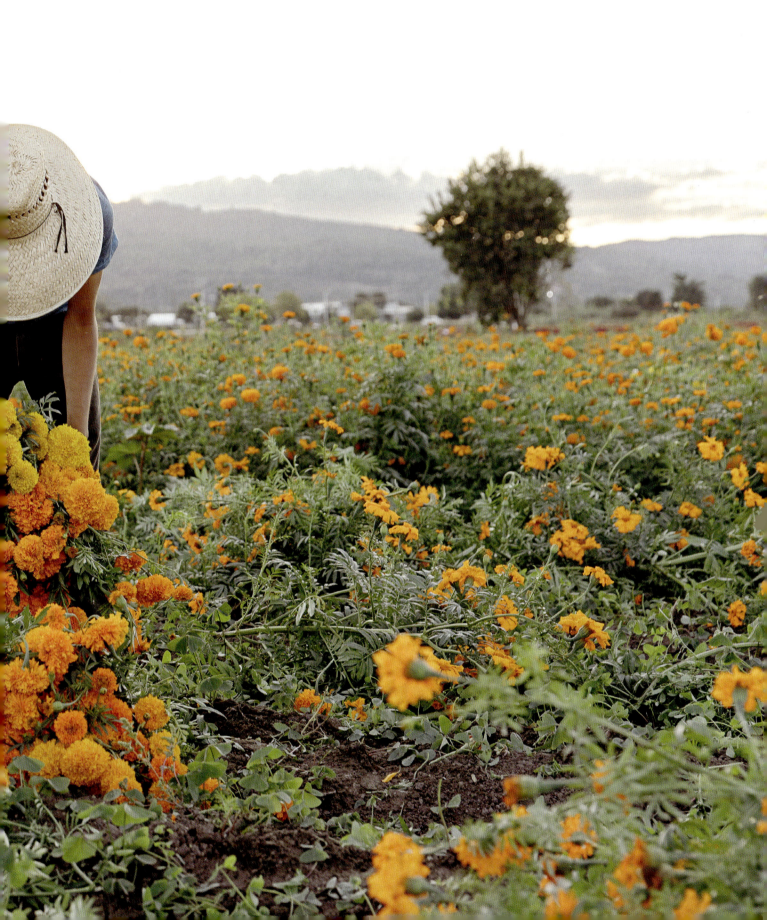

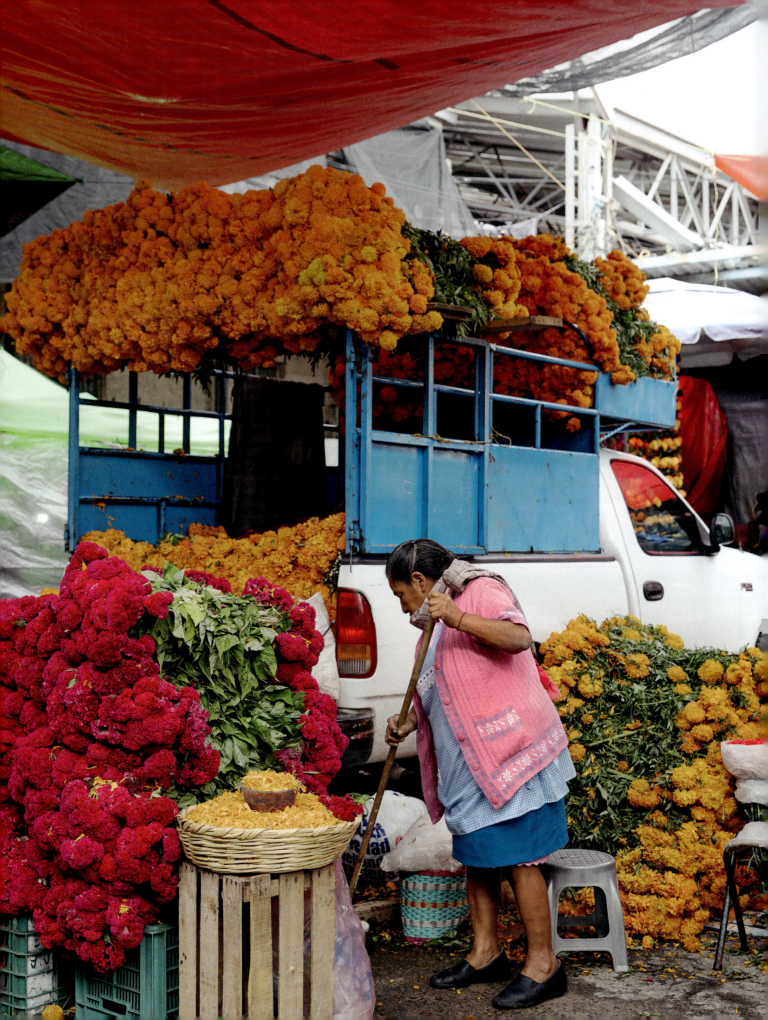

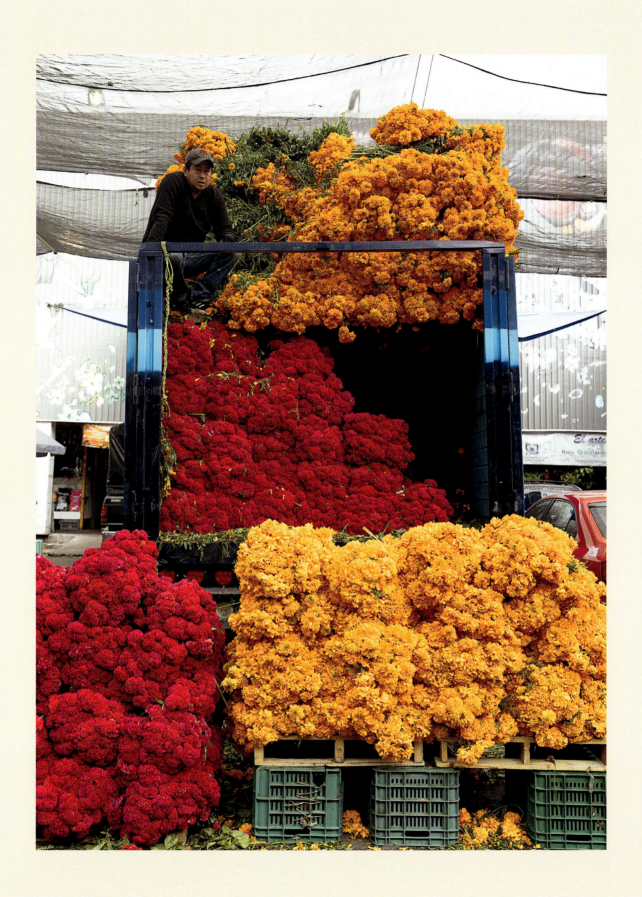

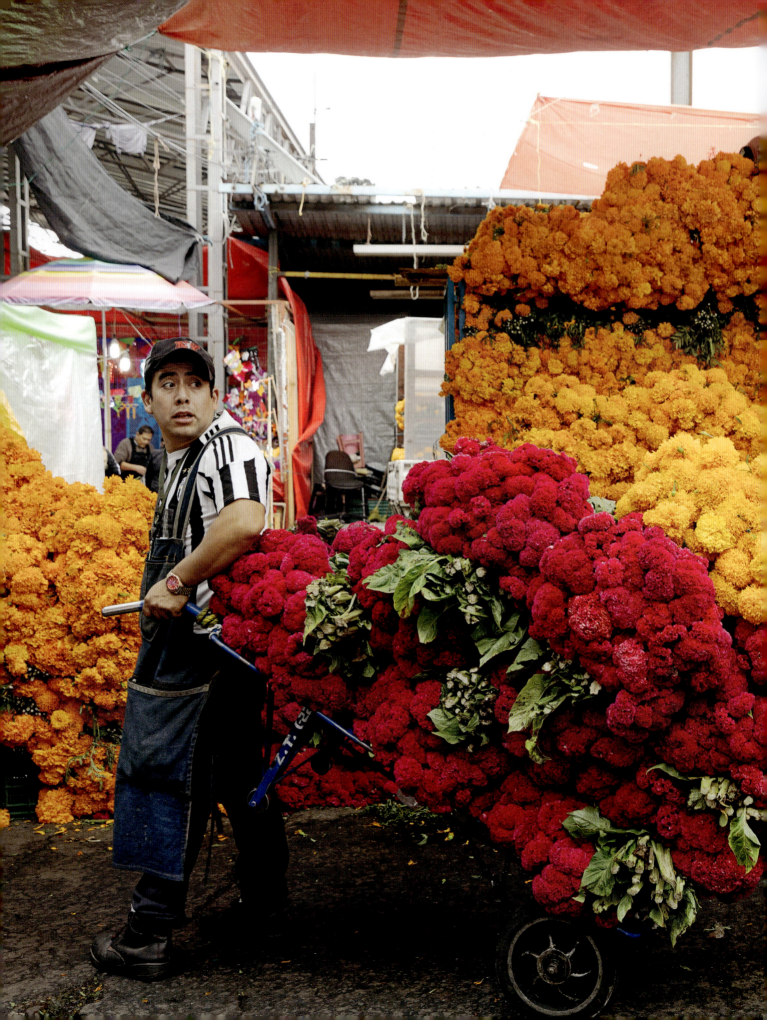

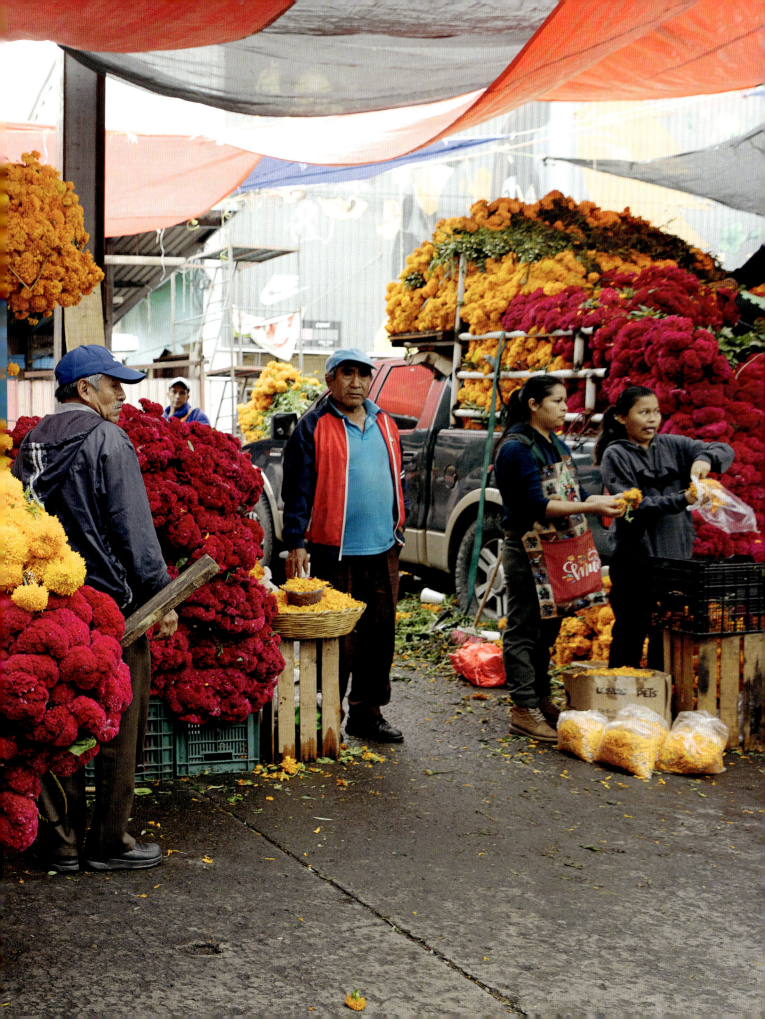

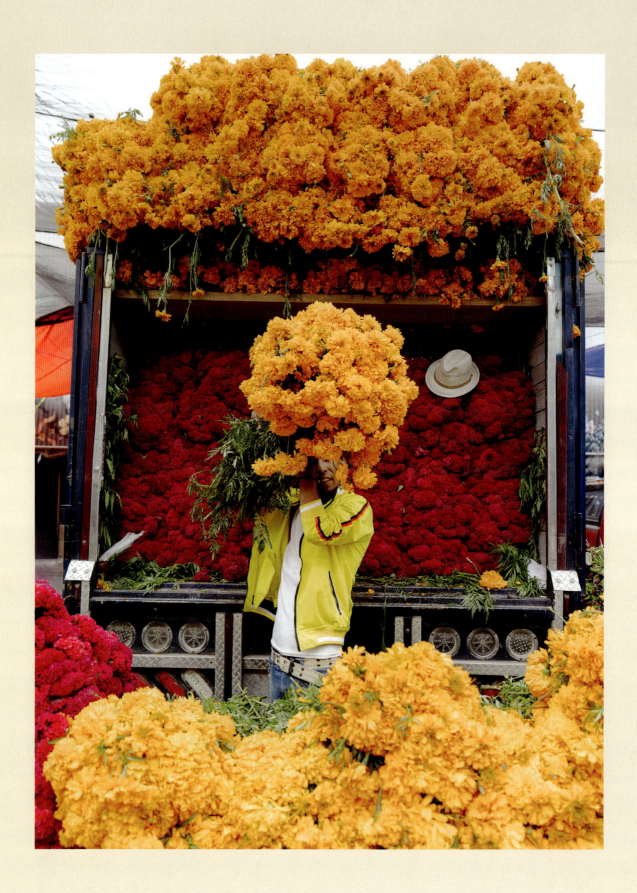

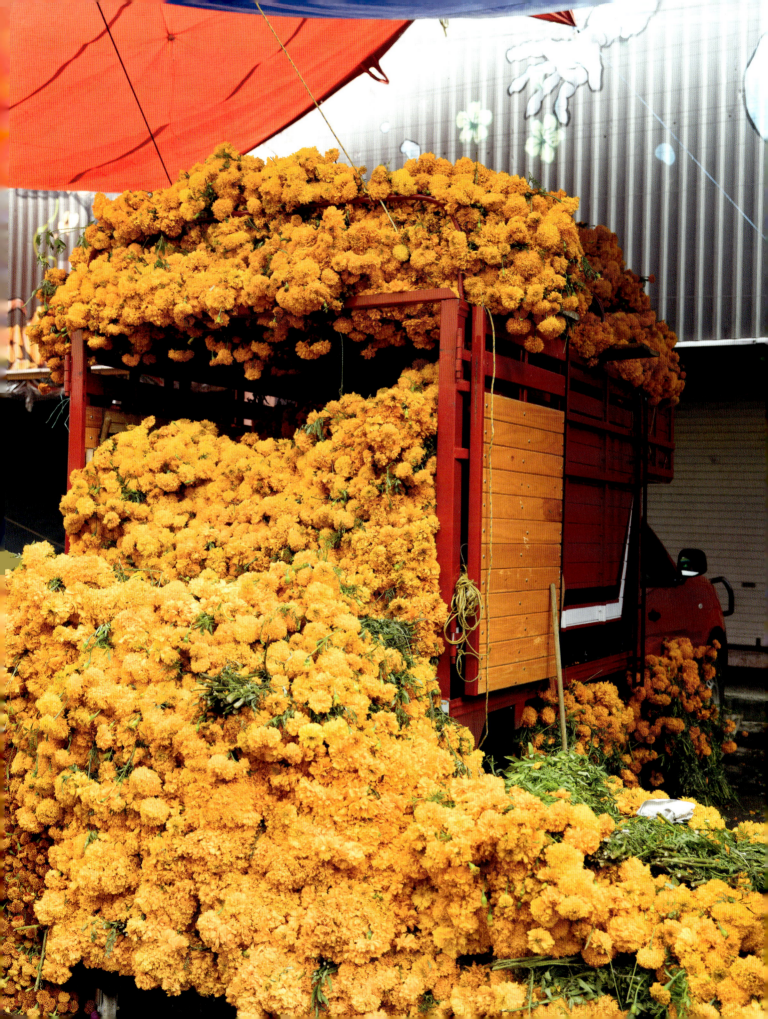

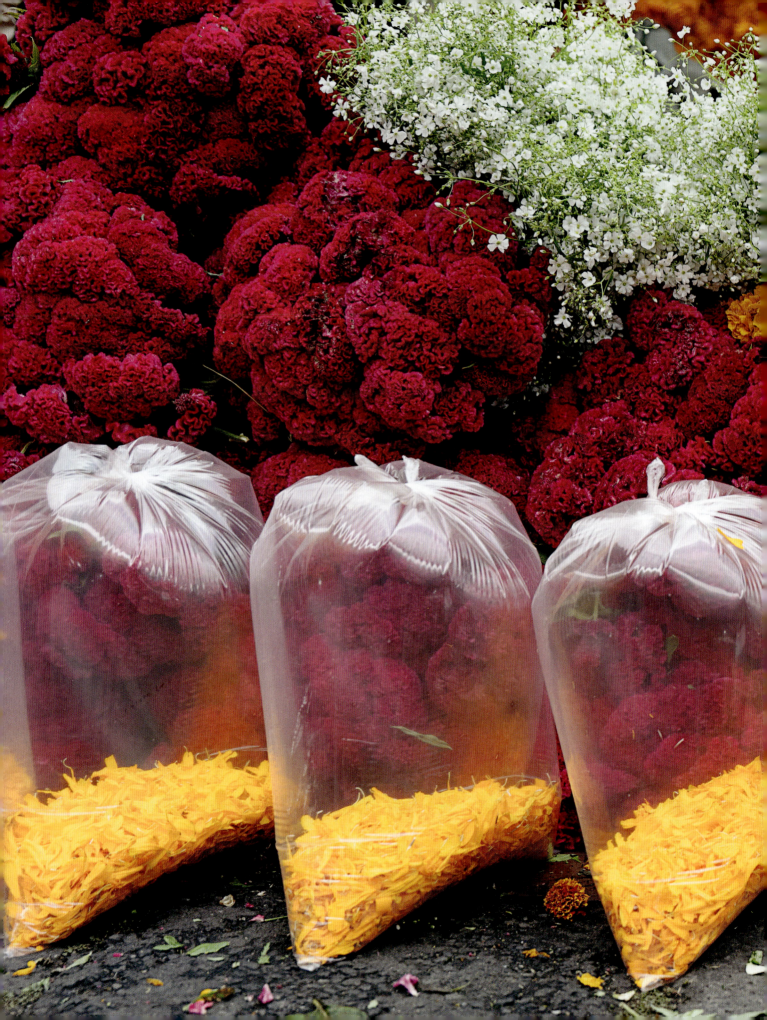

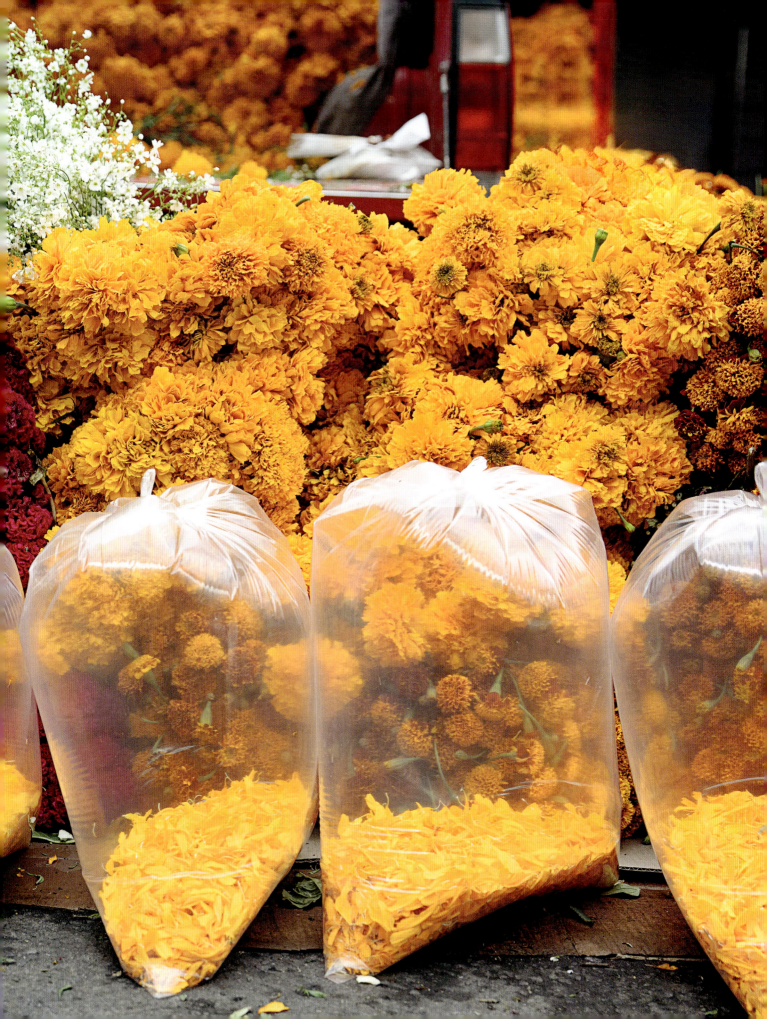

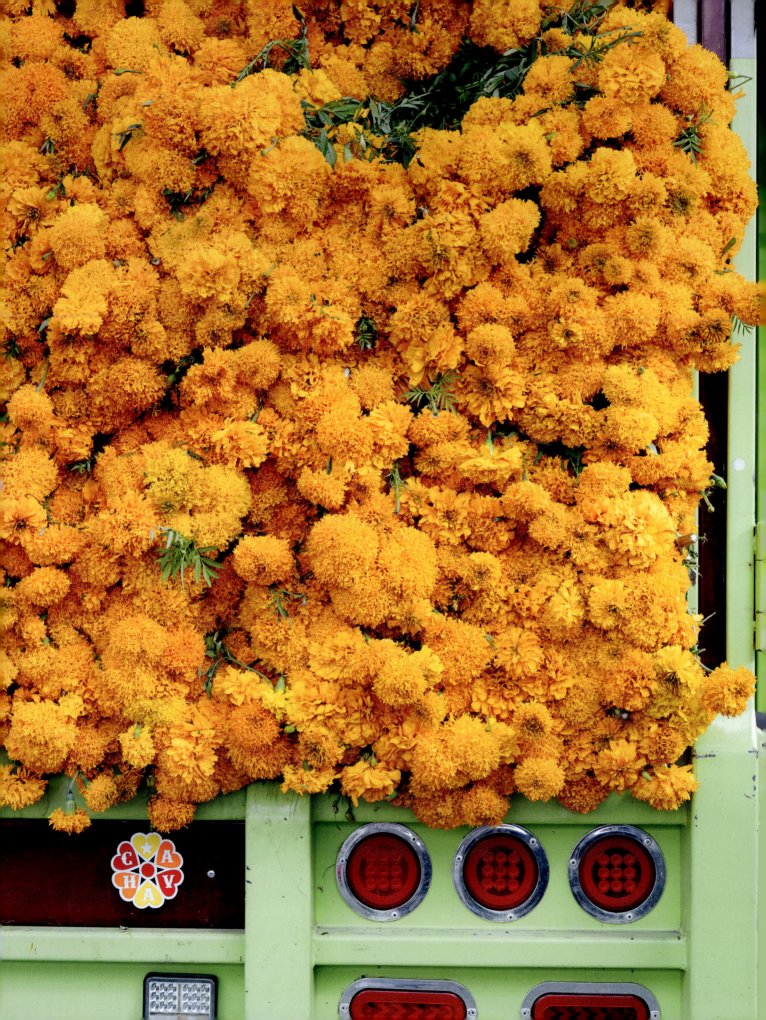

FOOD AND DRINKS

In Mexico, when you receive a guest, you must always offer them something to eat or drink. The same applies for the dead, which is why we place their favorite foods and drinks on the altar.

It is common to see tequila, beer, mezcal, and Coca-Cola on altars in Mexico. And in regions with more intact indigenous communities, like Michoacán, Oaxaca, and Puebla, it's common to see *mole negro* with chicken and sesame seeds, or *tamales de mole*—because these are celebratory dishes that are meant for fiestas.

Fruits like bananas, jicama, plantains, guayaba, and mandarin oranges are also popular. When I was in Cuanajo, Michoacán, I learned that *nísperos*, or loquats (which are native to central-eastern China), are also used for altars.

People often wonder what to do with the food on the altar after Día de Muertos. There isn't a firm rule: some families toss the food while others eat it after the deceased have had a chance to taste the offerings. Those who do eat the food have told me that it loses flavor by the time the living partake because they believe their loved ones have enjoyed the offerings.

HUMMINGBIRDS

Though hummingbirds are not a traditional Day of the Dead element for the altar, they have long held importance in Mesoamerican culture. The Aztecs believed warriors could be reincarnated as hummingbirds, and the Mayans believed they were messengers from the gods. Today, the legend has evolved, and many Mexicans like to say that when a hummingbird visits, a recently deceased relative is sending a message that they are okay. Shortly after my grandmother passed away, my dad saw a hummingbird in the backyard, a rare occurrence. It made him so happy, and it gave us comfort that my grandmother was acknowledging him from the afterlife. If you see a Day of the Dead altar with a picture of a hummingbird, it most likely represents this mythology and the soul of the departed.

MONARCH BUTTERFLIES

In Michoacán, the Purépecha natives believe monarch butterflies are the souls of the dead coming to visit us—similar to hummingbirds. (And, just like the souls of the dead, monarch butterflies love the color of marigolds.) Although monarch butterflies are not a traditional element required on an altar, I always include them in honor of my grandmother, Tita Susana, who was from Michoacán. Whenever I see monarch butterflies, I feel my grandmother's presence and love surrounding me. It really is magical that the monarch butterflies migrate all the way from Canada to my grandmother's home state in central Mexico, arriving just in time for Día de Muertos.

PALO SANTO

A type of incense whose name translates as "sacred wood," palo santo can be found in the Yucatán peninsula of Mexico. It has been used for centuries by indigenous communities in spiritual practices and sacred rituals to heal both physical pain and disease caused by stress. Palo santo is well known for its calming aroma and woody scent. Typically used to attract positive energy to spaces and to provide an overall feeling of relaxation, palo santo can be used during Day of the Dead as a substitute for copal to attract our loved ones.

PAN DE MUERTO

There are certain aromas that conjure the essence of Day of the Dead celebrations. One is the musky smell of marigolds, and another is the hypnotic and woodsy smell of copal. And then there's the scent of spicy-sweet anise and tangy orange peels emanating from *panaderías* making pan de muerto.

Pan de muerto ("bread of the dead") can only be found during Day of the Dead season. It's made with wheat flour, egg, sugar, anise, and orange zest or orange blossom water; the loaves are topped with pieces of dough shaped like crossed bones and covered in sugar. Traditionally, the round shape symbolizes the circle of life and death, the bones represent the spirits of the deceased, the orange blossom aroma guides the spirits, and the sugar embodies the tears shed by the living in memory of the deceased. It really is a tasty treat, and I look forward to it every year!

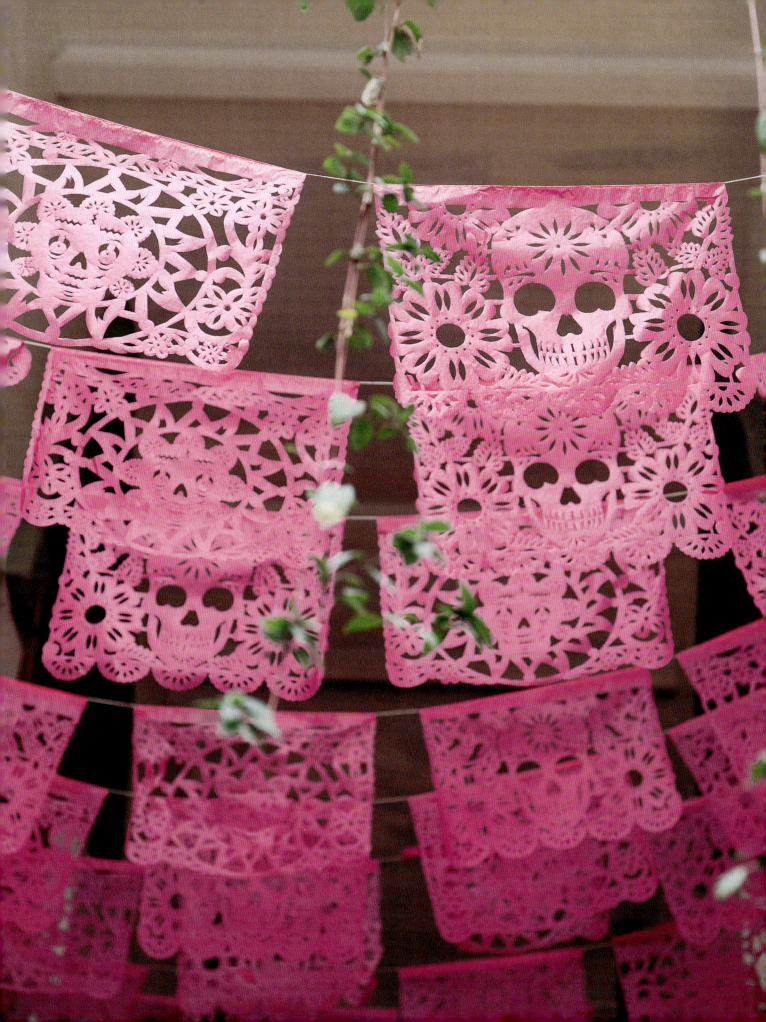

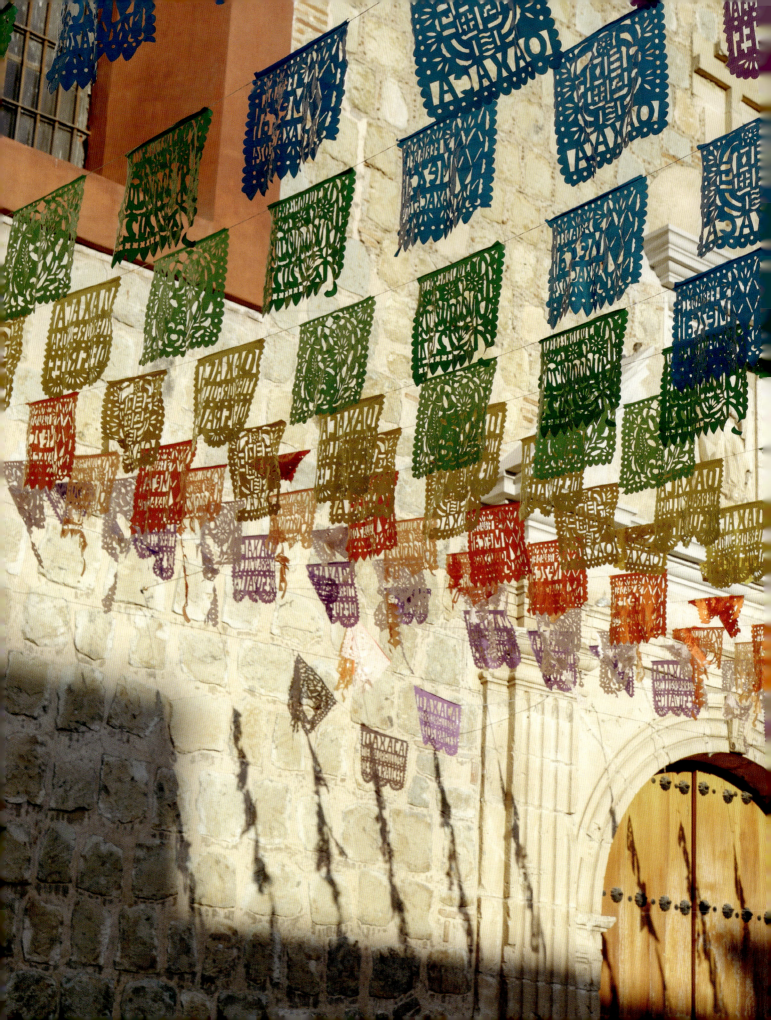

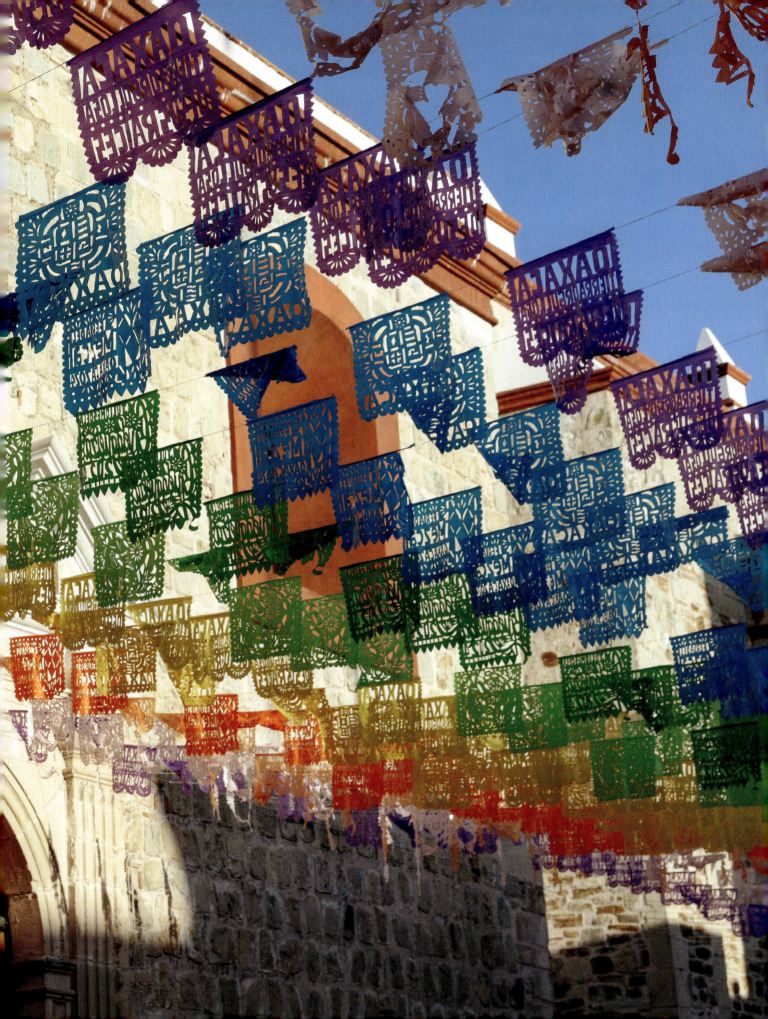

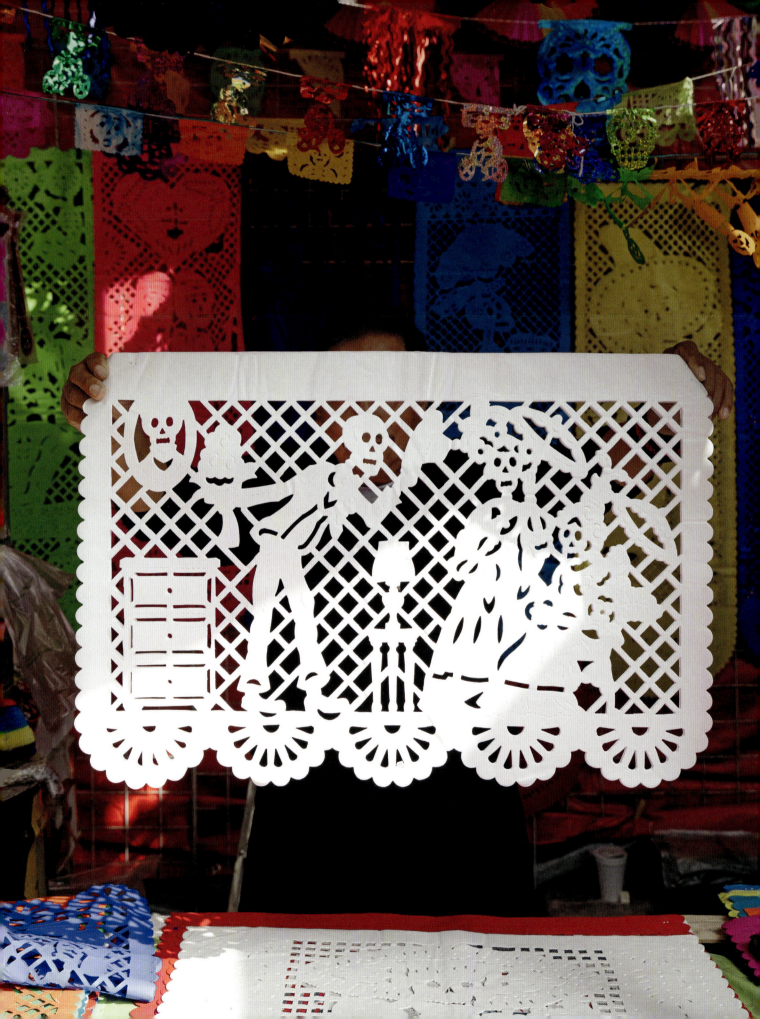

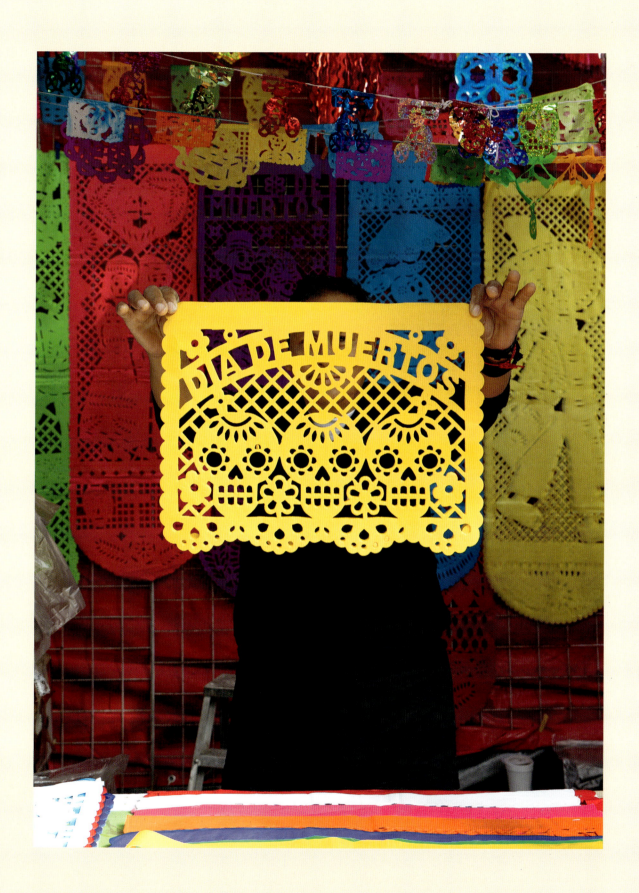

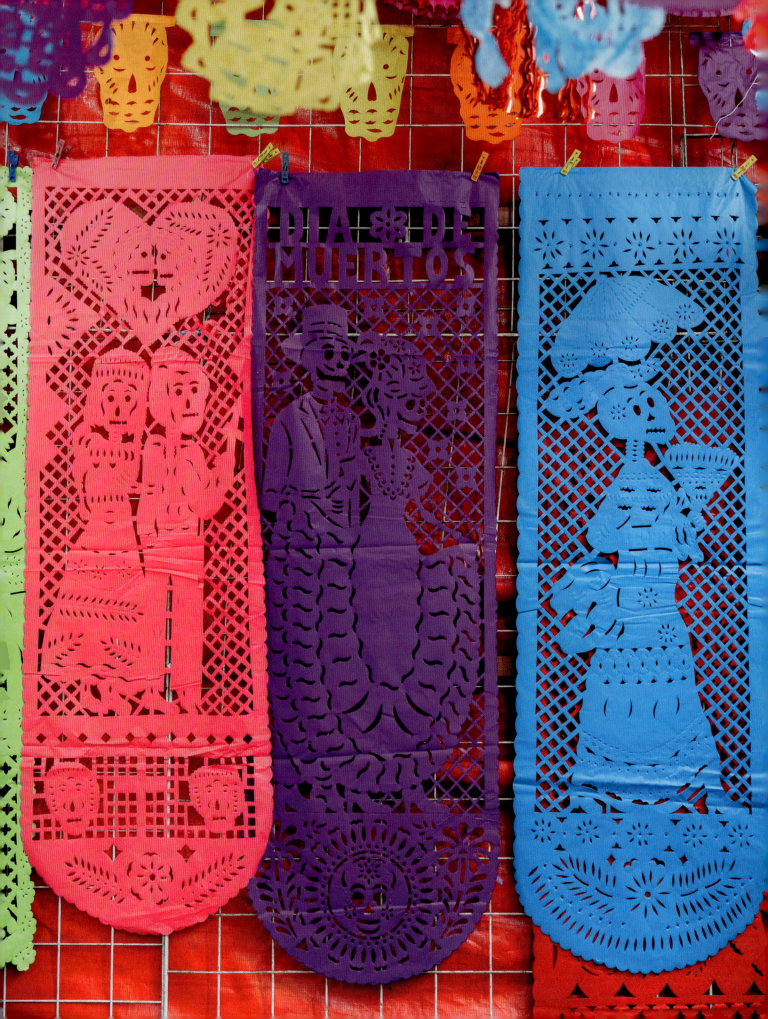

PAPEL PICADO

Papel picado is a must on any Day of the Dead altar. Garlands of colorful tissue paper cut into intricate designs, papel picado can often be spotted on the streets of Mexico. Common illustrations from this traditional Mexican folk art include animals, flowers, and skeletons.

During Day of the Dead, papel picado serves as a symbol of the fragility of life. The yellow and purple colors often used during Día de Muertos symbolize purity and mourning, and it is said that the holes in the tissue paper make it possible for the souls to travel to visit us. When the wind blows, garlands of papel picado create an especially magical and spiritual feeling reminding us that the season has arrived and our ancestors are coming.

PERSONAL ITEMS

Personal items make each altar unique. If the deceased had a favorite necklace, book, or jacket, relatives can add it to the altar for their loved one's enjoyment. For kids, or angelitos, it's common to see their favorite toys or dolls; the children can play with these when they arrive. Any object that reminds you of your loved one or that can help re-create their essence is appropriate to place on the altar ahead of their arrival.

PHOTOGRAPHS

Photos are among the most important elements on the altar. They allow the deceased to recognize their home and to see that their loved ones have reserved a place for them. Photos also keep the departed one's memory alive and allow younger generations to learn more about their ancestors.

RUG

A rug or mat is provided for the souls to rest when they arrive. A *petate* is a traditional rug woven from fibers of palm leaves; it is often used for making beds and tables. In pre-Hispanic times, the deceased were often buried in petates, and during the Mexican Revolution, they were used as a substitute for coffins. They have also been used as a place of rest for those who are near death.

SAINTS AND RELIGIOUS SYMBOLS

Mexico's Catholic heritage is the reason many altars incorporate crosses, saints, and La Virgen de Guadalupe. I always like to include La Virgen de Guadalupe for my grandmother Tita Susana, who was an active member of her church and the Guadalupana Society, a religious association of Mexican women who carry out acts of charity and are devoted to honoring La Virgen de Guadalupe.

SALT

Across many different cultures, salt is used for purification. In Day of the Dead altars, it's symbolically included to prevent the body of the dead from becoming contaminated during their journey to the land of the living, allowing them to return the following year.

SKELETONS

Skeletons remind us that no matter what our life on earth looks like, everyone looks the same underneath it all. In Mexico, you'll find many different papier-mâché skeletons that look lifelike. Some are dressed in costumes to look like Frida Kahlo and Diego Rivera; others may be riding bicycles or playing in a mariachi band. Although these skeletons aren't considered a traditional element of the altar, they can be found all over the country during this time of year. The skeletons remind us to accept the reality of death; by displaying them, we show that we are not afraid of it.

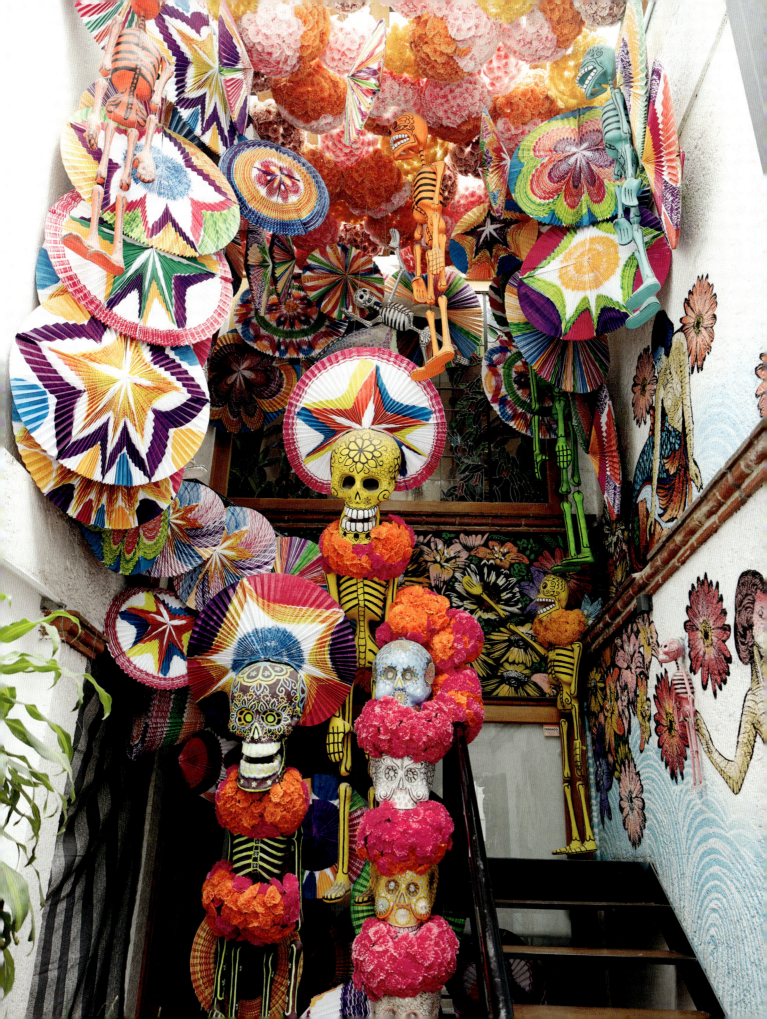

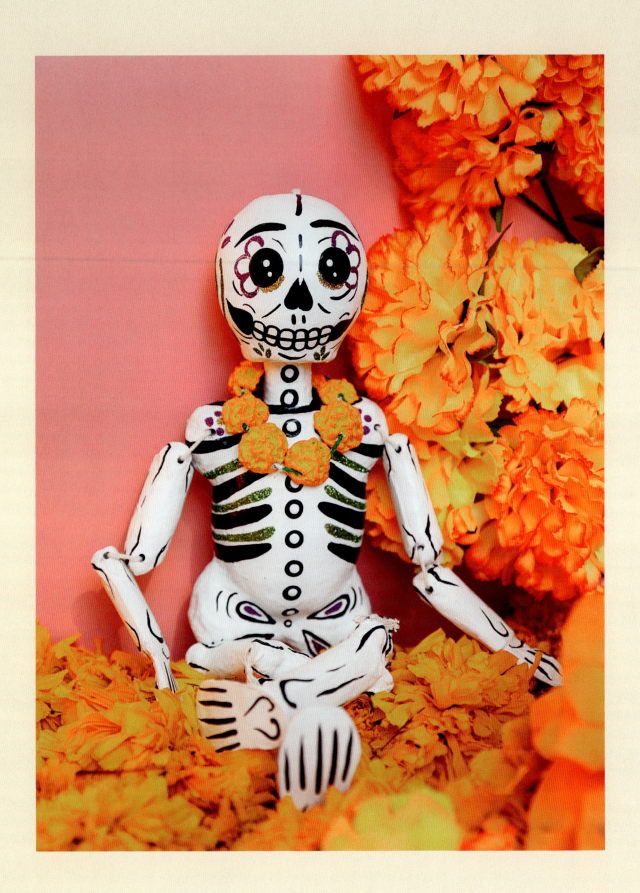

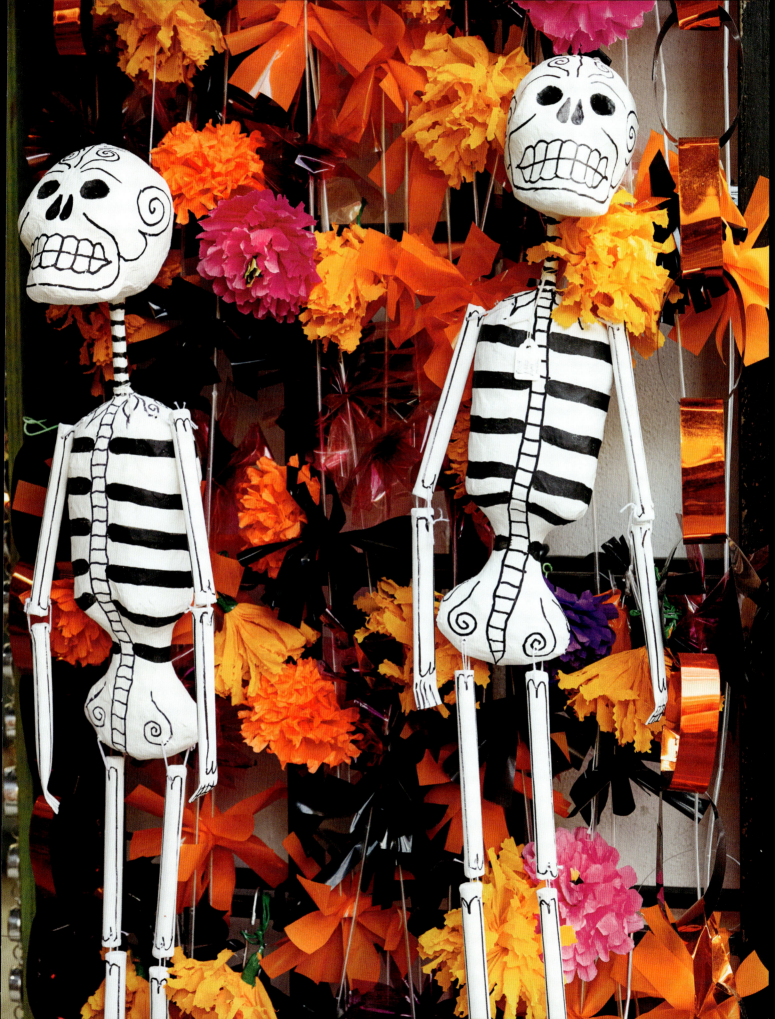

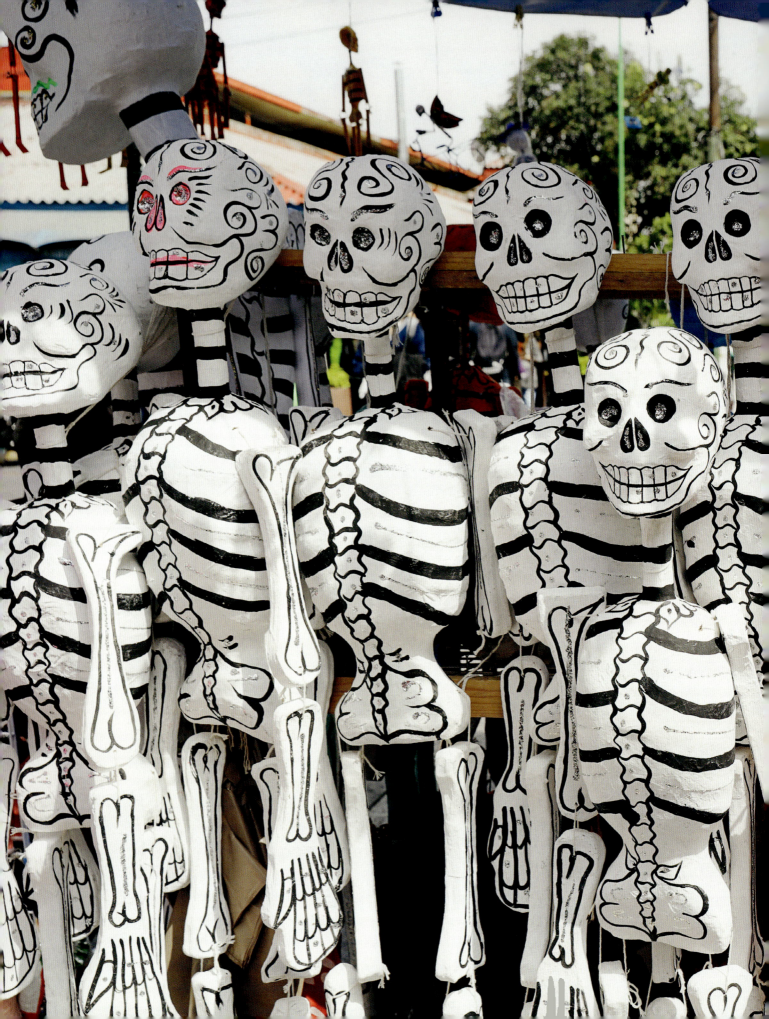

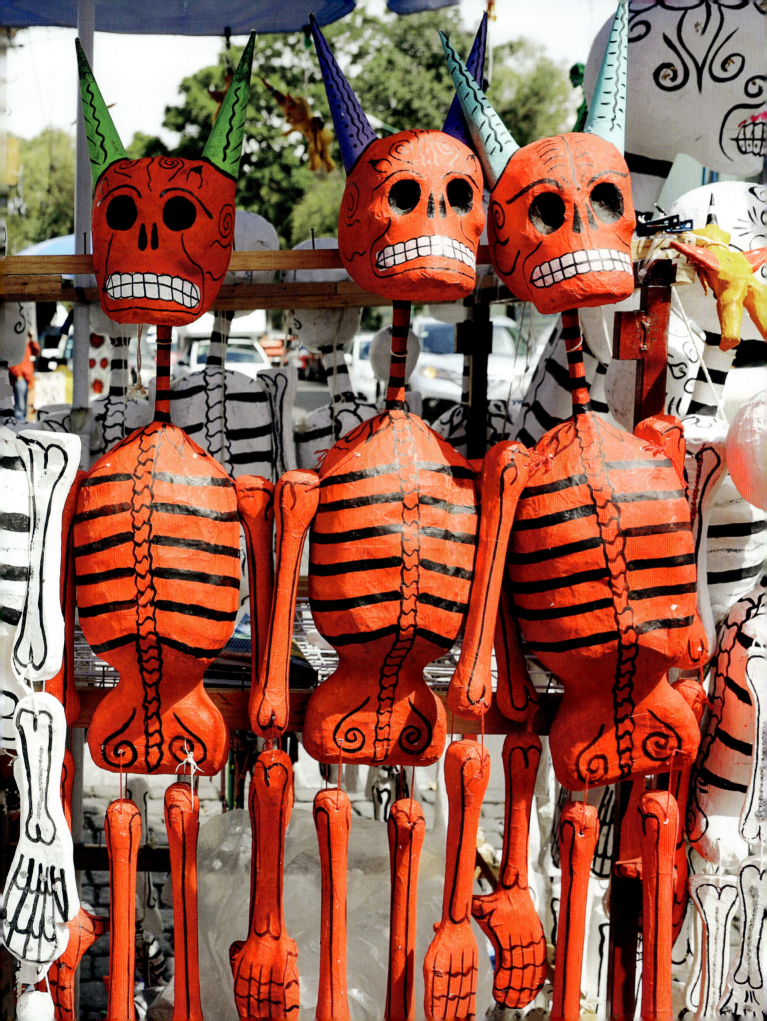

SUGAR SKULLS

This traditional item, dating back to the eighteenth century, has become so popular that large retailers in the United States advertise them as "Halloween decorations." But their actual meaning is significant (and it has nothing to do with Halloween).

During Day of the Dead, we place sugar skulls on our altars with the names of the deceased to honor our loved ones who have passed. Smaller skulls are used to represent children, while larger ones represent adults.

Traditionally, sugar skulls are made from *alfeñique* (a sugar paste that can also include ingredients like egg whites, lime, vanilla, and corn starch) using clay molds, but you can also find them made of chocolate with amaranth. The sugar skull is often personalized with the name of the deceased.

Guadalupana, a family-owned Mexican bakery in Brooklyn, made a custom sugar skull for my Tito Santiago a couple of months after he died. The gesture was so sweet, it brought tears to my eyes. After seeing the other family members displayed on my altar, they offered to make sugar skulls for my Tita Susana, my Tito Carlos, and my cousin Lila. The gift really touched my heart, and it made me so happy to be able to honor my loved ones with a custom sugar skull next to their pictures.

Sugar skulls are not just for the dead, though. They can also be gifted to the living with their name added as a way to save a place for them in Mictlān, the underworld. If someone gives you a sugar skull with your name on it, do not be alarmed! It's just another way to say, "I love you." Sugar skulls can be eaten, but I personally don't recommend it—it's a giant block of sugar that could last many years on your altar as long as you take care of it.

The most beautiful sugar skulls can be found in Mexico City, Puebla, Pátzcuaro, and at the annual alfeñique fair in Toluca. There's a lot of debate surrounding the exact origins of sugar skulls. Some historians believe they were inspired by *tzompantli*—the racks used to display the skulls of war captives and other sacrificial victims in pre-Hispanic Mexico. These skulls were used as trophies or in honor of a god at festivals. Others say that the sugar skull was an invention of the Spanish, who brought sugar and the Arab alfeñique technique to Mexico.

While we don't know for sure where they originated, an 1843 passage written by the American explorer John Lloyd Stephens alludes to a similar concept he encountered in Yucatán: "Along the wall . . . were the bones and skulls of individuals in boxes and baskets, or tied up in clothes, with names written upon them."

Stephens goes on to describe the inscriptions on the skulls, which said things like "Soy Pedro Moreno: un Ave Maria y un Padre nuestro por Dios, hermano" ("I am Peter Moreno: an Ave Maria and an Our Father for God's sake, brother").

In an effort to understand why the skulls were displayed publicly, Stephens asked the priest why they were not permitted to rest in peace. The priest explained that in the grave they are forgotten, but when they are displayed with labels, they remind the living of their former existence.

Regardless of the truth of these stories, one thing remains certain: without the blending of indigenous and Spanish Catholic traditions, the sugar skulls of today would not exist as they are.

TABLECLOTH

Every altar should be layered with a tablecloth, typically white, to symbolize both the purity of the loved one's soul and our joy that they are coming. Modern altars may use different textiles to represent the stories and history of family members. For example, one year I used a dark beige Otomí tablecloth draped with a sarape in honor of my grandfather, who was from Saltillo, Coahuila, where sarape textiles are made.

WATER

Water is an important element that should never be absent from the altar. Intended to quench the thirst of the spirits after their long journey, water is believed to be the first thing the spirits look for. Some claim that after Día de Muertos, water in a glass on the altar gets lower, proving that loved ones have visited.

XOLOITZCUINTLE (MEXICAN SPIRIT DOG)

The Xoloitzcuintle, commonly known as "the Mexican hairless dog," is a breed that's existed for at least 3,000 years. Its name is derived from *Xolotl*, the Aztec god of lightning and fire, and *itzcuintli*, the Nahuatl word for dog. The Aztecs believed these dogs helped souls navigate the challenges leading to the ninth and final level of Mictlān, the underworld. Traditionally, they have the duty of guarding humanity in life and guiding them in the afterlife. Today, Mexicans refer to them as "Xolos" for short (pronounced *sholos*).

Many consider the Xolo to be a strange and ugly dog. But in Mexico, the dog is regarded as an emblem of pre-Hispanic culture that must be honored. Frida Kahlo loved these ancient Aztec dogs; she often painted them and had them as pets. They were also favored and loved by other famous Mexican artists, including Francisco Toledo, Juan Alcázar, and Diego Rivera.

Traditionally, a Xoloitzcuintle figurine is placed on the altar to guide the souls back to us across the river from the land of the dead.

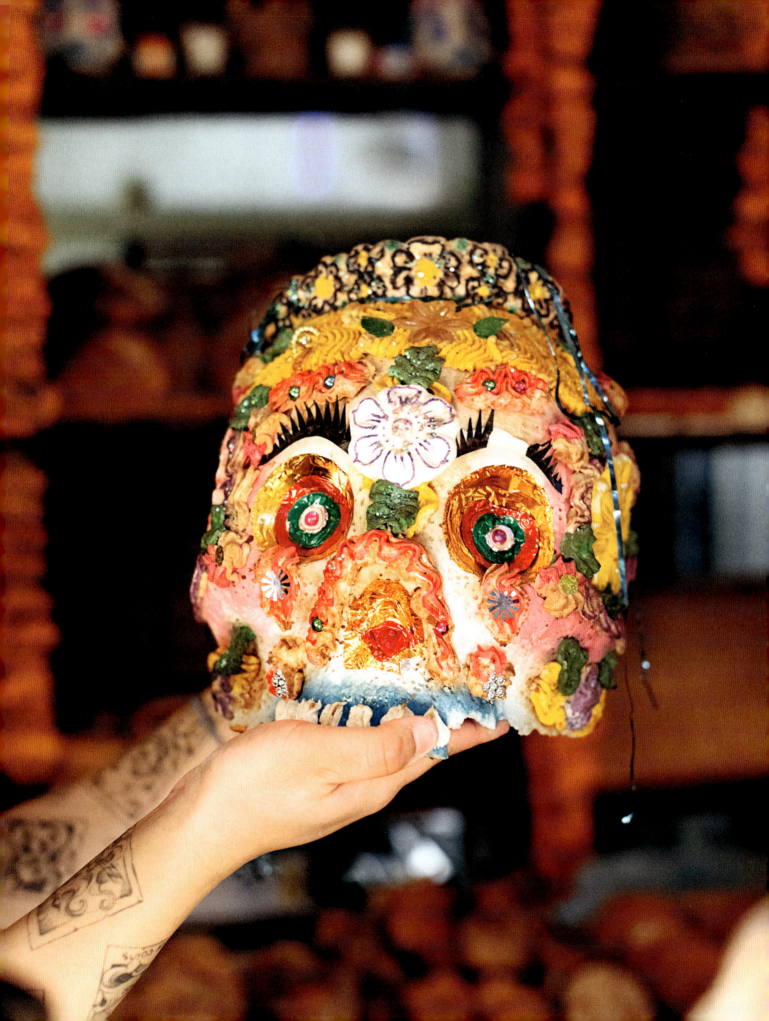

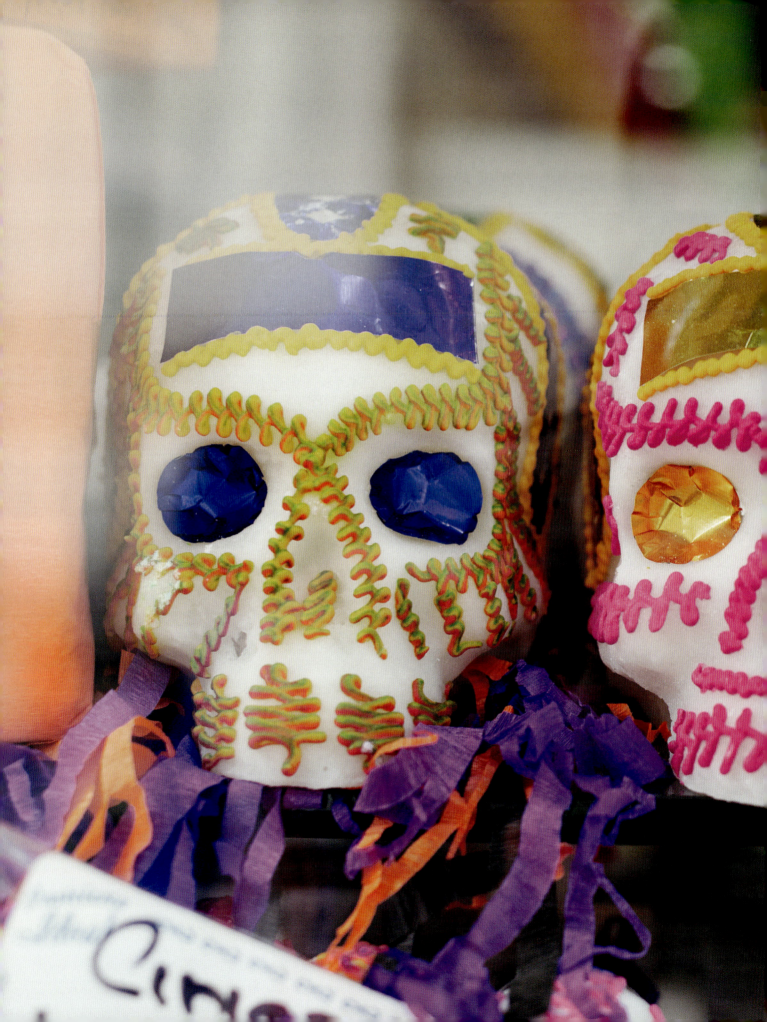

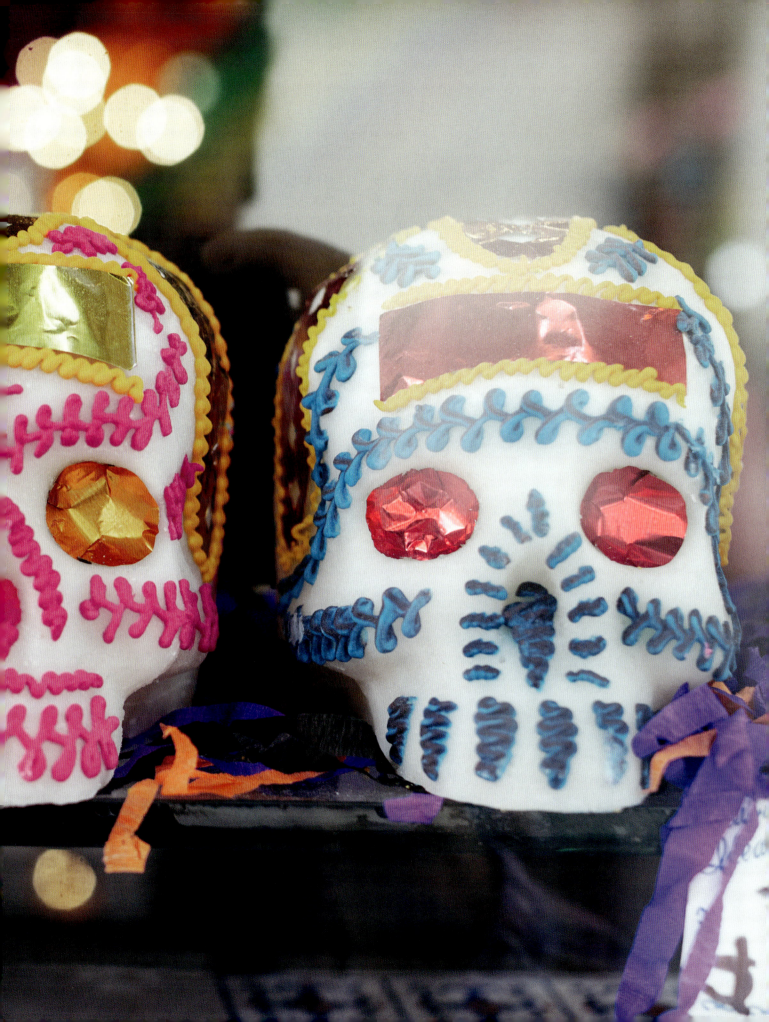

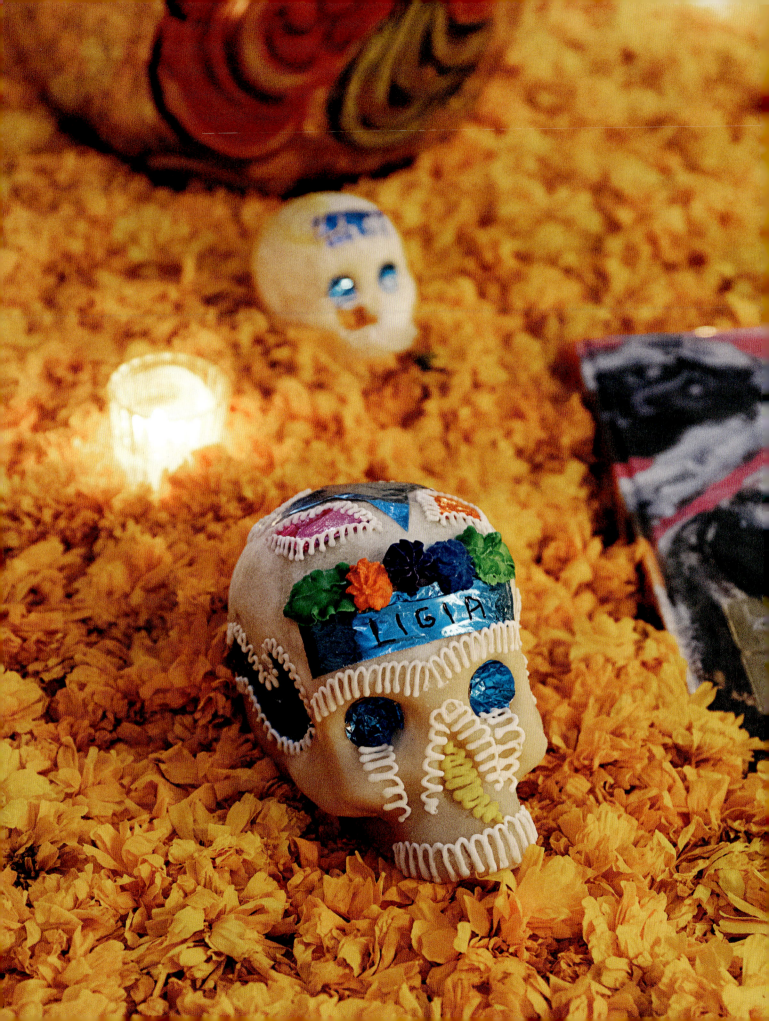

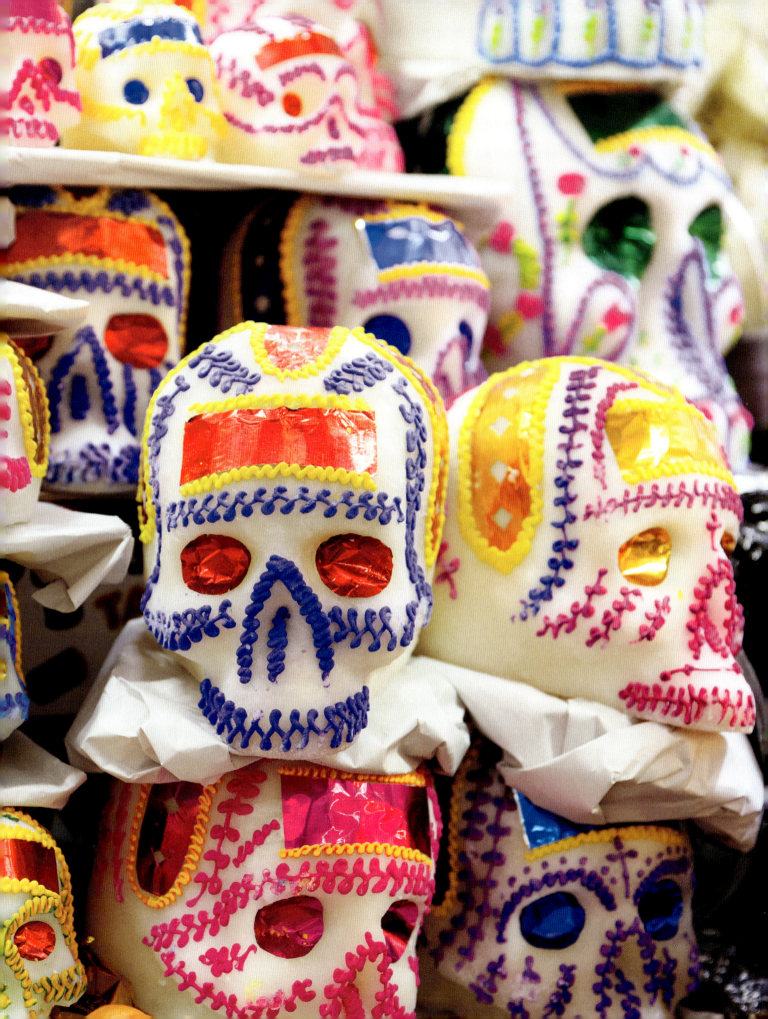

PAN DE MUERTO

During my travels, I learned that there are many variations of this traditional bread. In Mexico City, some bakeries sell a version called *pan de totomoxtle* (pictured on page 132), which is made with corn husks burned into black ash. Some say the bread's dark, smoky color resembles the ashes of the dead. Though I like the creative interpretation, I've found it doesn't taste any different than the more traditional sugar bread.

In Oaxaca, I came across three other styles of pan de muerto. One is called *pan de Mitla* (pictured on page 133) and can only be found in the town of Mitla; it's traditionally very large and intricately decorated. The artisans use royal icing to adorn the bread with hieroglyphs from the ruins of Mitla, which is believed to have been a sacred burial site for the Zapotec people. The word *mitla* also derives from the Nahuatl word Mictlān, which means "place of the dead." This style of bread can also be decorated with flowers, skeletons, and other Day of the Dead symbols. Each bread includes a *carita*, or little face, molded with dough and hand-painted using natural vegetable-based ingredients.

Pan de Zaachila (pictured on page 134) is one of the most beautiful versions of pan de muerto I've ever seen. This style is very colorful, with intricate flowers made from dough that resemble embroidery. The bread is traditionally large and also includes a carita. This bread can be personalized by request with other images, like a loved ones' favorite animals, activities, or names.

Pan de yema (pictured on page 136) is a traditional style of egg bread that can be found at certain markets in Oaxaca. Although this bread is the least intricate pan de muerto, it is perfect for dunking in a *chocolatito* (a Oaxacan hot chocolate). And while it can be found year-round, during Día de Muertos, pan de yema is made special by being decorated with a carita. As you may have gathered by now, caritas are very typical and traditional in Oaxaca, where they are used specifically for pan de muerto. The little painted dough faces represent the souls of the departed; they vary in style. Some caritas are skulls while others look like living faces; they are always colorful and hand-painted, so each is one of a kind.

In Pátzcuaro and neighboring communities in Michoacán, the bread takes on an anthropomorphic shape, resembling a mummy inside of a coffin. In this part of Mexico, it isn't called pan de muerto but *pan de animas*, or "bread of souls," (pictured on page 140)

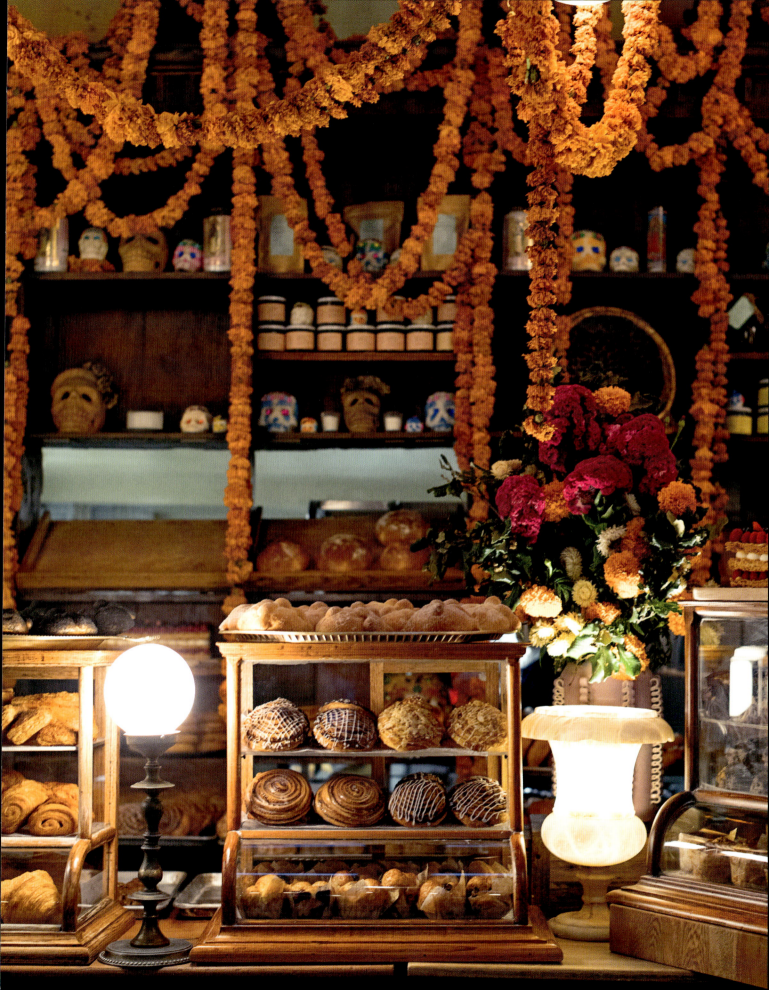

and the panaderías that make the bread are usually family owned and have been in operation for multiple generations.

While searching for bakeries in Michoacán, I stumbled upon a no-name bakery on Paseo Street in Pátzcuaro. It was actually located inside the home of the Garcia family. We walked to the back, where the smell of bread emanated from a dark room. Inside the room, four family members, including ninety-three-year-old Ramón Garcia Calle (pictured on page 139), were baking fresh *conchas* and pan de animas. At first glance, I had no idea Ramón was ninety-three years old—he handled his paddle with the strength of a middle-aged man, wasn't remotely bothered by the heat of the wood-fire oven, and worked with the same endurance as family members half his age. With a smile on his face, he told me, "The years do not pass by in vain."

I loved his spirit, and asked him if he thought he would make it to one hundred years. His answer was reassuring: "Of course, it's only seven more years."

I thought about how age sometimes really is just a number. Ramón had a sparkle in his eye and a fervor for life that reminded me of a twenty-something. That must have been why the bread tasted so good—as they say in Mexico, the secret ingredient is to make the food *con mucho amor*!

But it wasn't just Ramón. Everyone I talked to in Michoacán seemed excited to prepare la bienvenida for the deceased. Later the same day, I would run into a youthful seventy-year-old named Arturo Ceja Melgarejo, who was selling pan de muerto on Alcantarilla Street. You would think it was his first day on the job because he did it with so much enthusiasm. In fact, he had been selling bread on the same street for forty-five years. He told me with pride, "I was also born on this street—Alcantarilla!"

Just a thirty-minute drive outside of Pátzcuaro, in Cuanajo, a young family was preparing pan de animas with devotion and joy. "We help each other as a family, and it's a privilege because people trust us to make large bread to adorn their altars," thirty-year-old baker Hugo Cesar Juarez Tellez told me.

Tellez, who has been selling pan de muerto out of the same home for the last ten years, charges 40 pesos (roughly $2) for one loaf, which is then resold for about 120 pesos ($7) in the city. The family makes around one hundred loaves a day from October 31 and November 2. I was impressed to learn that Tellez built his oven with his father.

I asked if he and his wife could make a pan de muerto for my late grandmother Tita Susana, who was from Pátzcuaro. They gladly accepted.

While they worked on my grandmother's custom pan de animas, I asked their five-year-old daughter, Mayte, to show me her family altar. She ran to the altar, excited, and told me that they were waiting for their loved ones to arrive that evening.

I smiled and thought about how lucky I am to be a part of a culture that honors traditions that someone as young as five and as old as ninety-three are proud to be part of.

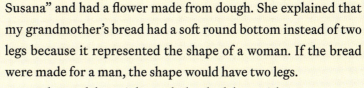

Sandra, Mayte's mom, presented me with the pan de animas, which said "Tita Susana" and had a flower made from dough. She explained that my grandmother's bread had a soft round bottom instead of two legs because it represented the shape of a woman. If the bread were made for a man, the shape would have two legs.

I hugged her tight and thanked her with watery eyes. Spending time with her family and laughing with Mayte is a memory I'll treasure forever.

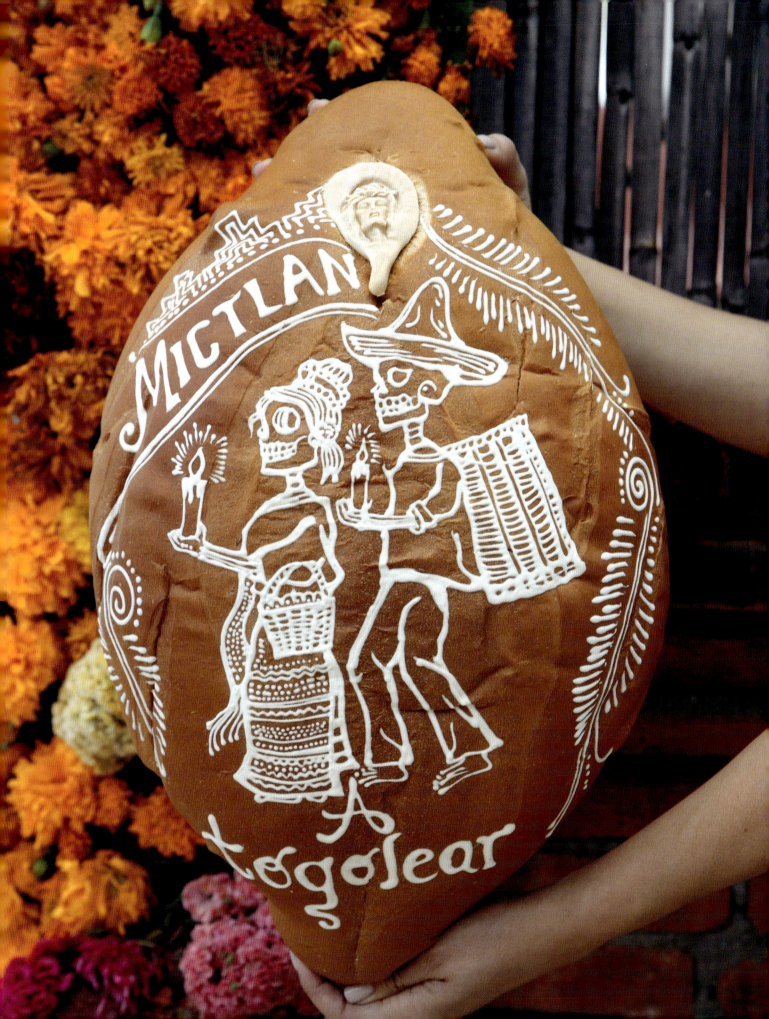

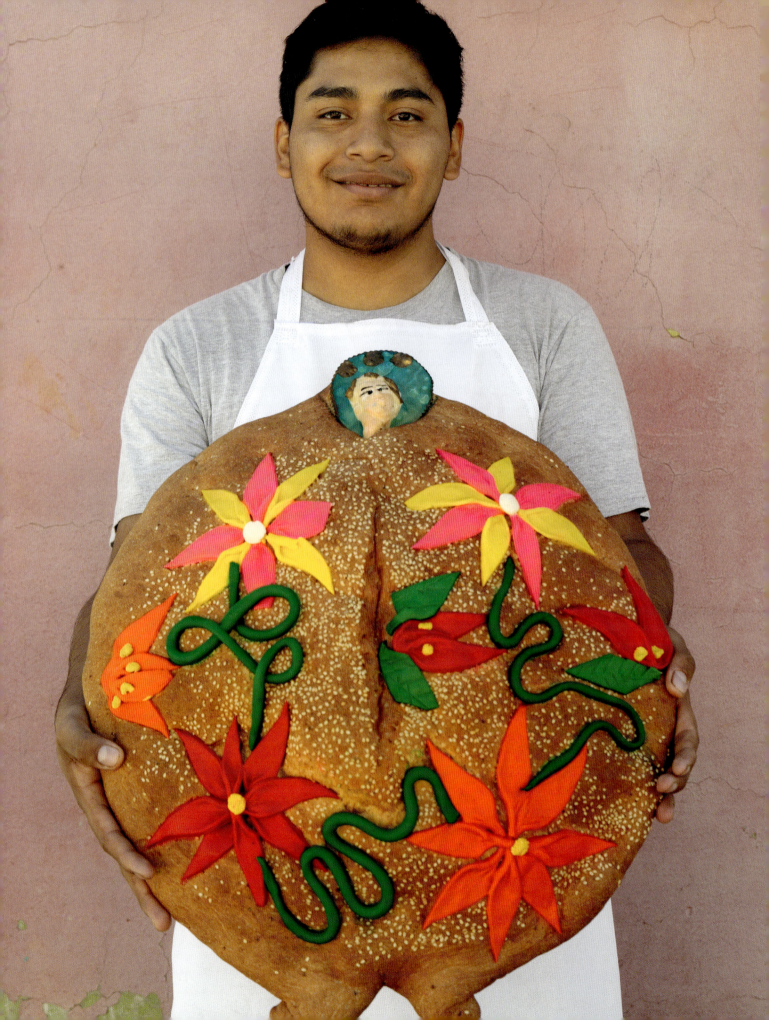

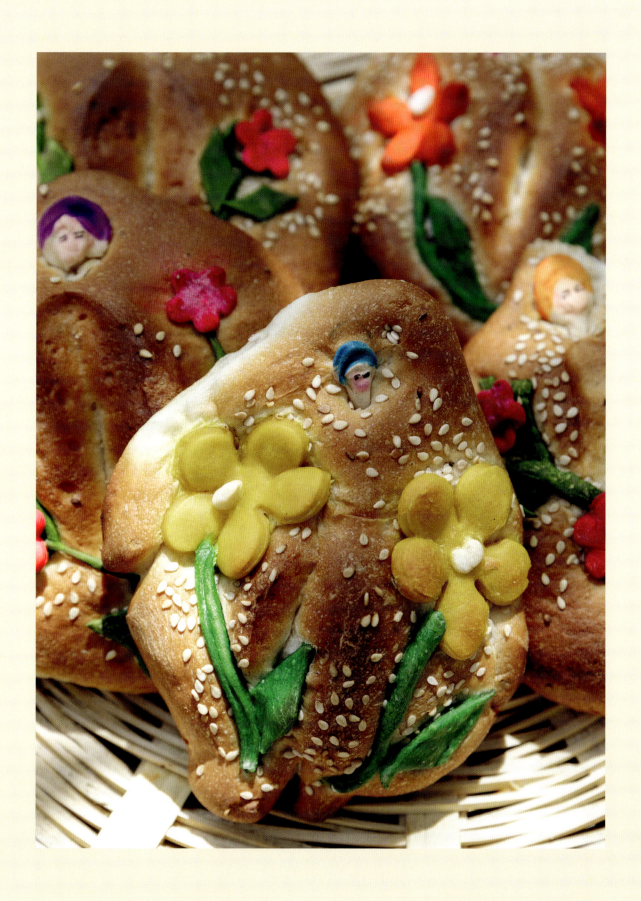

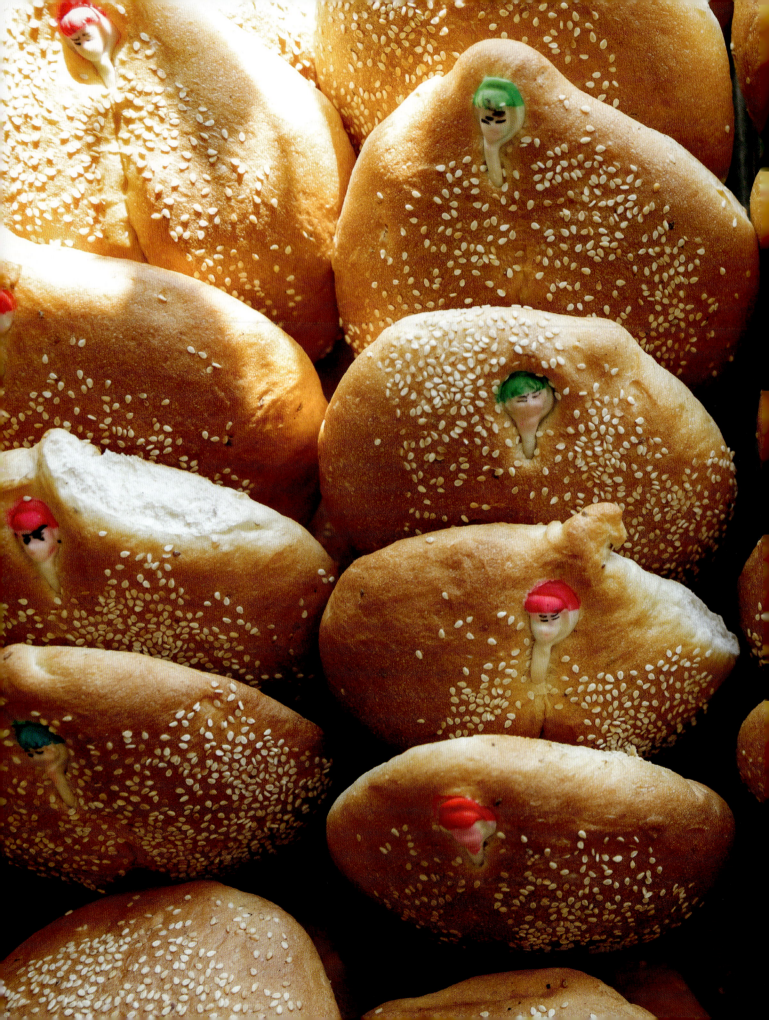

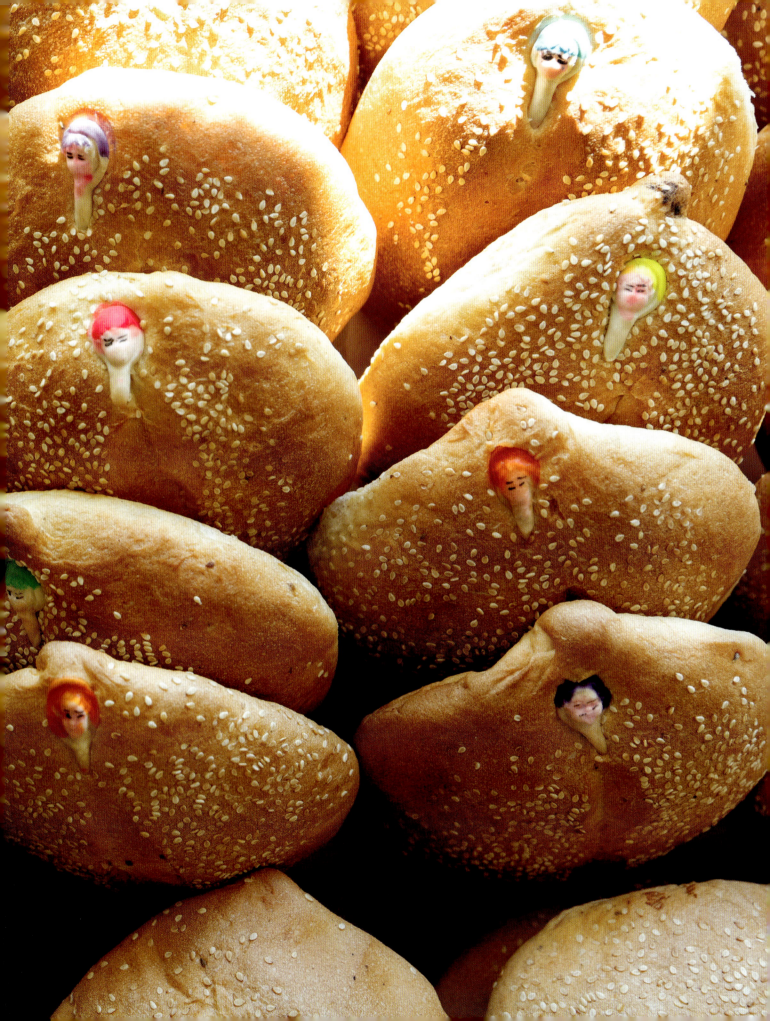

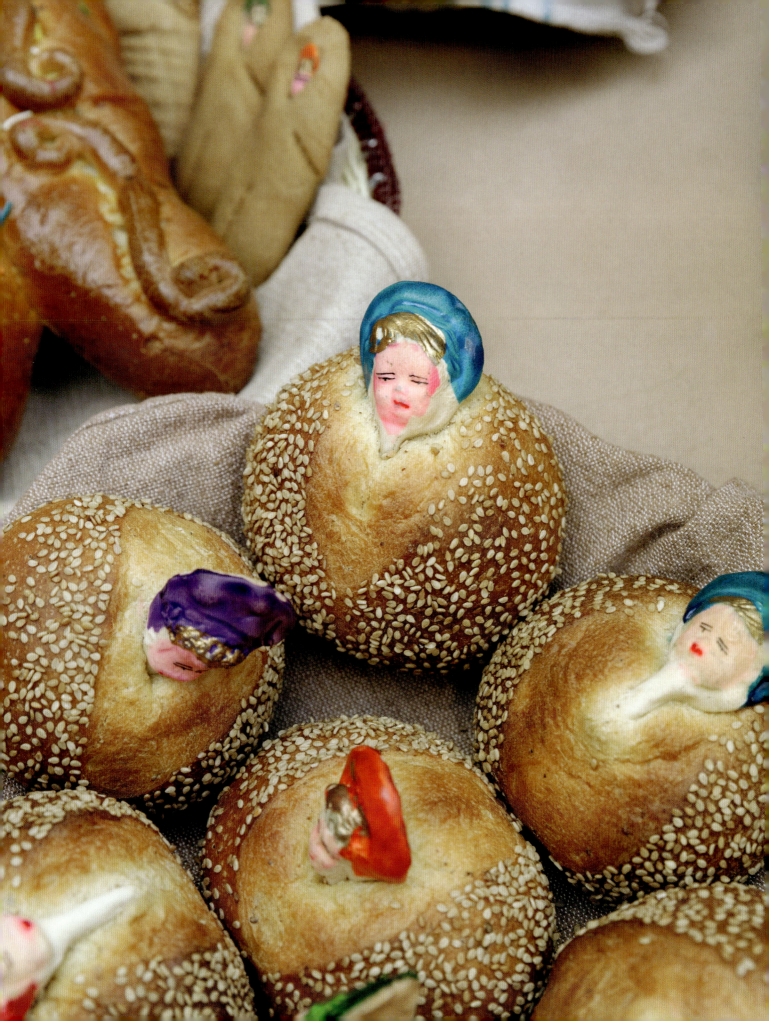

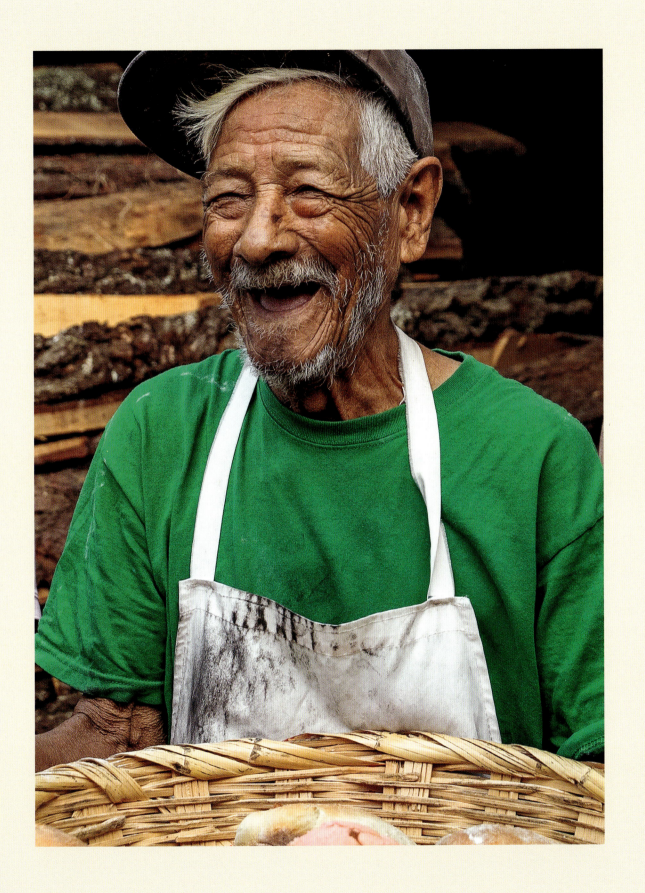

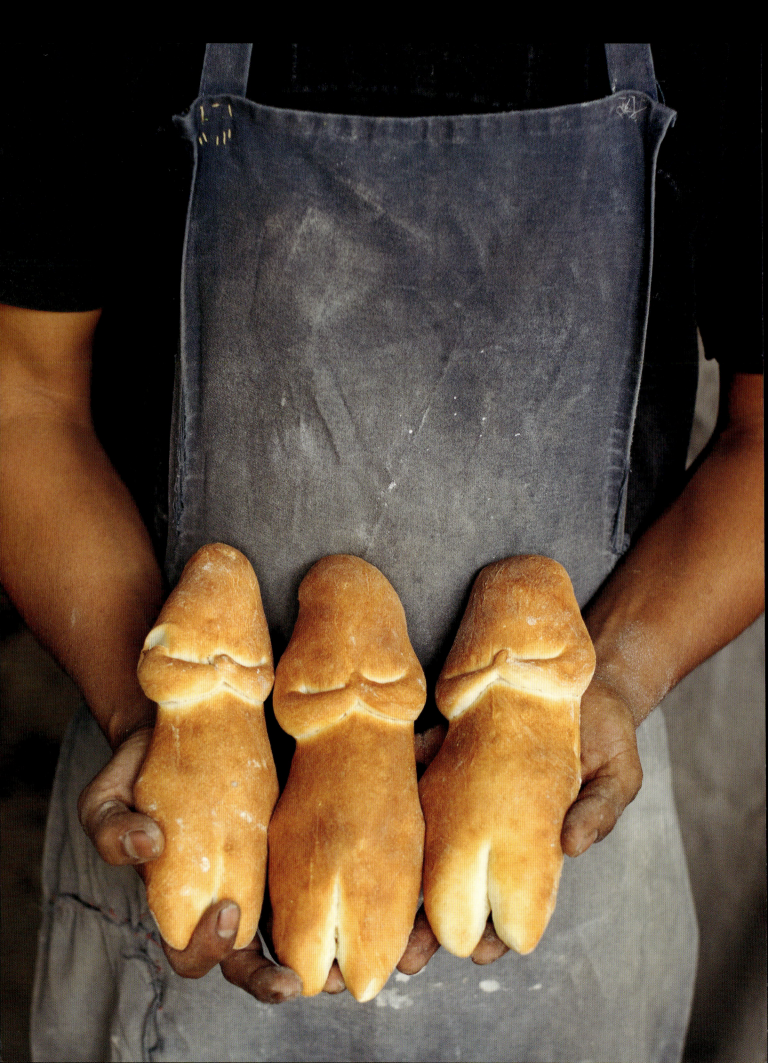

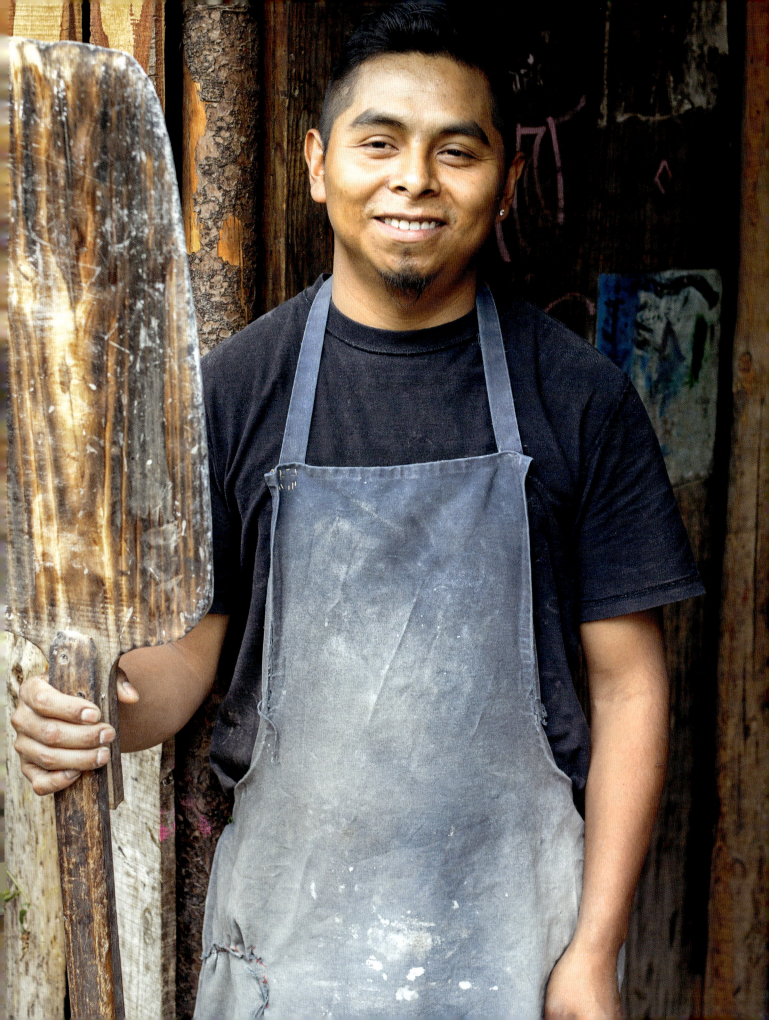

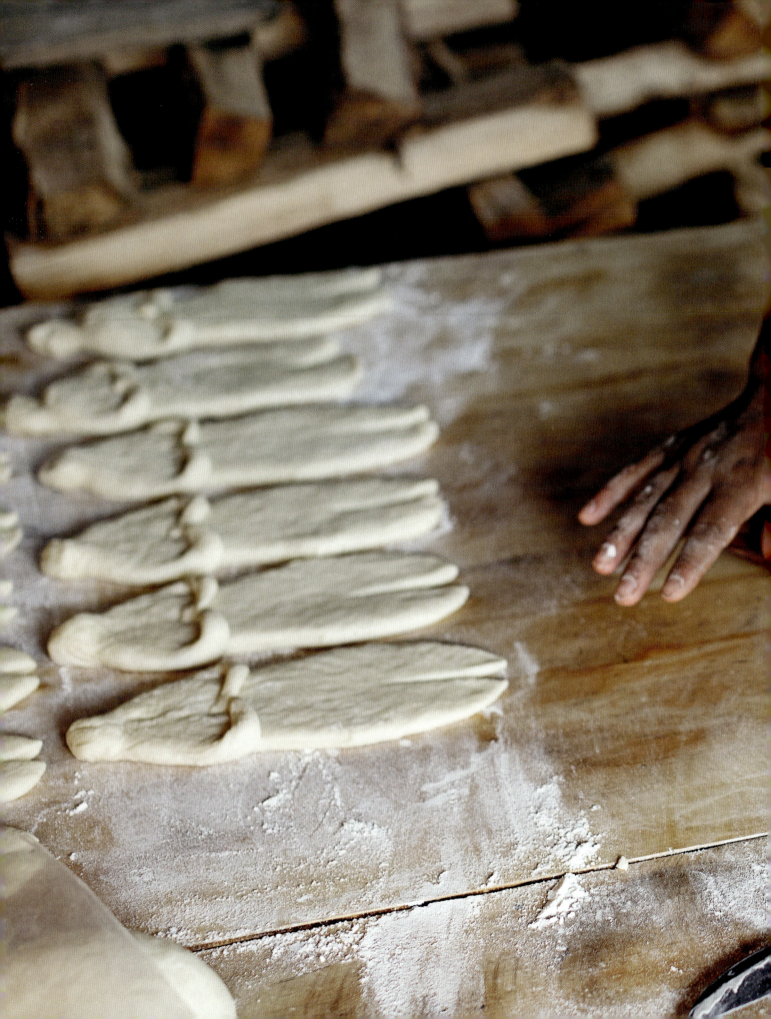

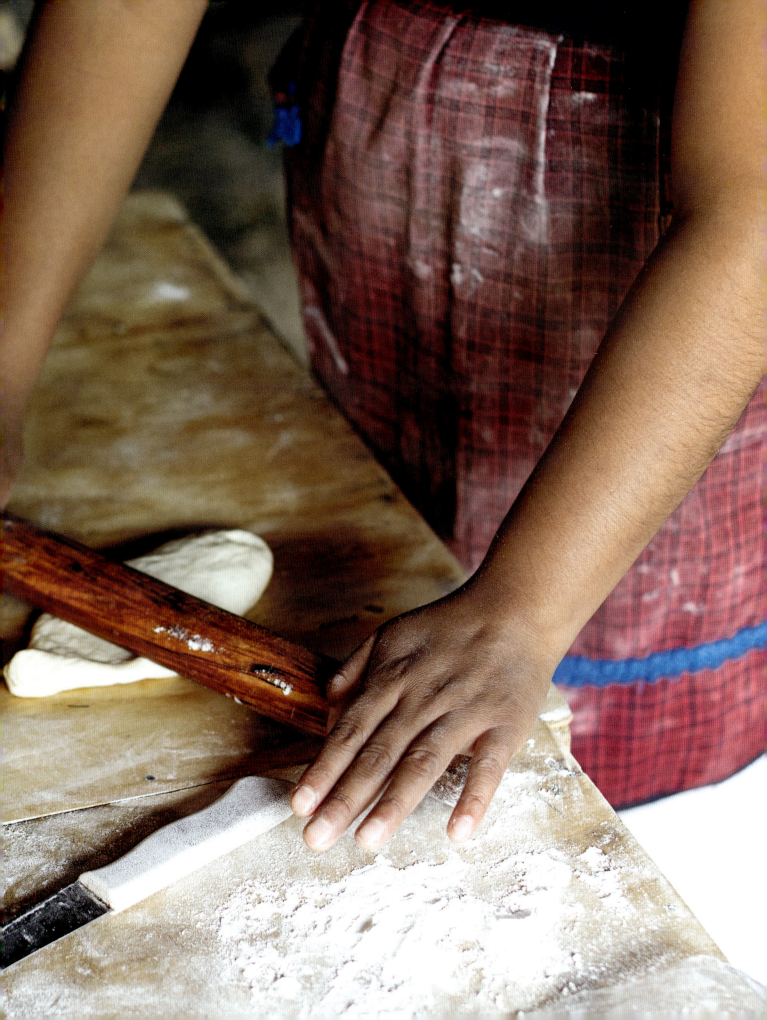

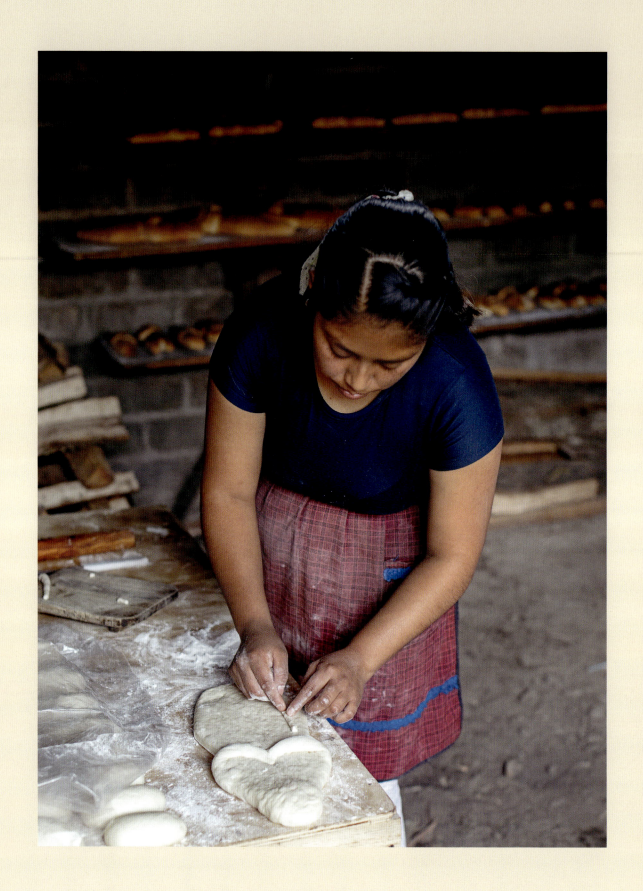

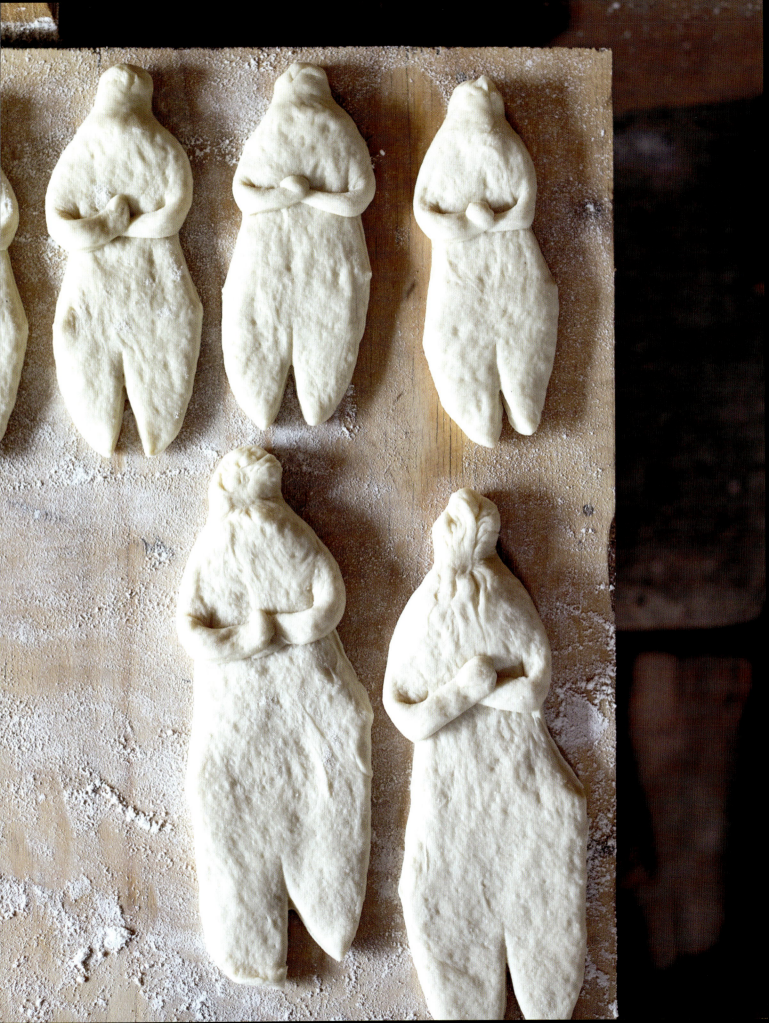

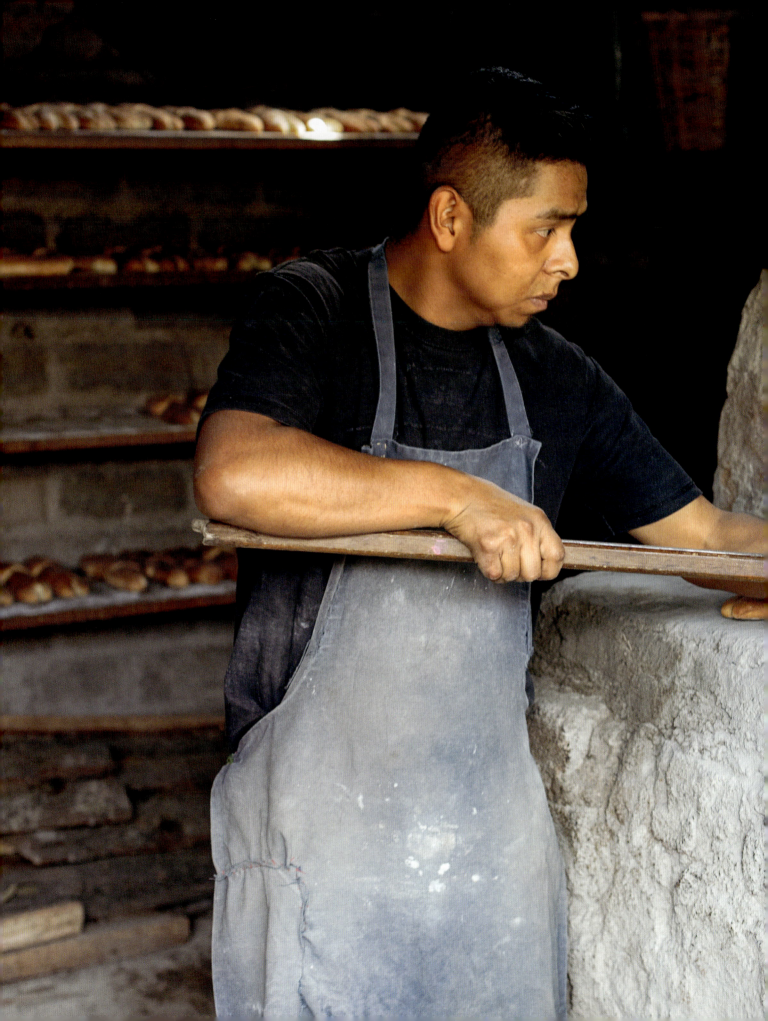

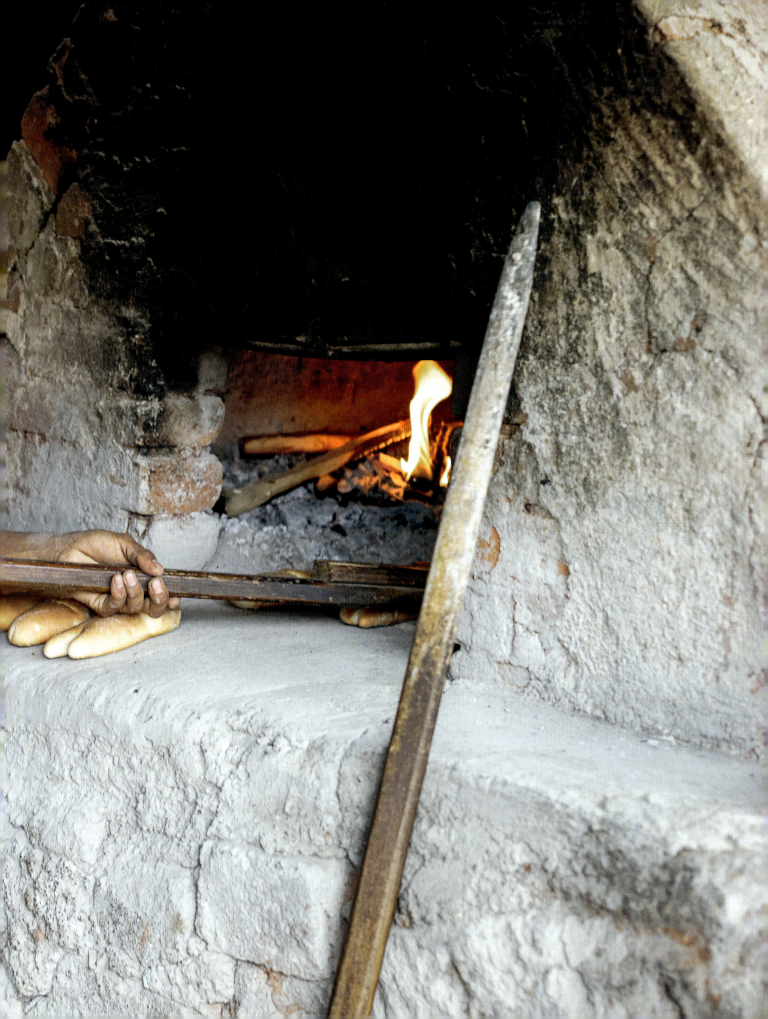

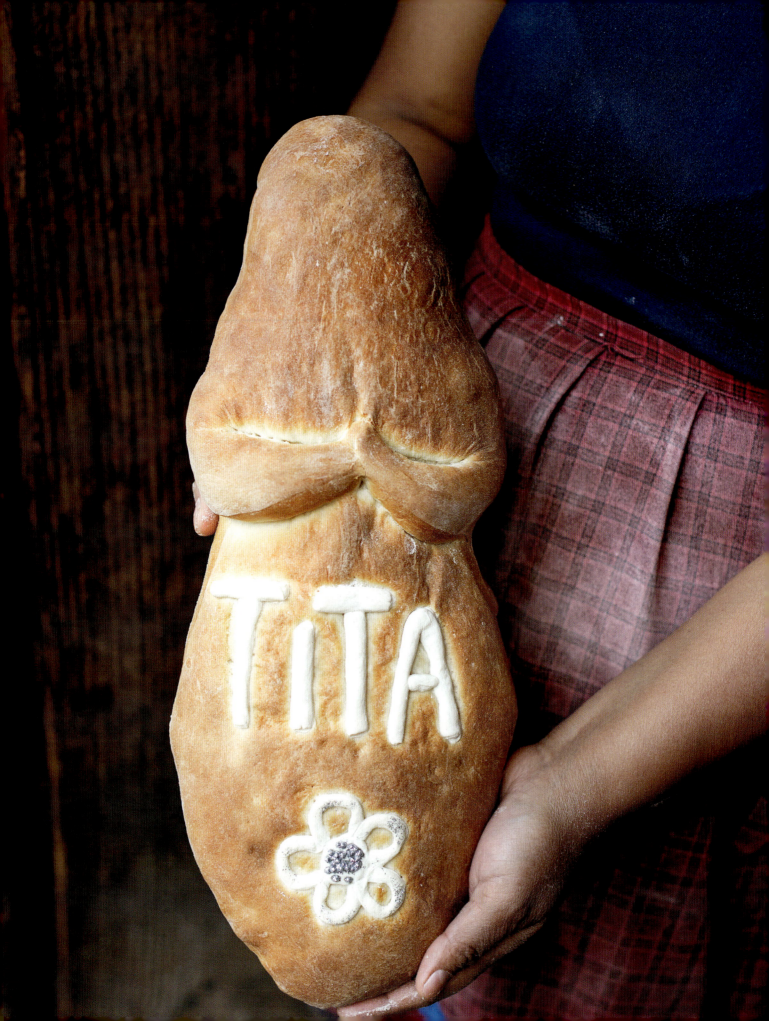

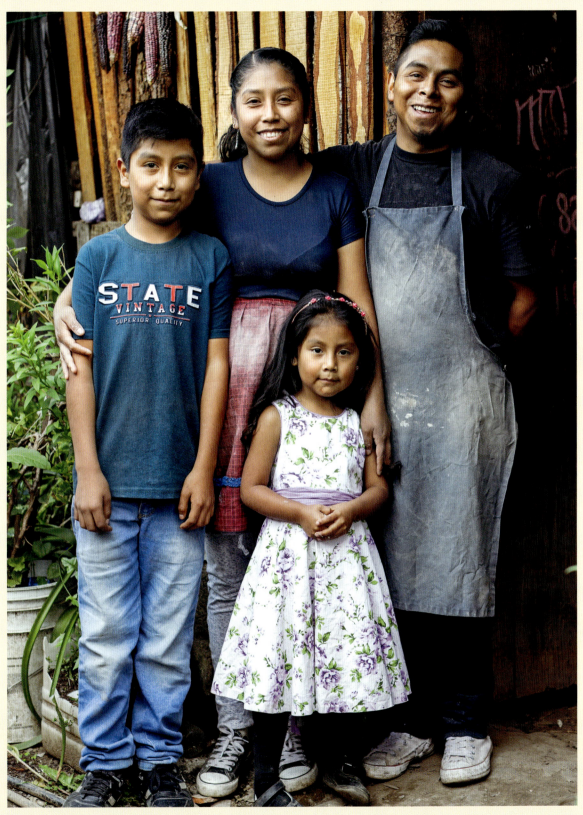

The Tellez family at their home and bakery in Cuanajo, Michoacán. Left to Right: Luis Enrique, Sandra, Mayte, and Hugo Cesar.

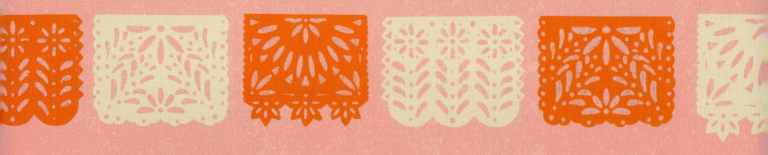

THE COLORS OF DAY OF THE DEAD

As a Mexican-American living in Dallas, Texas, I grew up celebrating Halloween—and, like most kids, fearing ghosts. It took me time to embrace the idea that death didn't have to be scary.

There was always a part of me that believed that spirits and ghosts could come back from the dead and scare us. When I was little, I used to tell my Tita Susana, "Please don't come back and haunt me when you die!" She would laugh and shrug her shoulders, but I remained terrified.

Growing up with Halloween's scary images of ghosts, vampires, zombies, and goblins, it makes sense to assume that a day dedicated to the dead would be just as spooky, but by now you know how Day of the Dead is about celebration and love rather than fear. Like Halloween, Day of the Dead also has a color scheme to match, but while Halloween is full of black and ominous imagery intended to frighten, the most prominent color used during Day of the Dead is orange. Pink, purple, white, and yellow are also common.

Just like the elements of the altar, each color used in Day of the Dead festivities carries its own meaning. For example, we use marigolds because their orange color is said to be the only color that the dead can see and because orange represents the light of the sun.

Purple represents mourning and grief and is used to honor Catholic traditions and to symbolize the death of Jesus. (However, not everyone who uses the color purple in their Day of the Dead celebration is Catholic or religious).

Red has several meanings. Traditionally, it represents the blood of life, and it can also be used to honor mothers who died in childbirth or soldiers who died in battle. Some Catholics use it to represent the blood of Jesus Christ.

Yellow is used as a symbol of light or to remember those who died in old age. It is often represented by the light of the candles on the altar.

White represents innocence, purity, and heaven, and it is used in altars commemorating children or babies who died.

Pink is the symbol of joy and is used to represent the happiness families feel in reuniting with their loved ones. In Mexico, it is common to see pink candles, pink paper garlands (papel picado), and pink flowers during this time of year.

Blue has two chief meanings. It represents water and is often represented by the glass of water we leave out for our loved ones who might be thirsty. It's also used to pay tribute to those who passed away from drowning.

Green symbolizes energy, vitality, and health; it is used to honor those who died young.

Black is rarely used for Day of the Dead, but it may be seen as a background color or used to represent Mictlān, the underworld or land of the dead. On altars, it can be seen on skeletons of La Catrina or black clay skulls.

But again, colors can take on other meanings as an altar becomes more personalized. For example, I always add a blue paper flower for my cousin Lila, who loved the color of the ocean. So if your loved one had a favorite color, you can also incorporate it in their altar to honor them.

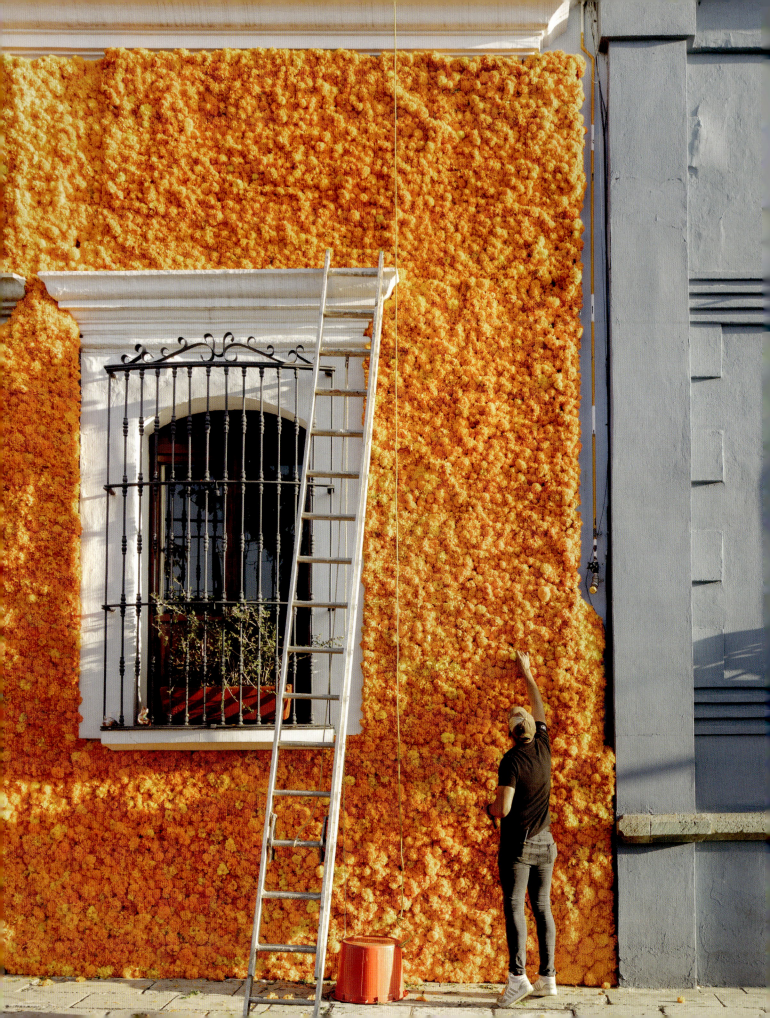

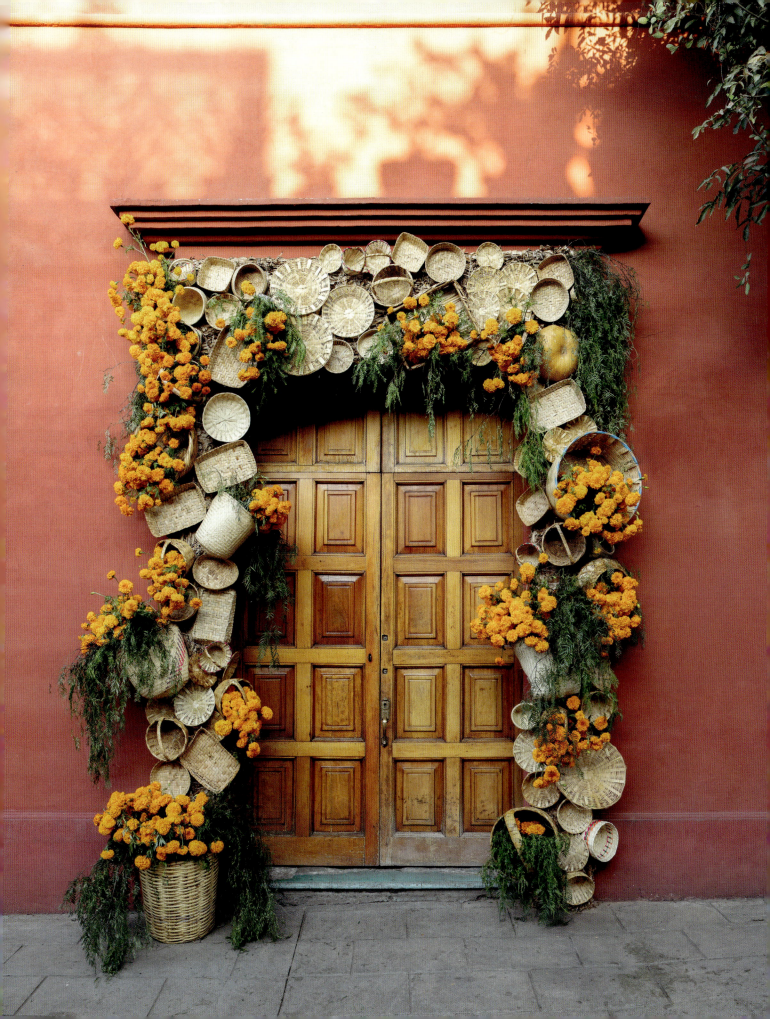

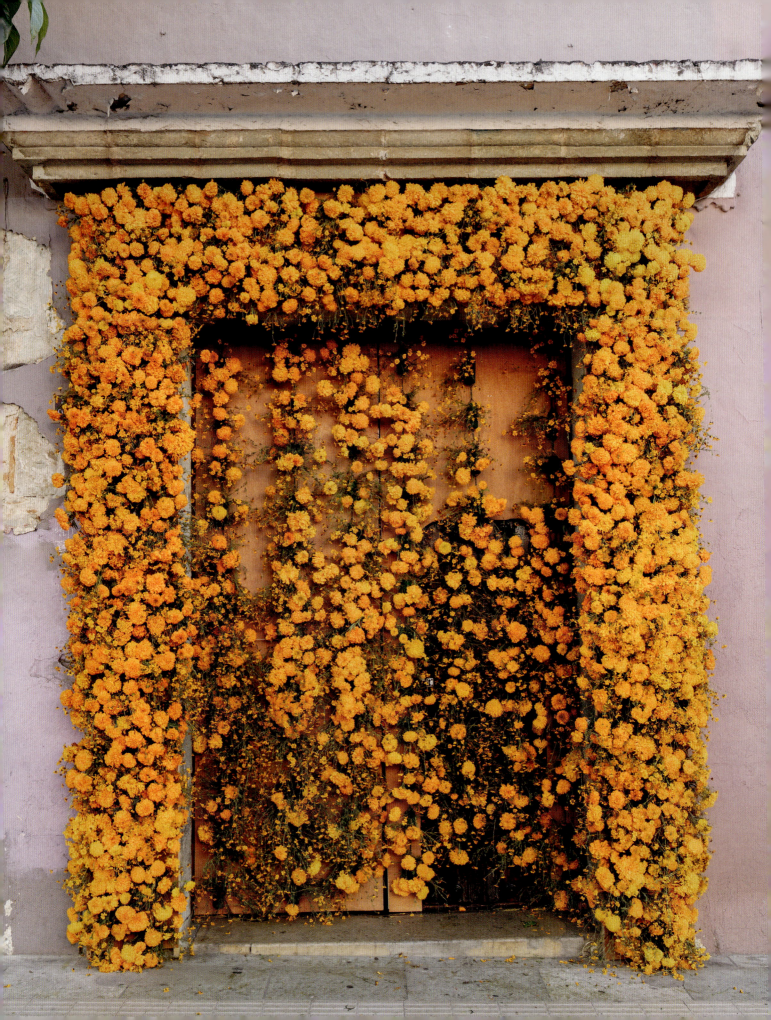

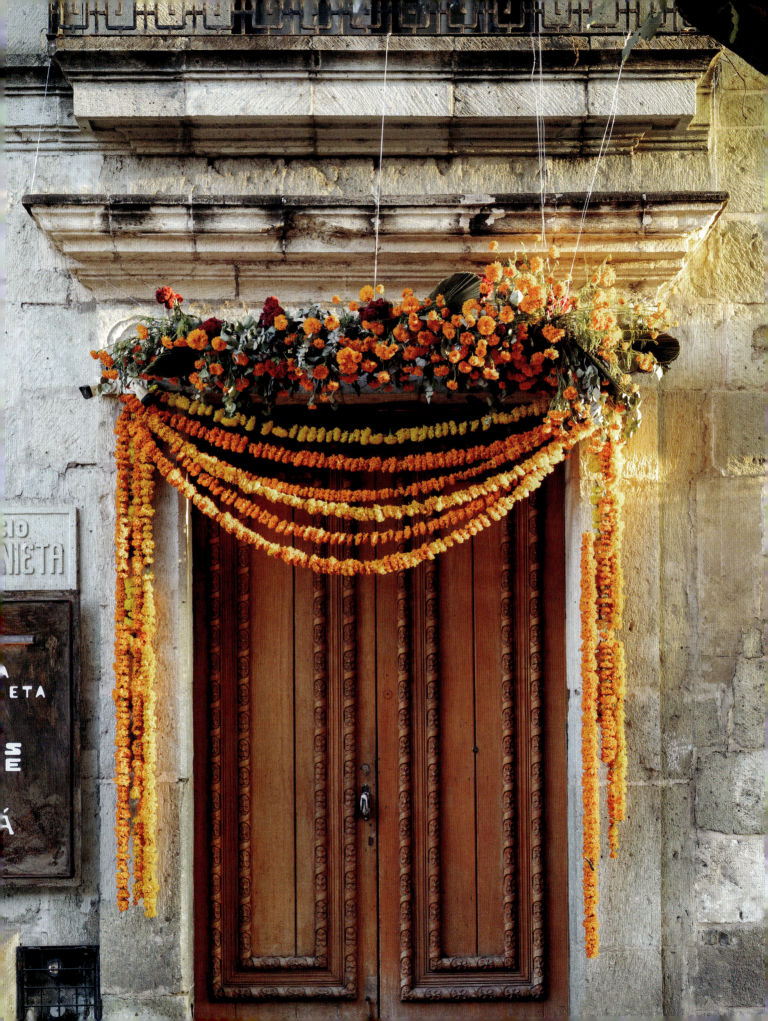

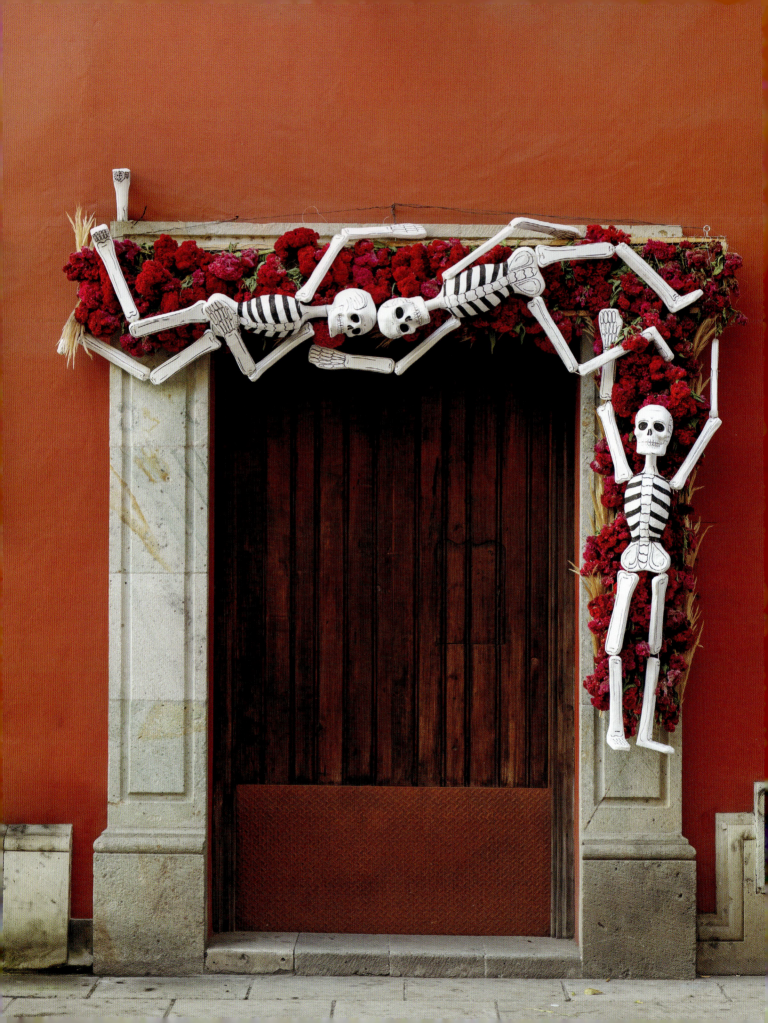

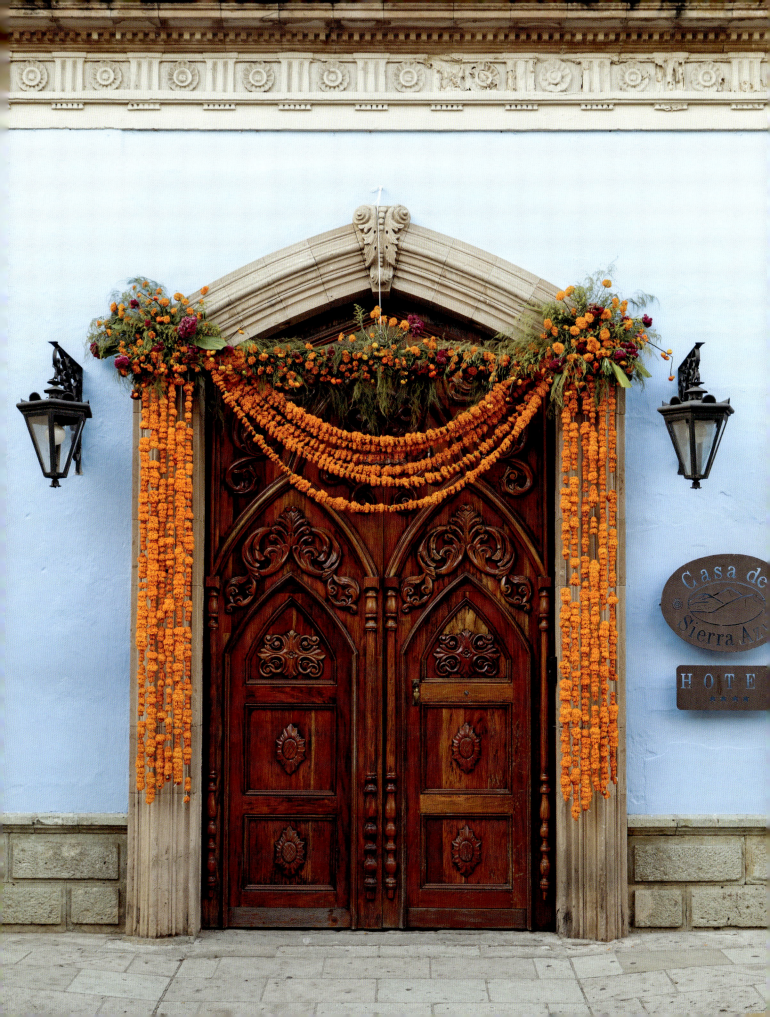

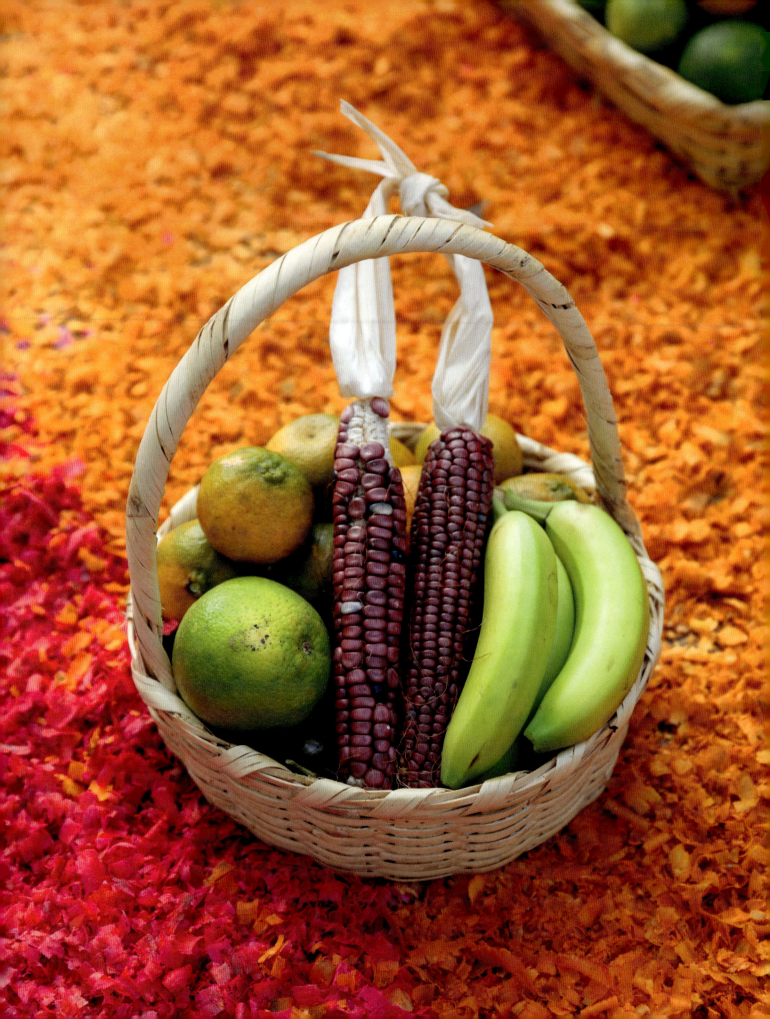

THE OFRENDA BASKET

When I arrived in Morelia, I was mesmerized by the gigantic cempasúchil (marigold) arches. Walking beneath them, I felt like I could magically transport myself between the land of the living and that of the dead.

Famously known as "the soul of Mexico"—and the best place to experience Day of the Dead festivities—Michoacán has always held a special place in my heart. It's my grandmother's home state and the place where she met and fell in love with my grandfather, Tito Carlos. As I walked around Morelia, I kept imagining what it would have been like to experience Día de Muertos when my grandparents lived there. Although I had celebrated Day of the Dead as a Mexican-American in the United States, this was my first time experiencing it in Michoacán. I felt emotional, knowing that while I would never be able to experience this moment with my grandparents, they were smiling down on me, excited that I finally got to witness this magical event in their favorite place on earth.

As we drove to my Tita Susana's hometown of Pátzcuaro, pickup trucks filled with piles of marigolds sped down the highway. I was told that Michoacán was the best place to experience Day of the Dead in its most authentic form.

When I arrived in Pátzcuaro, I was advised to prepare an ofrenda basket for the families I would visit. An ofrenda basket is an offering traditionally comprised of fruits, candles, and other items to add to someone's altar. While I wandered in search of suitable items, I thought about how my grandmother had walked these same cobblestone streets. Being in Pátzcuaro felt like coming home to me, and I was grateful for the chance to reconnect with her in this way.

When I arrived to the market, I purchased traditional *veladoras* (white candles in glass votives) and fruits at the mercado, including guayaba, *granadas* (pomegranates), *ciruelas* (cherries), and *nísperos* (loquats). The vendor also encouraged me to purchase some *flor de animas,* purple flowers with a tiny stem on the inside, resembling the face

of a skeleton. I hadn't seen this flower at markets in Mexico City, but the flower seller assured me that it was a traditional flower from this region for this time of year.

I was also informed that my baskets would need a *punto de cruz* (cross-stitch) napkin. These are traditional in Mexico and popular in Michoacán, but for some reason I struggled to find them in the city. When I asked why, I learned that, unfortunately, fewer and fewer artisans make them, and they are slowly becoming a thing of the past. Luckily, I found an artisan who was selling them next to the church where my great-grandfather Arturo Flores was buried—the Basílica de Nuestra Señora de la Salud. I wondered what he would think of his great-granddaughter visiting almost seventy years after his daughter Susana left her hometown. I had never met my great-grandfather, but I did feel emotional recalling how devastated my Tita Susana was when she lost her father and hero as a child.

Preparing an ofrenda basket is one of my favorite customs. I can imagine it would have been something my grandmother would have taught me if I had grown up in Michoacán. That evening, I would deliver the basket to a family in the small Purépecha town of Cuanajo, which is known for carpentry and for traditional Día de Muertos celebrations. When we arrived, my jaw dropped in awe as I watched the locals prepare to receive their lost loved ones. The center of the square was adorned with a forty-foot-tall wooden horse covered in fresh marigolds. The sky was filled with colorful papel picado, and traditional handwoven baskets were everywhere. Legend has it that the wooden horse, similar to the Xoloitzcuintle, or hairless dog, helps guide the spirits back to their homes. But unlike the Xoloitzcuintle, which is more common on altars in Mexico, these wooden horses can be found only in this town. Just when I thought it couldn't get any more remarkable, I noticed a rainbow peeking out of the horizon above the mountains. I took it as a sign that my grandmother and Lila were sending me a message. After seeing how locals celebrated and prepared, I wished we did this in the United States. I felt lucky to be there at that moment and to witness firsthand such magical traditions.

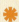

A couple of hours later, we would visit the home of a local woman named Marilú, who had passed away in childbirth at age thirty-four. As I looked at her picture on the altar, I couldn't stop thinking about the fact that we were almost the same age when she died. Her family was honoring her as *el muerto del año*, the person who died that year.

Contrary to what many people believe, not every town builds extravagant altars for their loved ones every year. In some parts of Mexico, families don't have an altar at home, but instead they visit the *panteones* (cemeteries). In Cuanajo, and other towns of Michoacán, the community celebrates el muerto del año—in this case a party in honor of someone who died that same year. When a muerto del año is celebrated, the family prepares a beautiful altar with a very large arch and multiple tiers. They make tamales, and guests arrive with ofrenda baskets and/or wooden horses adorned with fruits and marigolds to honor the person who died. This extravagant celebration happens in the first year of the person's passing. If someone died years ago, they are typically honored with a smaller altar that is not heavily adorned or accompanied by as many offerings.

This year, Marilú's altar (pictured on page 176) was filled with fruits, cempasúchiles, candles, and pan de muerto. One of the breads had her name and another had her baby's name: Isabelita. Friends and family who visited her home brought baskets filled with fruit, candles, and other items to decorate the altar. Before they entered, they asked, "Ya llego el muerto?" ("Has the dead person arrived?") To which the family responded, "Ya llego." ("Yes, they have arrived.") In exchange for the offerings, the family thanked visitors by filling their baskets with fresh homemade pork tamales.

When I poked my head in to see how preparations were going, I found a group of women spreading masa on tamale leaves; a large, skinned pig hung from the ceiling. When I saw it, I exclaimed "¡Ay, cañon!" (which roughly translates to "Damn!"). The women laughed at my reaction, then told me it took four whole pigs to make 250 tamales, enough to feed approximately forty visitors.

Although the gathering felt like a party, there was still a palpable sadness. Marilú was young, and she had left behind two children, fifteen and eight years old. Her sister was sitting in the back, separated from the group, and I could feel and see her grief. I hugged her tight and told her I was so sorry. I wanted to take her pain away. It was hard to stop myself from crying when she told me she missed her sister's laugh.

Once darkness hit, around seven o'clock, the town became louder. The church bells could be heard ringing in the distance as kids set off fireworks in the streets and giggled when I jumped in fear.

Marilú's son was running up and down the dirt path of his neighborhood with his friends. When I asked him where he was going, he looked back over his shoulder and told me, "¡A la iglesia (to the church)!"

The children took turns ringing the church bells. They climbed up to the bell tower and pulled on the ropes, alerting the town that the deceased had arrived. The sound was eerie and ominous but nonetheless enchanting. The bells rang for more than a day without stopping, beginning at 7 p.m. on October 31 and ending at 12 a.m. on November 2. This required a whole team of kids, some of them quite young, who all took great pride in their work.

Walking through the town, we encountered a home where a mariachi band was playing. I asked what the occasion was; they explained that when a single unmarried person dies, mariachis are hired in their honor. In this case, the band was for Adelita—a gorgeous woman with curly black hair and a beautiful smile who was deeply loved by her family and friends.

As I ventured into more homes, I noticed that every house was decorated differently, each with its own traditions. The thing they all had in common was family and friends coming together to celebrate and honor the deceased. That evening, I realized that the beauty of dying in Mexico is that your memory will never be forgotten, and you can always count on a fiesta.

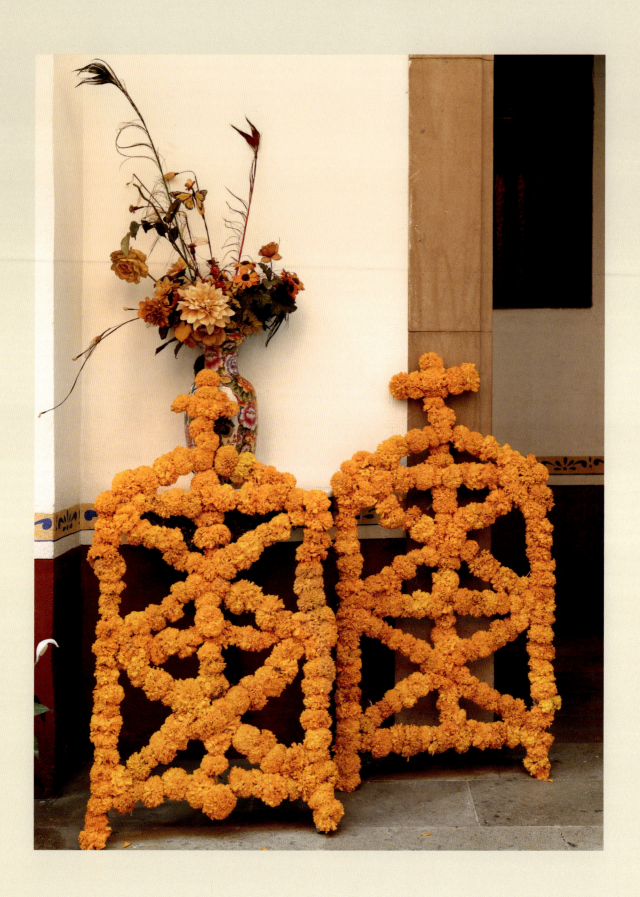

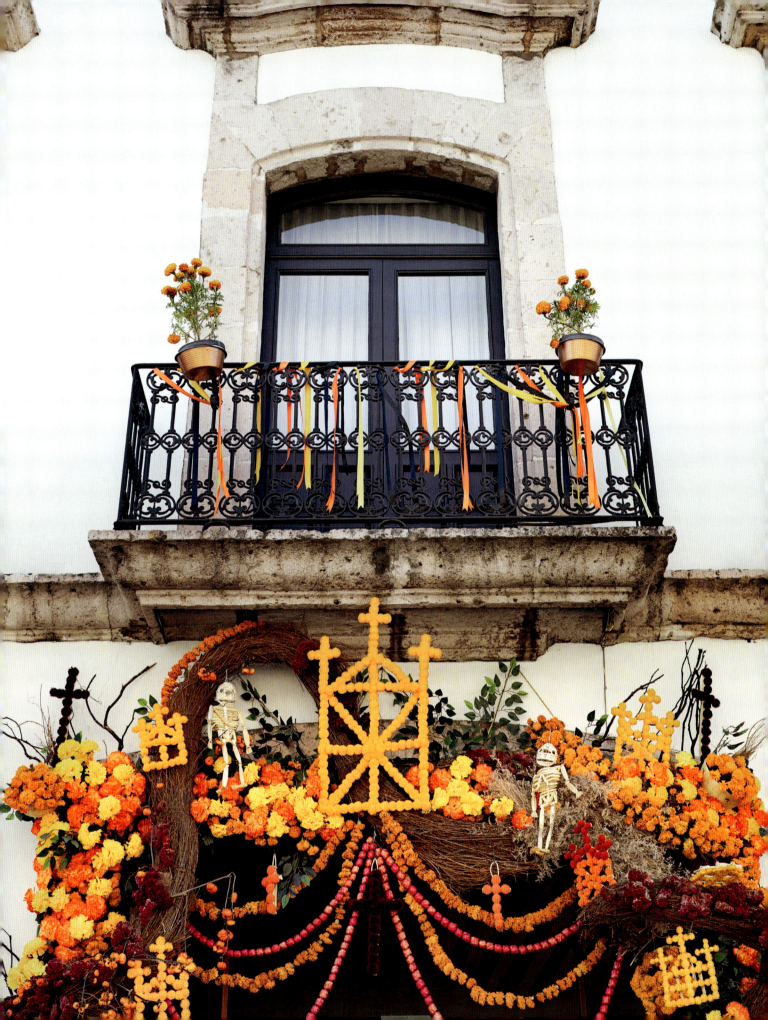

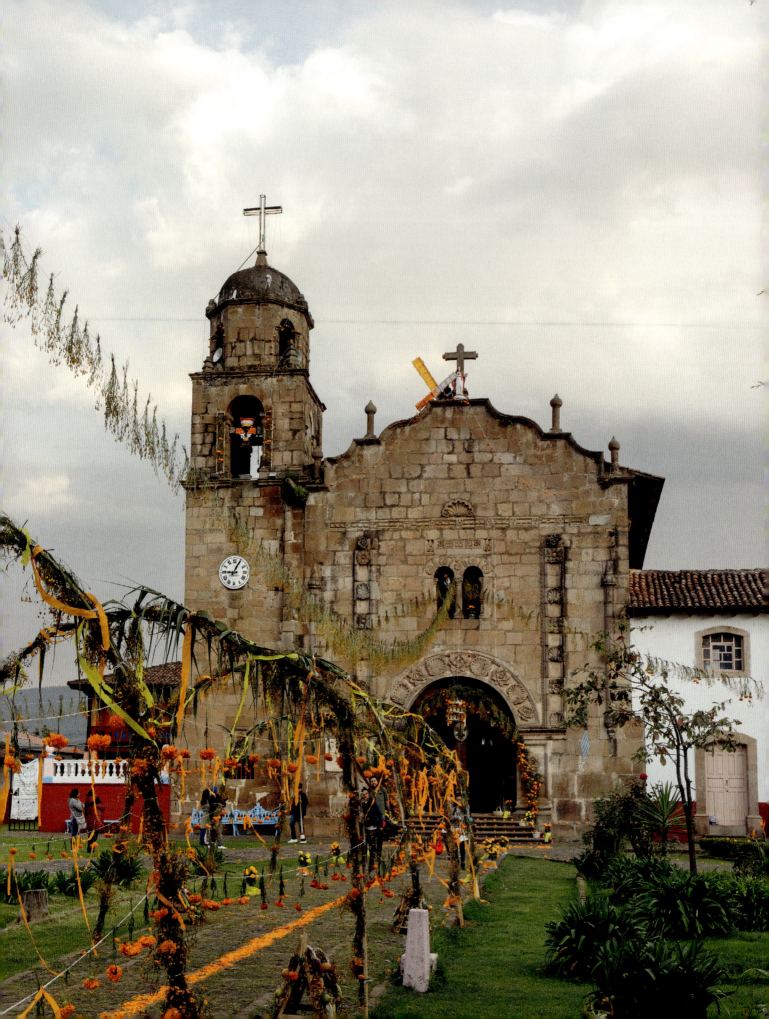

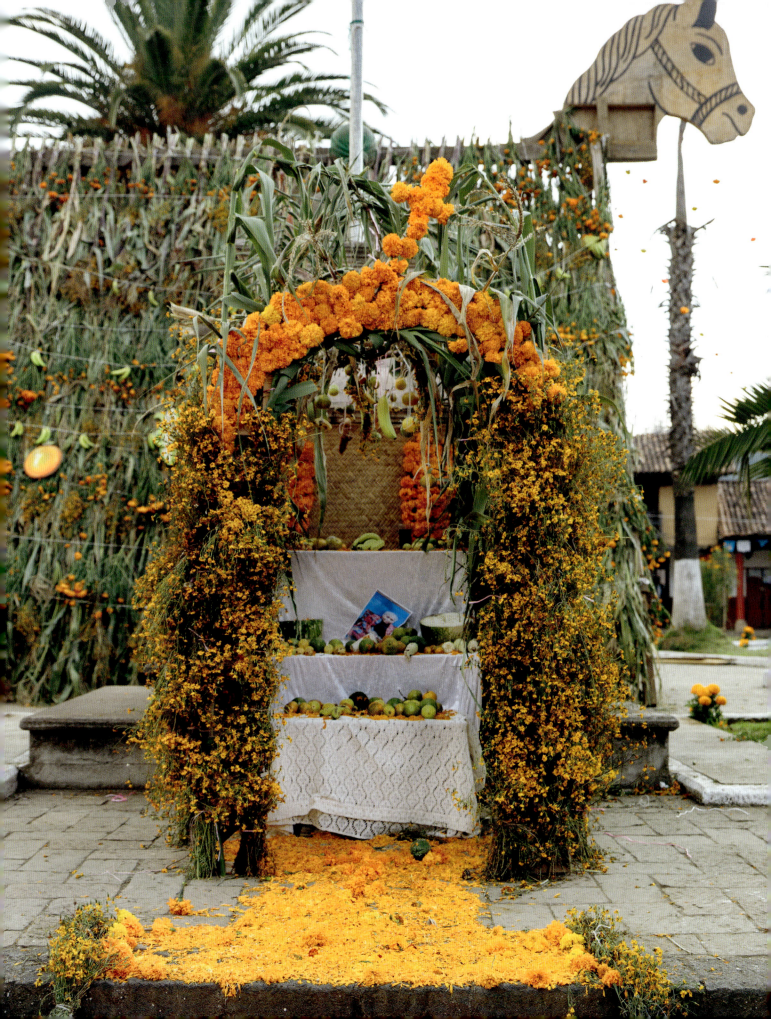

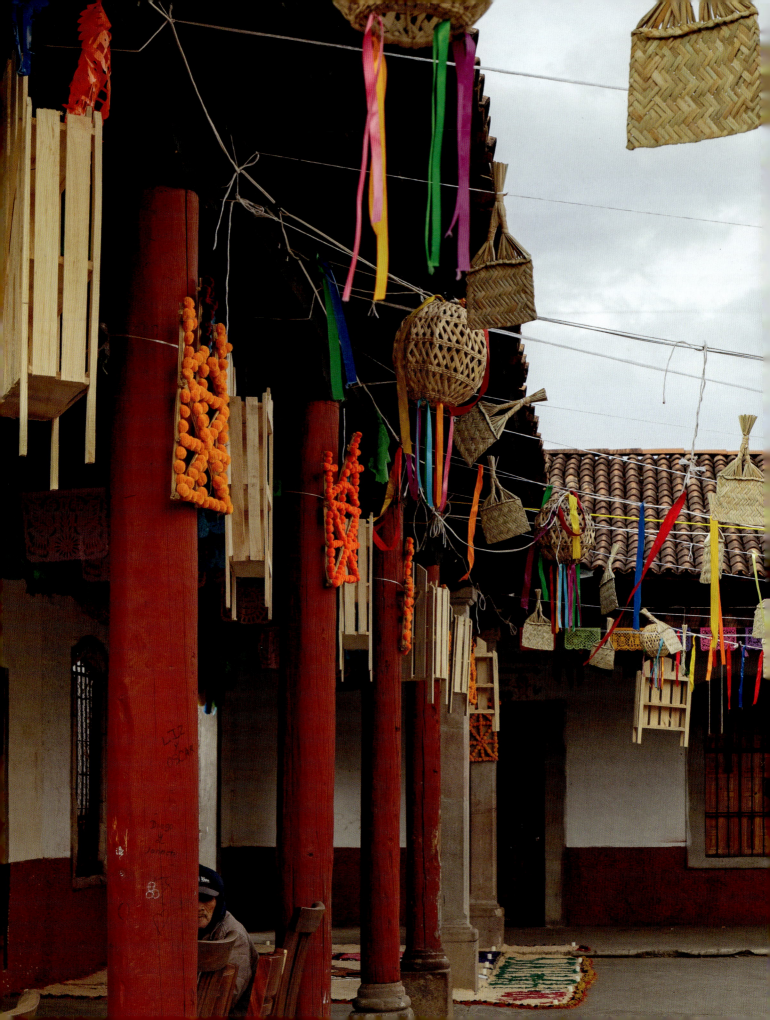

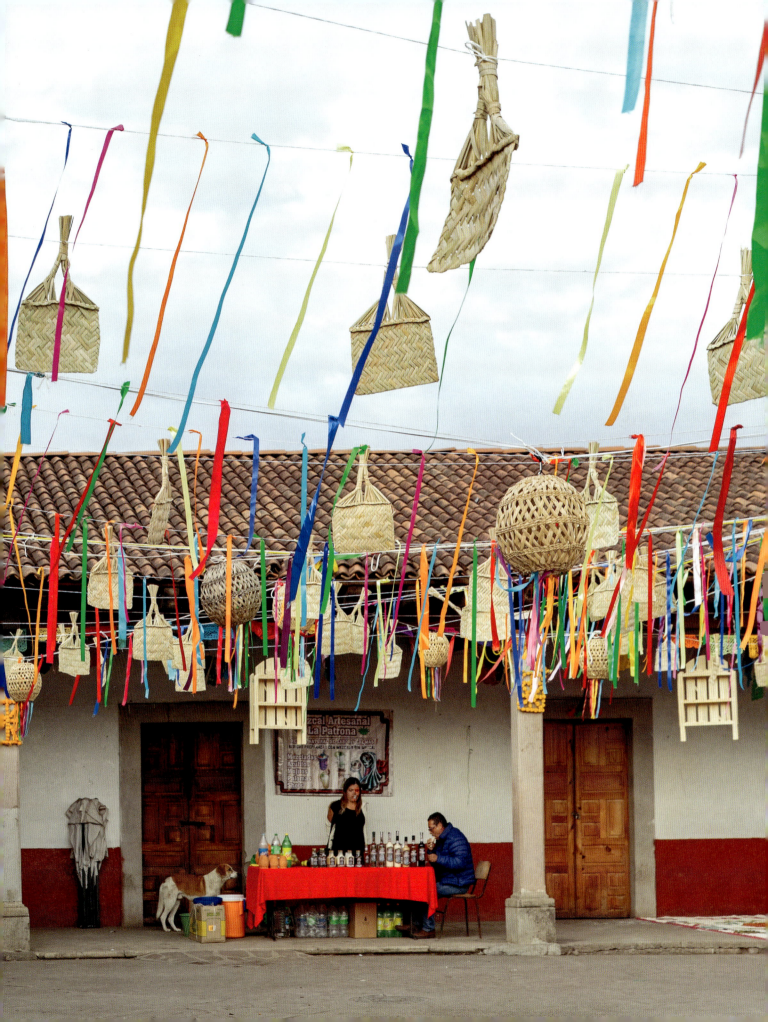

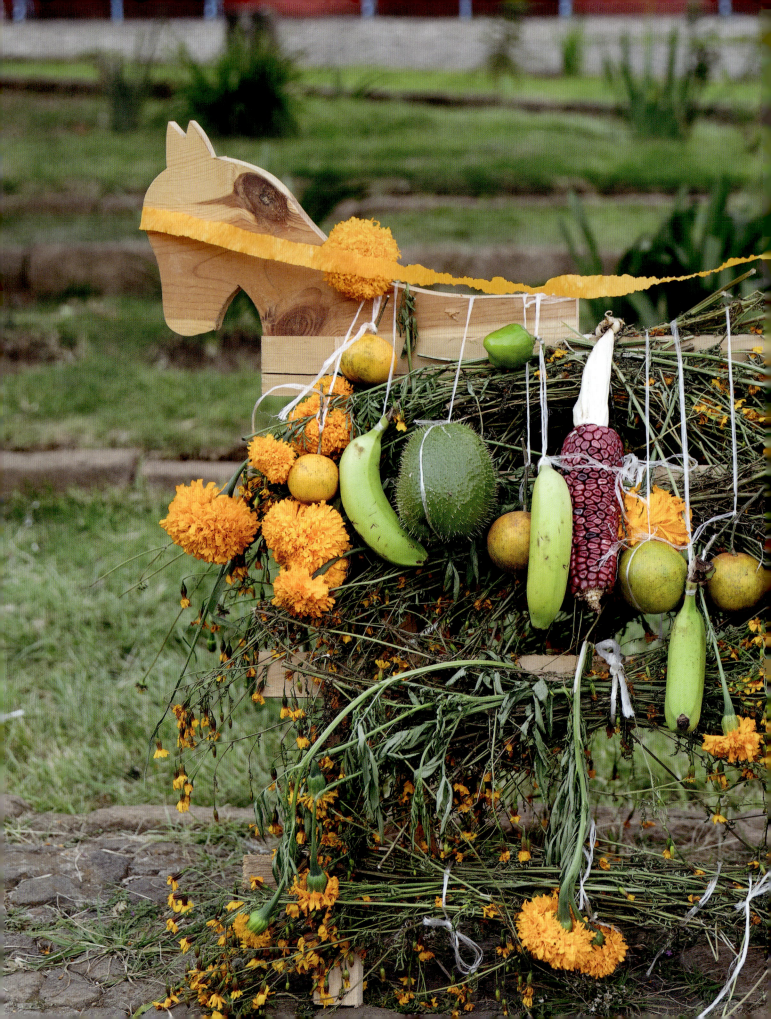

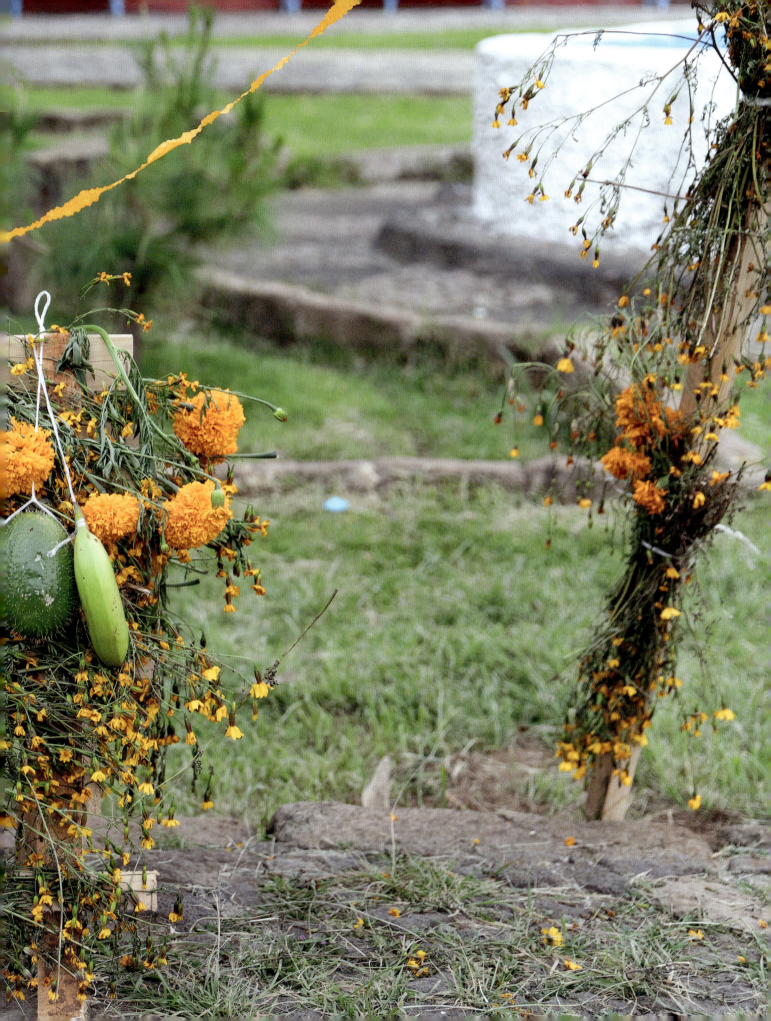

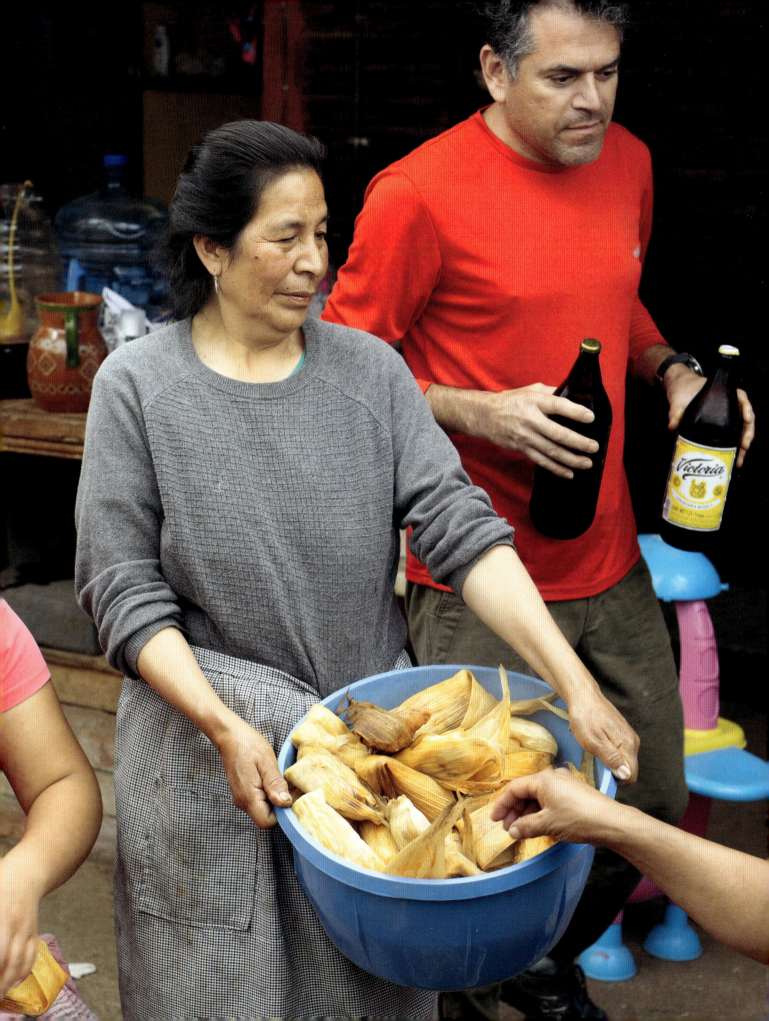

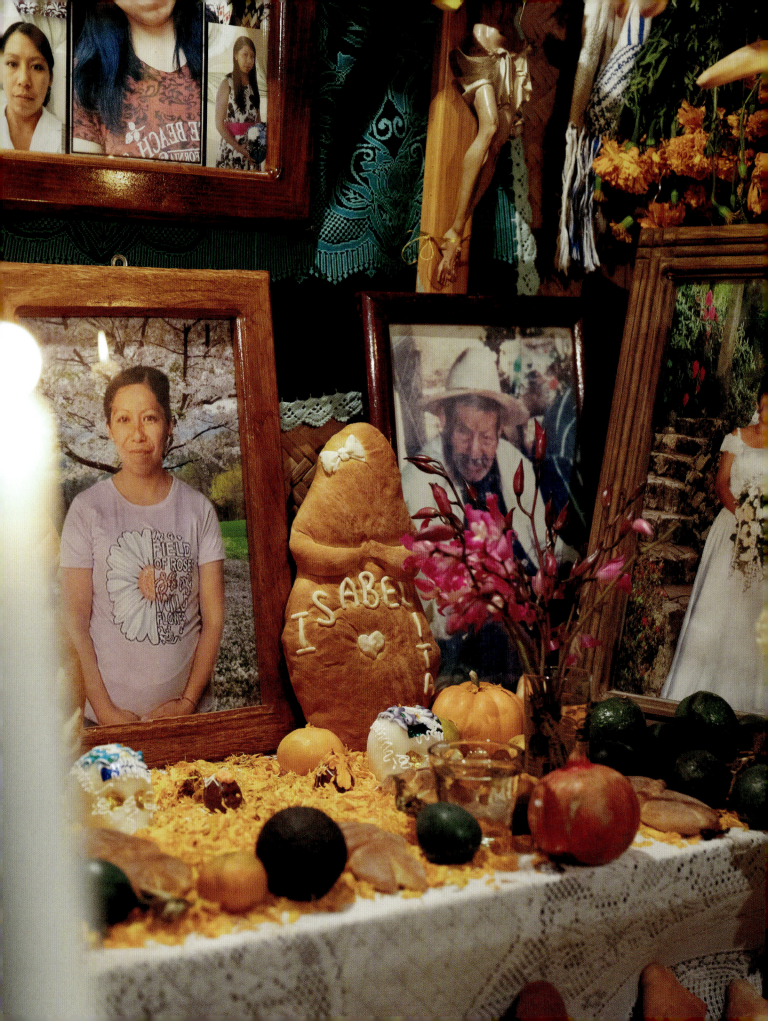

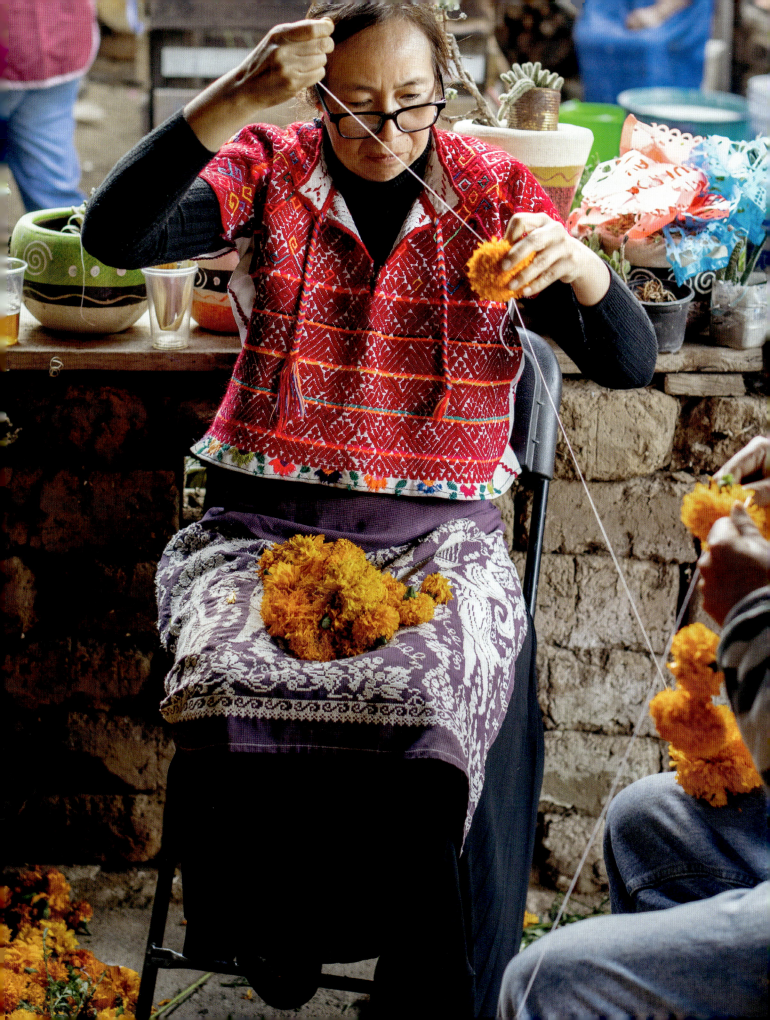

CREATING AN ALTAR OF YOUR OWN

When my cousin Lila died, I was desperate to soothe my pain. I wanted to reconnect with her, and I wondered if building a Day of the Dead ofrenda could help me heal. When I researched the process, I was shocked and overwhelmed at the number of rules, traditions, and guidelines. As I read about the different elements, I worried that building something in Lila's memory would actually make the heartache more acute. I decided that I would perhaps try it the next year. But the following year, I faced the same uncertainty. I began to worry that I would never be able to build an altar.

A few years later, my grandmother and my husband's grandparents passed away within months of one another, and I was finally ready to build my first altar. This time the grief helped me stop worrying about the rules. I needed to begin the process of honoring my ancestors. I went to my closet to look for pictures of my relatives. I bought candles of various sizes and used the shelves in my kitchen cabinet to display the items I had collected, without stressing about whether what I was making was right or wrong. After finishing, I stepped back and smiled, knowing that what I had created was special, even if it didn't really adhere to a specific tradition. By letting go of perfection, I discovered healing in a way that I never knew was possible. I was able to reflect, meditate, and reconnect with my loved ones. Building my first altar made me recognize that I never have to worry about making mistakes because honoring my loved ones is more important than not commemorating them at all. My only regret was in wishing I had started the annual practice sooner.

If you're feeling overwhelmed by the idea of celebrating Día de Muertos, please remember that there is no wrong way to honor the ones you love. Of course, there are traditional elements such as marigolds, candles, and family photographs—but after traveling through Mexico, I can assure you: there is not a single "correct" way to celebrate. In fact, Day of the Dead customs and rituals vary dramatically throughout Mexico. Some altars have two tiers while others have three, four, or even seven tiers, depending on local

practices, personal preferences, a family's wealth or status, and the number of family members being honored.

It's also worth noting that while the practice of altar-making is based on a blend of Catholic and indigenous Mexican beliefs, you as a reader of this book may hold any of a wide variety of beliefs. My hope is to inspire people—perhaps you—to take time at least once a year to honor relatives who have passed away. Whether it's building an altar according to your own belief system, holding a memorial service, or hosting a special dinner, I hope that Día de Muertos will encourage you to come together with family and friends to talk about those who have died, instead of never talking about them at all.

All that said, learning a bit about the three main types of traditional altars (two-tier, three-tier, and seven-tier) can serve as guidance for whatever approach you are most comfortable with.

TWO-TIER ALTAR

Two-tier altars are the most common style; the two tiers are, usually, a table and the floor. The table is the top tier, used to represent heaven, and the floor is the bottom level and represents earth. This style of altar is common in private homes in Mexico as opposed to public spaces, but I've also found that friends who live in apartments are more inclined to build two-tier altars because of limited space.

THREE-TIER ALTAR

In a three-tier altar, the top level represents heaven, the second level symbolizes earth, and the bottom level embodies the underworld or purgatory. There are a few different ways to create the tiers in this style of altar. Some people stack a smaller table on a larger one; others use cardboard boxes or wine crates draped with a tablecloth. A three-tiered altar also always includes an arch, which represents heaven or the passageway from the afterlife for the souls to visit us on earth. For the bottom tier or ground level, altars include a mat or petate (a traditional rug woven from palm fibers) as a resting place for the souls who are visiting. The last level may also include a cross that is made from candles, flowers, or even sand.

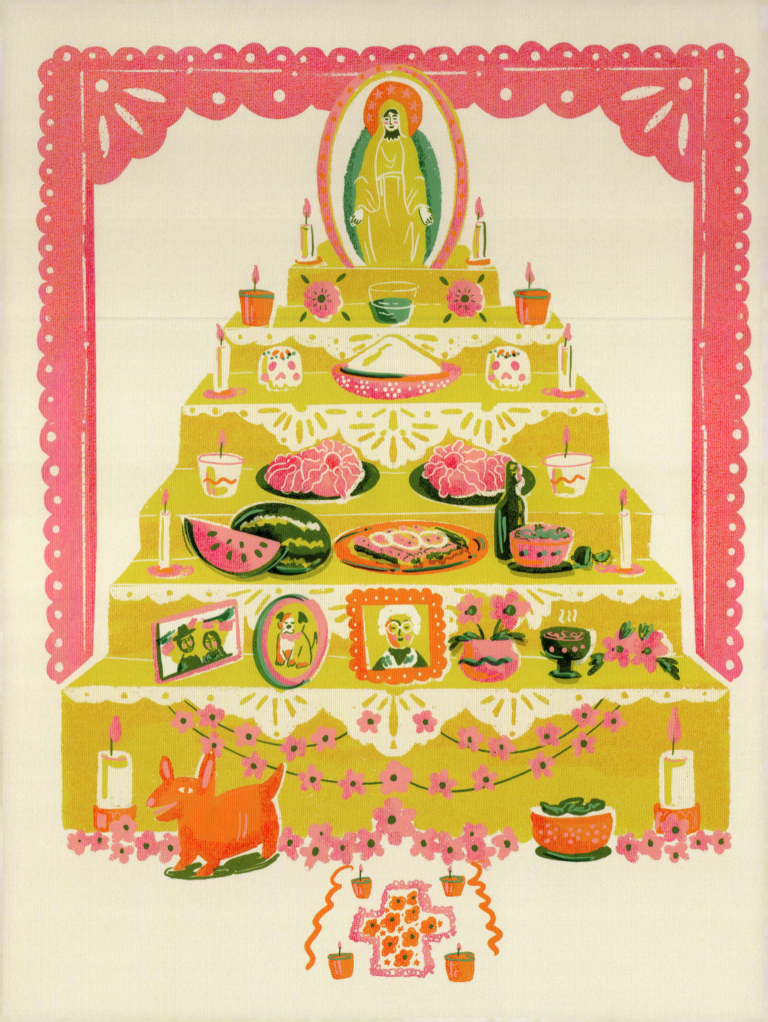

SEVEN-TIER ALTAR

If you walk around the *zócalo* (a public square or plaza) in any large city in Mexico, you may see seven-tier altars that commemorate large groups of people or celebrities. During my travels, I have also seen seven-tier altars in private homes—these always make me gasp, since I know how much preparation they take and how costly they can be. In a seven-tier altar, the elements of each level are as follows:

LEVEL 1: THE SAINT

On the highest level of the altar, an image of a saint to which the altar is dedicated is placed. In Mexico, it is common to see images of La Virgen de Guadalupe, Jesus, or the patron saint of the local town.

LEVEL 2: SOULS

This level is dedicated to the souls in purgatory. According to Catholic tradition, these souls must undergo purification before being allowed into heaven; this tier is intended to allow the souls of the deceased to obtain permission to leave. A cup of water placed here represents purity.

LEVEL 3: PURIFICATION

Salt is placed here to symbolize the purification of souls in purgatory, especially those of children.

LEVEL 4: BREAD

Day of the Dead bread, or pan de muerto, is placed here as an offering for the visiting souls.

LEVEL 5: FOOD

The deceased person's favorite dishes and fruits are placed here as an offering.

LEVEL 6: PHOTOGRAPHS

Pictures of the deceased are placed here to honor their memory and to ensure that they are never forgotten.

LEVEL 7: THE CROSS

A Christian cross made of seeds, fruits, flowers, or candles is placed here so that the deceased can atone for their sins.

All together, the seven levels represent the seven deadly sins and the steps the spirit must go through to reach peace and eternal rest.

ALTAR FOR BABIES

During my travels to Oaxaca, I saw a type of Día de Muertos altar I had never seen before. When I asked what it was, my friend Leslie explained to me that it was a baby altar, which honors all of the babies who were lost via miscarriage, birth, or infancy. I thought about how beautiful it was to hold space for this specific type of loss, which is excruciating to endure but important to acknowledge.

GUIDANCE FOR BUILDING YOUR FIRST ALTAR

If this is your first time celebrating Día de Muertos and you're doubting yourself—or ready to give up because you're feeling emotional strain—I encourage you to take deep breaths, be kind to yourself, and lead with your heart. This process should feel therapeutic and relaxing, not stressful. If you're still feeling doubtful, ask yourself, "How would my loved ones want me to celebrate their memory?" By asking myself this question, I have found that my ancestors' spirit and memory always guide me in the right direction. Your altar doesn't have to be built in one day. You can take your time and process everything over multiple days, if that feels more emotionally and physically manageable for you.

As I have built more altars over the years, I have found that I am able to process more information and learn more about the rules and traditions. Every year my altars grow larger, incorporate more elements, and feature multiple tiers. It has been my personal experience that it's best to start simple and to gain a better understanding year after year, as you work up to building more traditional or elaborate altars. And if you're feeling any financial or perfectionist strain in the process, remember that it's more important to focus on reserving the time to honor your loved ones than it is to build a perfect altar. This is not about building something extravagant, showy, or expensive. It's about creating something from the heart, for your heart.

WHEN TO PLACE A FAMILY MEMBER'S PHOTO ON THE ALTAR

Customs and traditions vary from region to region. There are some towns in Mexico that hold the belief that if a soul has departed recently, relatives should wait a full year after their passing before placing their photograph on the altar. This idea stems from the belief that the soul needs time to make the journey to the afterlife before they can visit again. This prevents them from getting lost during the voyage. But not everyone holds this belief, and some choose to place the images of the deceased immediately after their passing because they believe the souls will not get lost and that they will, in fact, visit that year. I personally do not wait a full year and do not believe the souls will get lost. When my grandfather Tito Santiago passed away in August, I honored him that same year, and it helped me heal and reflect since I was not able to attend his funeral in Saltillo.

WHEN TO TAKE THE ALTAR DOWN

This custom also varies from state to state, and there is not a set rule; however, most believe that after November 2 the spirits' visitation ends. After this date, some families choose to eat the food after the deceased has had a chance to taste the offerings while others toss the food. Slowly, the altar becomes smaller, and eventually it gets taken down. But in other communities, such as certain towns in Oaxaca, they wait until November 8 because they re-celebrate any festivity every eight days. This tradition is referred to as "octava," which translates to "eighth." Locals re-celebrate Día de Muertos one last time before taking the decorations and altars down. Others I've spoken with keep an altar up year-round with candles and some flowers, but they save the practice of sharing offerings of food and beverages specifically for Día de Muertos.

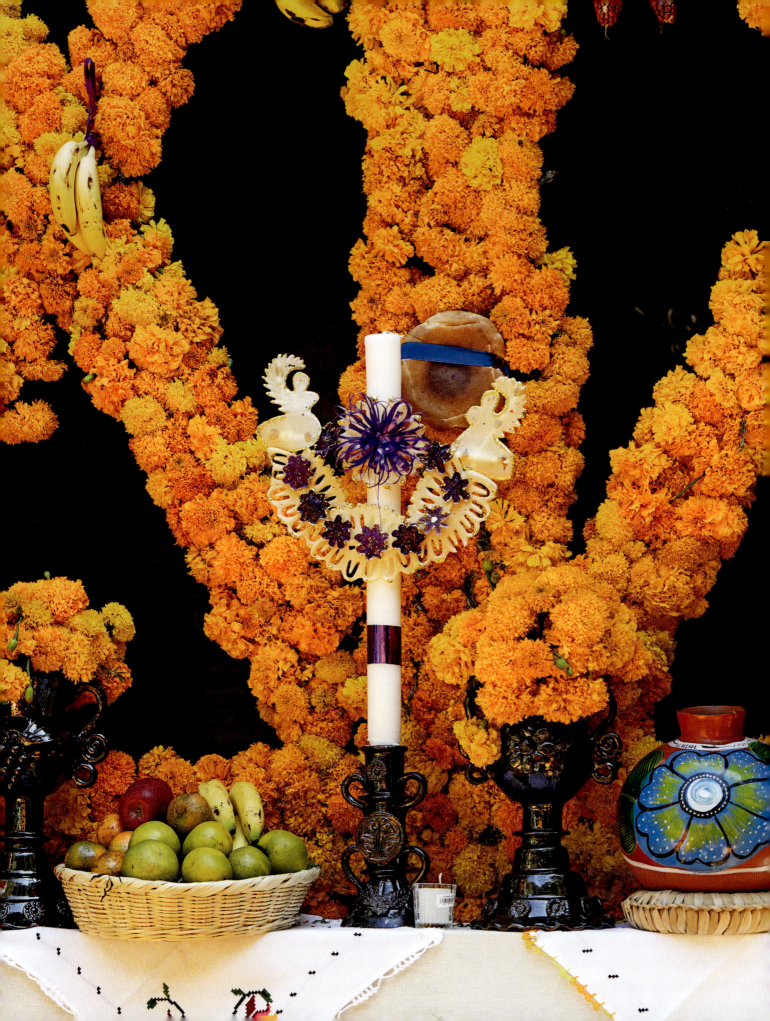

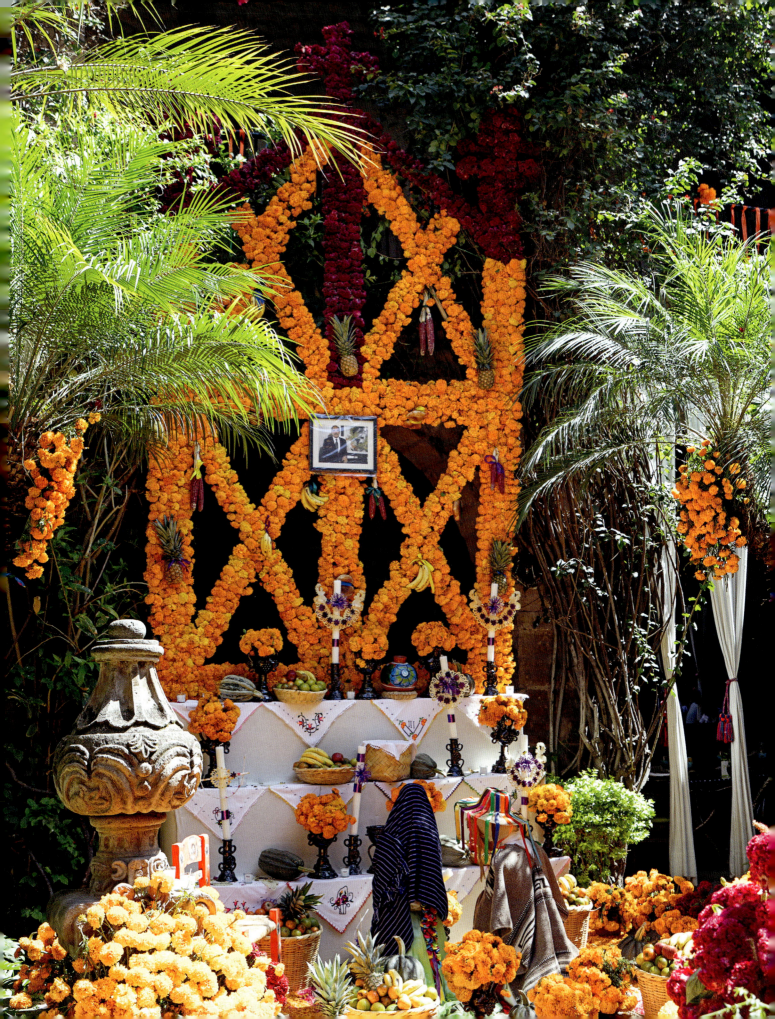

Being in Mexico during Día de Muertos was magical, but by the end of the trip, I realized that nothing compares to celebrating at home with loved ones. Since much of my family has now immigrated to the United States and the older generations are no longer with us, it feels more important than ever to preserve these traditions. Whether you also have families who have left Mexico, or you're new to this and inspired to create traditions of your own, I wanted to share a few activities so you can celebrate at home. For help, I turned to two women who inspire me. Acclaimed chef Fany Gerson of La Newyorkina will show you how to make delicious pan de muerto and design expert Sarahli Wilcox of Hauz and Co will walk you through making sugar skulls and papel picado. I hope you and your family enjoy making these as much as I do.

DAY OF THE DEAD CALENDAR

Day of the Dead is primarily celebrated on November 1 and 2, but there are other dates on which some people choose to commemorate specific lost souls. It depends on who died and how they died. Similar to altar-building practices, the dates associated with certain customs can vary from region to region, and not everyone chooses to recognize them. For example, in Michoacán, they keep things simple and believe that children and people who never got married (*solteros*) arrive on November 1, and adults who did marry in life arrive November 2 at dawn.

Here are some other honorary dates that some choose to recognize.

OCTOBER 27
A day to remember pets.

OCTOBER 28
or Saint Jude's Day, is a day to remember tragic deaths, including those who died from violence or suicide, or in accidents.

OCTOBER 29
A day to remember those who died by drowning.

OCTOBER 30
A day to honor those who have been forgotten or who don't have any family to remember them.

OCTOBER 31
A day to honor those who have not been baptized, including children in limbo.

NOVEMBER 1
A day to honor children younger than twelve.

NOVEMBER 2
A day to honor adults who have died.

CATRINA PAPEL PICADO

BY SARAHLI WILCOX

Makes 4 per tissue paper

Papel picado is used throughout many Mexican celebrations and is a key element on a Día de Muertos altar. Stacks of tissue paper or plastic sheets are chiseled by hand to create elaborate designs depicting nature and special occasions that can be strung onto a garland and hung up for decoration. With the template and step-by-step instructions, you can make your own. This works with multiple sizes of tissue paper; the minimum size required is included here. Use what you can find.

Papel picado printable template
Printer and copy paper
Tissue paper sheets
 (minimum 13 by 18 inches / 33 by 46 cm)
Paper clips
Cutting mat
Precision craft knife
Paper hole punch
Scissors
Craft twine/string
Glue stick

To use the template shown, search for "Sarahli's papel picado" on mexicoinmypocket.com, then download and print it on regular copy paper.

Take a piece of tissue paper and fold in half longwise so the short sides are touching. Take the long-side again and fold in half so the short sides are touching once more. Fold the tissue paper once more so the long sides are touching, for a total of three folds.

Fold the printable template in half along the vertical line as shown on the template with the printed side facing out. The shapes will match and mirror on both sides.

After folding, lay the printed template on top of the tissue paper. The folded edge of the template should be lined up with the folded edge of the tissue paper. Use paper clips to hold the papers together.

On a cutting mat, cut out the template through the tissue paper along the printed lines using a craft precision knife, scissors, and/or a paper hole punch interchangeably.

For the main silhouette and bigger shapes, scissors are preferrable. To cut small, narrow shapes, use a craft precision knife directly over a cutting mat. For any circles, use a hole punch to get a perfect circle!

After cutting the silhouette and the shapes outlined, gently remove the paper clips and unfold the tissue paper. Remove the template—there should be 4 tissue cutouts of the papel picado design.

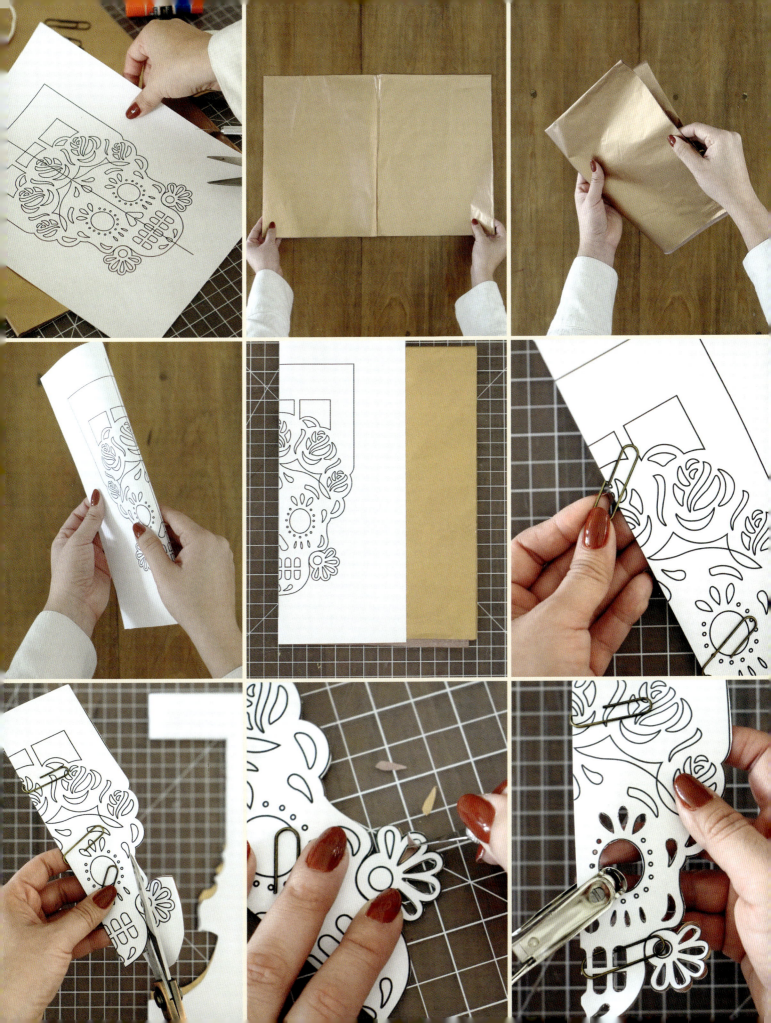

Repeat the same steps until there's enough papel picado for a garland. To make more at once, layer 2 or 3 sheets of tissue paper together at a time. If you're feeling creative, try improvising and cut your own patterns using the same folding steps.

To make it into a garland, space out your papel picado evenly across some craft twine. Attach the papel picado to the twine using one of these methods:

Method 1. Fold the top flap of the papel picado over the twine. Use glue to adhere the flap to the rest of the papel picado, concealing the twine.

Method 2. Punch holes toward the top of your design and slip your string through the holes. Tie a knot after a few of the holes in each piece to prevent the pieces from sliding.

For storage, fold and store your papel picado in a binder or storage container for reuse.

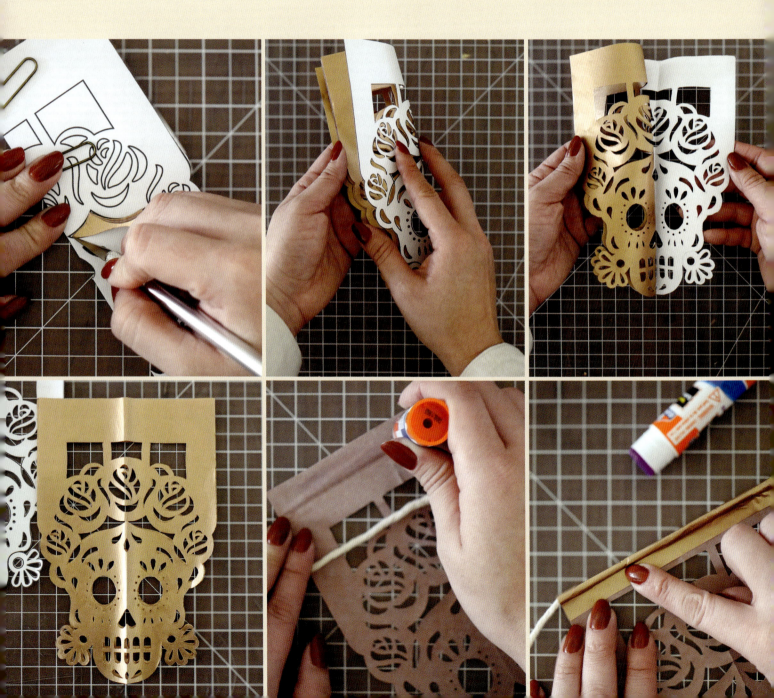

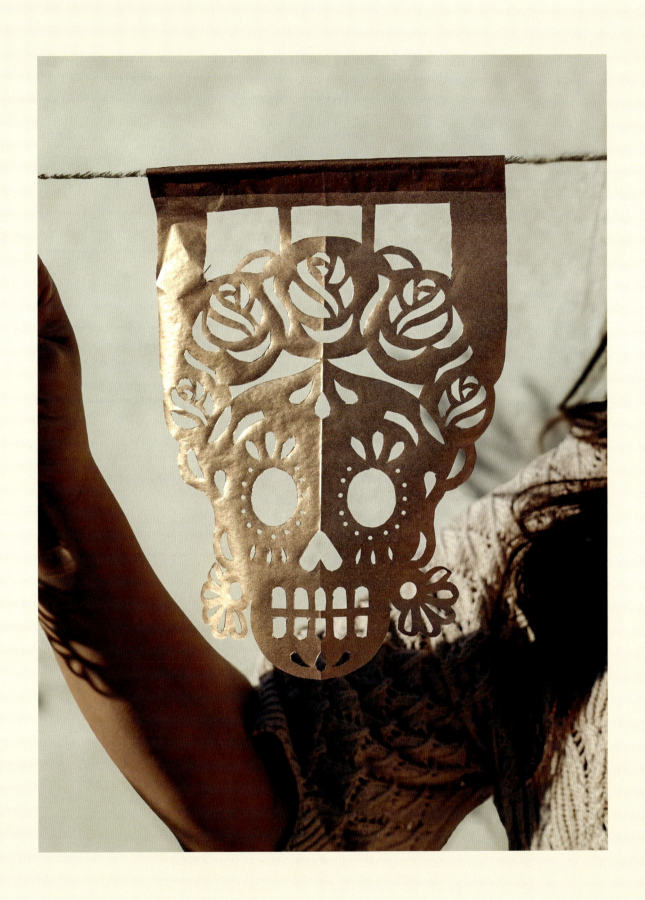

CALAVERITAS DE AZÚCAR (SUGAR SKULLS)

BY SARAHLI WILCOX

Makes 4 Sugar Skulls

Sugar skulls are a traditional, artisan craft made to represent the deceased, and they are used to decorate a Día de Muertos altar. Typically, the name of the person you're honoring is written across the sugar skull forehead. This activity is a great way to involve the entire family, and decorated skulls can be kept for years of altars to come.

SKULLS

6 cups (1.2 kg) granulated sugar
¼ cup (36 g) meringue powder
⅓ cup (80 ml) water
Medium (4¼ by 3½ inches / 11 by 9 cm) two-sided sugar skull mold
8 cardboard squares (large enough to hold half a sugar skull)

ASSEMBLY AND DECORATION

White ready-made royal icing (firm)
Food coloring
Florals, beads, sequins, feathers, or other decorative touches
Squeeze bottles with decorating tips

To form the skulls: In a large bowl, whisk the sugar and meringue powder together, then add the water and mix with your hands, making sure all the granules are evenly damp.

Squeeze a handful of the mixture in your hand; if it holds together, it's ready. The mixture should look crumbly and feel like damp sand but should not be super wet.

The sugar mix ratio must be exact. If it feels wet rather than damp, it will stick to the mold, and you'll have trouble pulling the skulls out. If you find your mixture is too wet, you can add more sugar or spread the mixture out on a cookie sheet to dry a bit. Check back in one-hour intervals.

Use a spoon to fill the mold with the sugar mixture, adding a bit at a time and compacting it into layers and smoothing it out as you go.

While filling your mold, the mixture should slide around a bit inside rather than stick to the sides if you have achieved the perfect texture.

Scrape off the excess sugar with the back of the spoon or use a cardboard square to level the skull inside the mold.

Place a cardboard square against the mold, press it to the skull, and flip the mold over onto the cardboard. Gently lift the mold—it should slide right off with a jiggle or two. Repeat the same steps for the next mold. You should end up with four front and four back pieces.

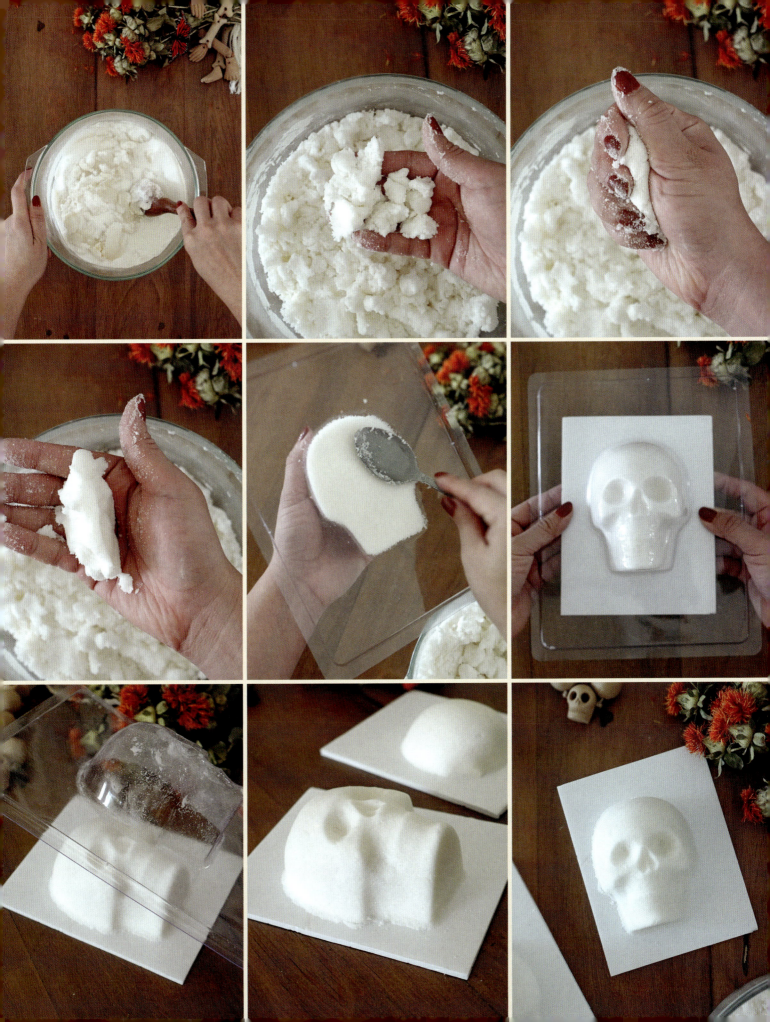

Be sure to rinse or wipe any excess sugar off of the mold after you demold your sugar skulls each time, then dry completely before making the next sugar skulls. Otherwise, the mixture may cling to the walls and pull chunks off your sugar skulls.

Let the skulls dry for 2 to 3 hours, then hollow out the backs with a spoon, leaving a ½- to 1-inch (1.3 to 2.5 cm) perimeter wall around the edges. This will help them dry faster, and they will be less heavy. You can use the excess for more sugar skulls; just add a few drops of water as needed to get back to the correct texture before using. Leave the skulls to dry overnight or place in the oven at 200°F (90°C) for 30 minutes to harden.

To assemble and decorate the skulls: In a small bowl, prepare the royal icing. Depending on firmness of the icing, you may need to add a bit of water— add ½ teaspoon at a time until the icing is the consistency of craft glue. Pour the royal icing into a squeeze bottle with a writer tip.

Once your sugar skulls are dry, attach the two sugar mold halves together with royal icing. Remove any excess icing with a damp towel. Once hardened, you can handle the skulls to decorate. Use a butter knife to gently scrape off the ridges where the two halves meet to smooth the skulls.

Dye your remaining royal icing in small batches using the food coloring.

Decorate your sugar skulls with the colorful royal icing, and use it as glue to attach other items like dried florals, beads, sequins, foil, rhinestones, feathers, etc.

Place your sugar skulls on your Día de Muertos altar and enjoy with family and friends.

These can last a few years stored in an airtight container in a cool, dry environment so you can reuse them year after year. Some of my oldest skulls are 4 years old, and the colors have faded a bit, making them look vintage. The white sugar will lean a bit yellow over time, but if stored under the correct conditions, they will last many years.

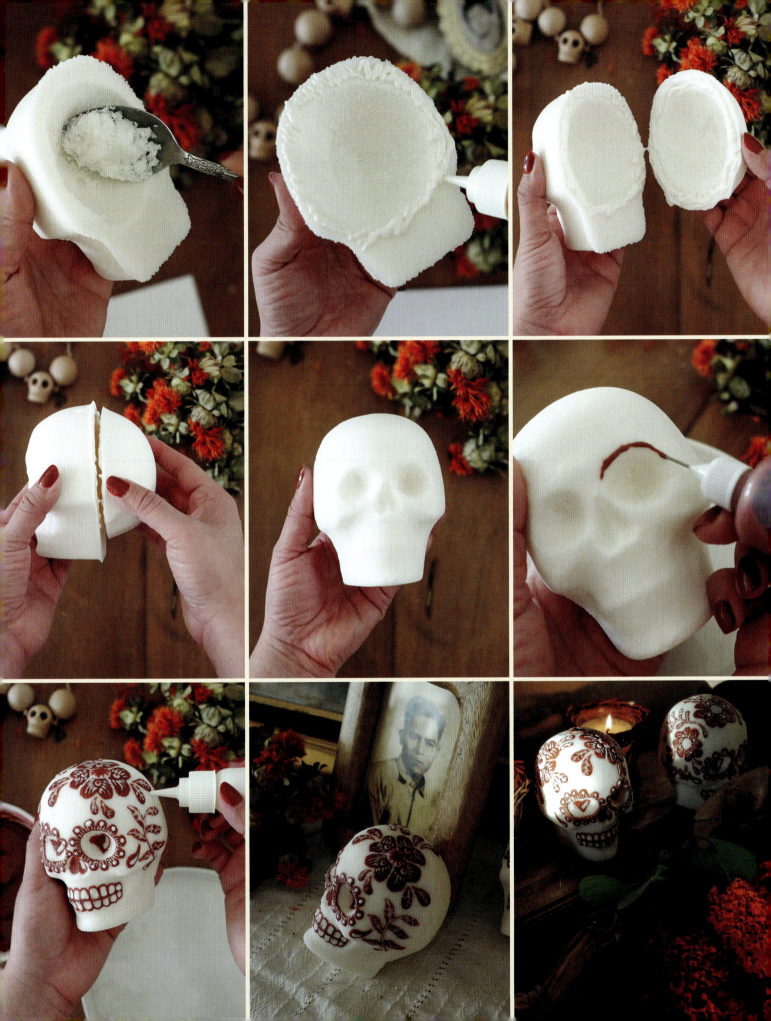

PAN DE MUERTO WITH CHARRED CORN HUSK

BY FANY GERSON

Makes 2 loaves

Pan de muerto is more than just a bread—it's a symbol of remembrance, tradition, and love. In Mexico, there are many different kinds of breads depending on the region and family customs. This type of pan de muerto is widely found in different parts of Mexico and is a personal favorite. The soft, fragrant loaf is often adorned with bone-shaped decorations and finished with melted butter and sugar. Here, we have the *totomoxtle* version (pictured on page 132), topped with burnt and ground corn husks. The totomoxtle adds a subtle earthiness and striking dark finish. To me, this bread symbolizes connection to the very essence of Mexican cuisine: corn.

BREAD

4 cups (480 g) bread flour, divided
⅔ cup (160 ml) milk, divided
1 tablespoon orange blossom water
¼ ounce (7 g) active dry yeast
½ cup (100 g) sugar
1¼ teaspoons kosher salt
1 teaspoon anise seed
1 teaspoon orange zest (optional)
3 large eggs plus 2 yolks, lightly beaten
1 cup (226 g) unsalted butter, room temperature (you can save the paper to grease the bowl, or just use cooking spray)

TOTOMOXTLE TOPPING (CHARRED CORN HUSK)

5 to 10 dried corn husks
¼ cup (50 g) sugar
Pinch salt
½ cup (113 g) unsalted butter

To make the bread: In a small bowl, combine ½ cup (60 g) of the flour, ⅓ cup (80 ml) of the milk, and the orange blossom water. Add the yeast and whisk well to combine (the dough should be sticky and smooth). Let sit in a warm place (about 70°F / 20°C) for 20 to 30 minutes, until it begins to bubble and puffs up slightly.

In the bowl of a stand mixer fitted with the hook attachment, mix the remaining 3½ cups (420 g) of flour, the sugar, salt, anise seed, and orange zest (if using) for about 30 seconds. Add the eggs, egg yolks, the remaining ⅓ cup (80 ml) of milk, and the yeast mixture. Mix on low until the dough starts to come together. Add the butter in small pieces while continuing to mix, then increase the speed to medium. The dough will look sticky but resist the temptation to add more flour. Continue to beat for 10 to 15 minutes, until the dough is soft and comes off the sides of the bowl and feels elastic. If the dough is still sticky after 15 minutes, add a little flour (no more than ⅓ cup / 40 g).

Lightly grease a large bowl. Transfer the dough to the bowl and cover with a towel. Let it rise in a warm place until it has doubled in size. Punch the dough down with your fist, gather the sides together, and flip it over so that the bottom is now the top. Cover with plastic wrap. Refrigerate for at least 4 hours or up to overnight.

Remove the dough from the refrigerator, uncover, and place a towel on top. Let it rise in a warm place for about 1 hour, until it comes to room temperature. Meanwhile, prepare the totomoxtle.

To make the totomoxtle: Dry the corn husks completely. To ensure they are absolutely dry, you can place them on a sheet pan inside an oven at 250°F (120°C) for about 5 minutes.

Put the dry husks in a large nonreactive pot and carefully apply a match or lighter (it's best to do this outside). Let them burn completely until they have dissolved. Once cooled, blend them into an even powder, sift out any remaining large pieces, and mix with the sugar and salt in a large bowl. Set aside. I like to make a large batch of this sugar as it's a lovely topping for many baked goods. Feel free to double or triple this recipe.

Separate out a piece of the dough, about the size of a large lime, by cutting, not pulling, to use for the decorative top. Divide the remaining dough in half and form into two loaves on a smooth, flat surface, making sure that the dough is tightly formed. Place on paper- or silicone-lined baking sheets. Flatten the tops lightly with the palm of your hand.

Take two gumball-sized pieces of the dough from the portion set aside for decorating and roll them into neat balls. Set aside on the baking sheets. Divide the remaining dough for the decoration into six "bones." Roll each bone out with your hands, from the center of the dough out, making strips that are about 1 inch (2.5 cm) longer than the width of the loaves. Press lightly with spread fingers, making knobs that resemble bones. Place three strips on top of one of the loaves, crossing them at the center. Repeat with the remaining strips on the other loaf, then cover lightly with a towel. Let sit in a warm place until doubled in size. To test if the dough has doubled, press lightly with your finger. It should slowly return to its original size.

Preheat the oven to 350°F (180°C).

Tap the bottom of the reserved gumball-sized dough balls with a little water and place them on the loaves where the bones meet. Bake for 40 to 50 minutes total, until the bread has a nice even golden color, then cover loosely with foil and continue to bake until an instant-read thermometer registers 190°F (88°C) and the bottom of the dough is browned. Transfer to a wire rack and let cool slightly.

Melt the butter in a small saucepan. Brush each loaf with the butter, making sure to brush all around the decorative tops.

Hold the bottom of a loaf (if it's too warm, use gloves or a piece of cardboard to hold it) and tilt the loaf around while sprinkling the totomoxtle on top to cover evenly. Let cool completely. Repeat with the remaining loaf.

ALTERNATE TOPPINGS:

Canela sugar: *Mix ½ cup (100 g) of sugar with 2 to 3 tablespoons of freshly ground cinnamon.*

Marigold sugar: *Mix 2 tablespoons of orange or tangerine zest and ½ cup (100 g) of sugar in a food processor and pulse. Mix with fresh marigold petals (make sure they aren't sprayed with pesticides).*

Sesame seeds: *Brush each loaf with egg yolk mixed with a touch of milk and top with sesame seeds before baking.*

In Mexico, Día de Muertos traditions differ greatly from household to household. For example, some families visit cemeteries at night, while others prepare altars and host dinner at home. And as Day of the Dead continues to grow in popularity, I've noticed that younger people are creating their own modern-day customs. In my own family, we have also started our own unique traditions, which I plan to pass down to my son, Luca, and his cousins, Kevin, Alex, Graham, Pierce, and Charlie, like the new tradition my grandfather, Tito Santiago (my son Luca's namesake) started. When I think about honoring these traditions in the future with my son, I get excited about teaching him how to prepare an altar, making sugar skulls, baking pan de muerto, and cooking my grandparents' favorite meals.

I hope that my son and his cousins will continue to celebrate Día de Muertos long after I am gone, no matter where they live or how much time has passed. I sincerely believe that if more of us make an effort to celebrate Day of the Dead with our children—whether it's reading books at home, building an altar, or making a relative's favorite meal—our traditions never have to die. I think it's beautiful to know that by staying committed to honoring our customs, our children can also learn to love and cherish the family members they never got the chance to meet.

By sharing my own family traditions with you, I hope you'll gain inspiration from them and develop your own unique customs, no matter where you live and how far removed you are from your ancestral homeland.

VISITING THE PANTEONES

As I stepped onto a small fishing boat in the dead of the night, I wondered whether these might be my final moments on Earth. I was already regretting my decision to visit the island of Janitzio at four o'clock in the morning.

When I was researching Lake Pátzcuaro in Michoacán during Day of the Dead, I came across images of candlelit boats decorated with fresh marigolds. But as soon as we got there, I realized those photographs had been AI-generated. I had been duped. Instead, it was pitch black, the freezing wind was blowing hard, and all I could see in the distance was the 130-foot-tall concrete statue of revolutionary hero José María Morelos. Even though the fisherman told us it would be a quick ten-minute ride, it felt like an eternity of worrying about our boat capsizing. I quietly thought to myself, *This is what I get for deciding to write a book about death.*

Christine, the photographer, laughed as I confessed my fears, and reminded me that there was nothing to worry about. Regardless, my mind continued to spiral. I started to envision the headlines: "BREAKING NEWS: American Journalists Go Missing in Mexico While Reporting on Day of the Dead." In truth, we were completely safe, and there really *was* nothing to worry about. But as we continued to travel in the middle of the night, the dark, quiet water and constant talk of death made me feel uneasy.

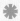

Despite the darkness during our travels, I felt at peace each time we visited the different panteones located around the state of Michoacán and on the islands in Lake Pátzcuaro. Once we were inside, I was always relieved to discover an enchanting world filled with hundreds of candles and fresh cempasúchil flowers. Although I had seen photos of the cemeteries before, none of them captured the feeling of being there in person.

The evening was crisp, and the sweet and spicy aroma of marigolds filled the air while families shared food and conversation. When I asked how long they planned on staying, many told me they would be there until 6 AM, while others said they would stay

even later to attend the noon Mass. Seeing them try to stay warm under their sombreros and wrapped in their wool ponchos, going on little to no sleep, made me realize how much they truly loved their relatives. Unlike accounts I had read, the cemeteries didn't feel like the site of a boisterous fiesta. Instead, they were quiet and peaceful, yet still as joyful in their way as any other celebratory gathering. While candles flickered, families exchanged memories and shared laughs; church bells rang in the near distance to welcome the spirits. I was curious to hear what the people were saying, but I dared not interrupt their one evening with their ancestors.

As we continued to visit other cemeteries in the towns of Arocutín, Tzurumútaro, and Tzintzuntzan I noticed that the tombstones were adorned with photographs of old and young, even some children. The babyish faces reminded me of how cruel and unfair life could be. Seeing their names depicted on the flower arches, I recalled the young marigold farmer in Copándaro who told me about his encounters with lost souls.

It's not unusual to hear stories from Mexicans who claim to have seen the dead. In fact, many locals who celebrate Day of the Dead believe that if you taste the food on an altar at the end of the evening, it will have no flavor: the relatives who have died have visited and enjoyed the feast that was prepared. I have not had this type of experience, but I am always looking for signs that my relatives are nearby. For instance, when I see monarch butterflies, I think of my grandmother Tita Susana, who taught me that each year they travel thousands of miles from Canada to her home state of Michoacán. The event is so extraordinary that the indigenous people have long believed the orange-and-black-winged insects are the souls of ancestors coming to visit for Día de Muertos. Skeptics might say these beliefs are a form of magical thinking, but it's not hard to be swept up in the fantasy when you think about all those millions of butterflies surviving the journey across North America every autumn.

Shortly before I left for Pátzcuaro, I spotted a garden full of monarch butterflies back home in Carroll Gardens. Seeing them flutter around a statue of the Virgin Mary located outside an abandoned brownstone made me wonder if I was hallucinating. I had never seen this many monarchs in Brooklyn. It didn't feel like a coincidence. I took it as a sign that my grandmother, who revered the Virgin, was giving me her blessing to visit her hometown and share her story. The next day, I ventured back to see if the monarchs were still there, but the magical messengers were gone, and I smiled, imagining my ancestors on their way to Michoacán.

*

When we arrived at the Island of Pacanda, locals were gathered at the cemetery singing songs in honor of Day of the Dead. As I took in the views of Lake Pátzcuaro at dawn, a sense of serenity and peace washed over me. I felt that my grandmother was nearby. But just like the brief visit of monarch butterflies back in New York, the moment was fleeting. As the sun rose and the magic of the spirit world disappeared, a tear rolled down my cheek.

Part of what makes death so hard is our uncertainty in what to believe. Some choose a bleak and pessimistic lens while others dream about paradise. I admit that sometimes I feel pessimistic and wonder whether I will ever get to see my relatives again. But I know that this fear—which haunted me on the fishing boat—does not necessarily confirm what life after death will be like. So instead of worrying about what awaits, I am hopeful that one day I will see Lila, Tita Susana, Tito Santiago, and Tito Carlos, and that our reunion will be just as captivating and inexplicable as the monarch butterfly migration. Until then, I will continue to look for signs that they are nearby and honor their memories by celebrating my love for them during Día de Muertos.

ETIQUETTE WHEN VISITING THE PANTEONES

While you will definitely see Catrina- and Catrín-style makeup all over the city, and you may choose to participate in having your own face painted, you should also be aware that locals consider it to be impolite to wear face paint inside of the cemeteries. So if you do choose to visit, consider washing it off beforehand.

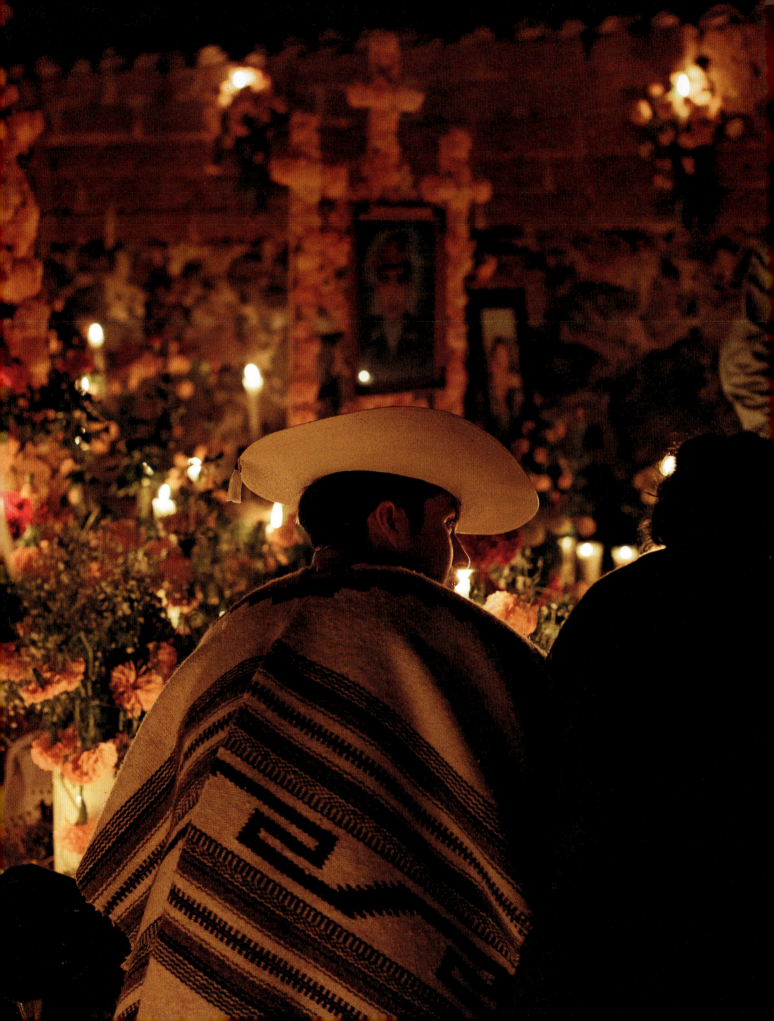

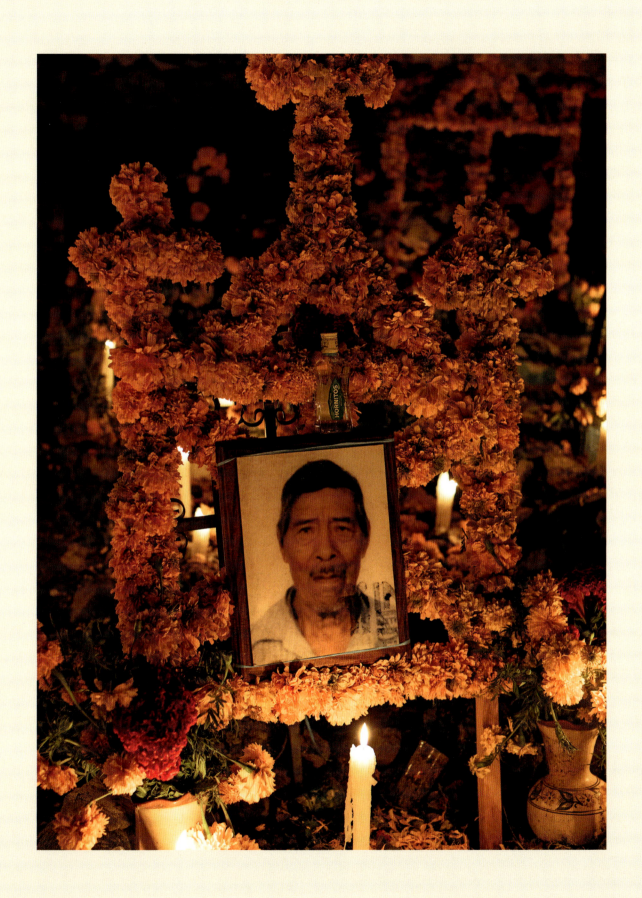

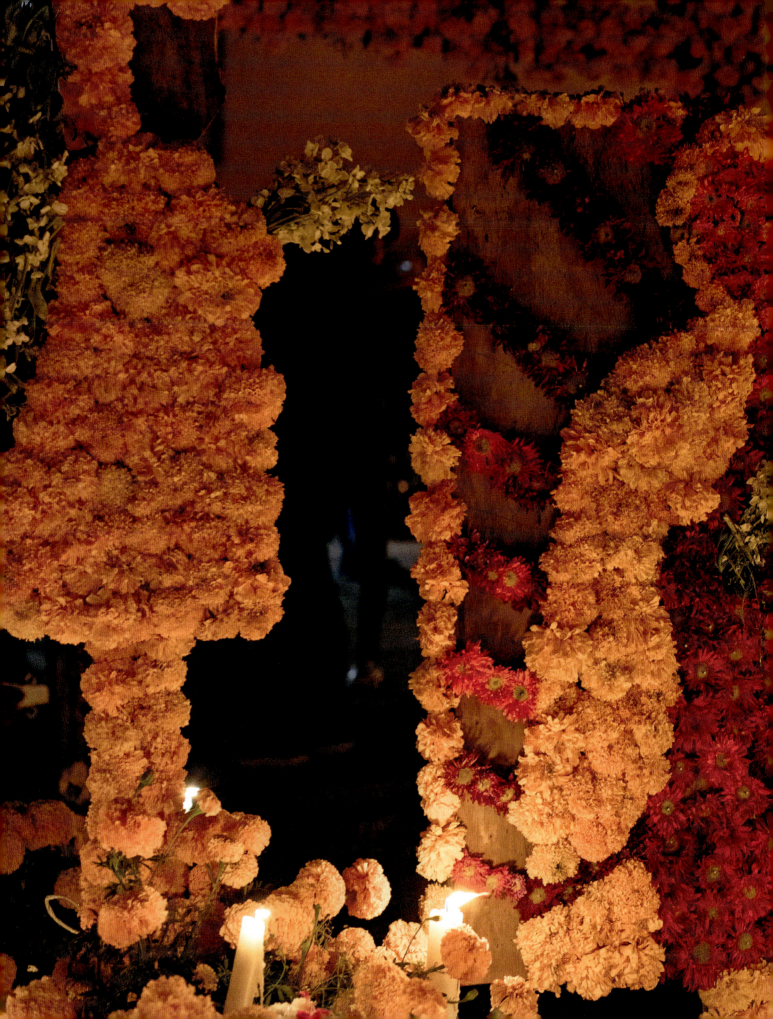

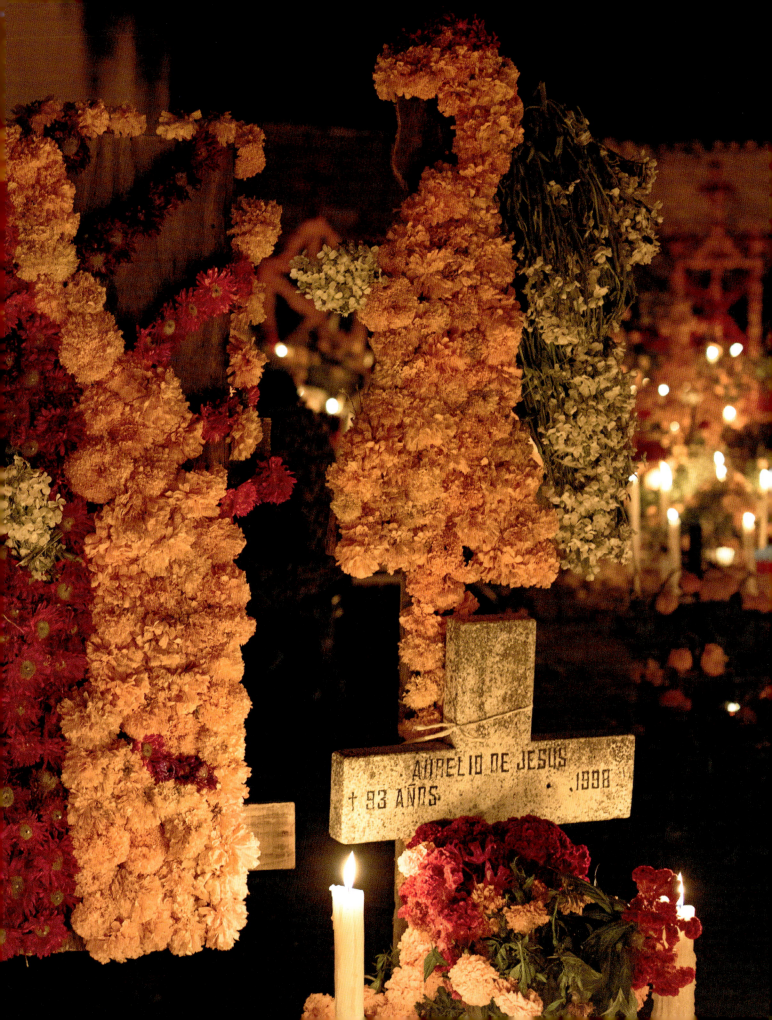

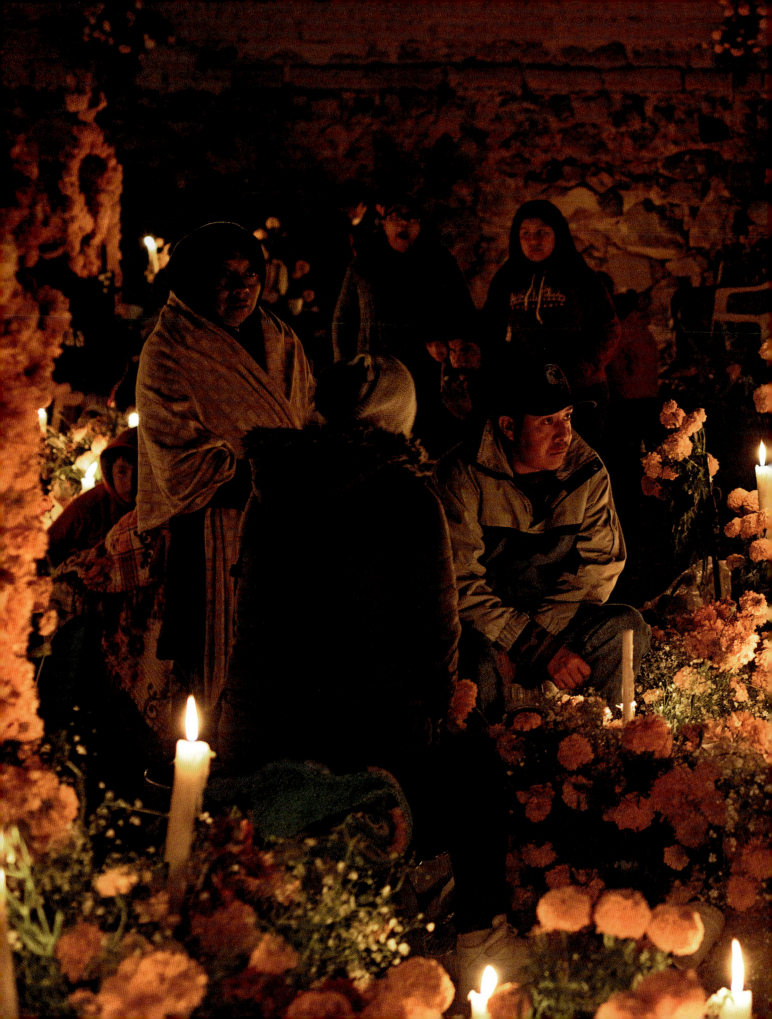

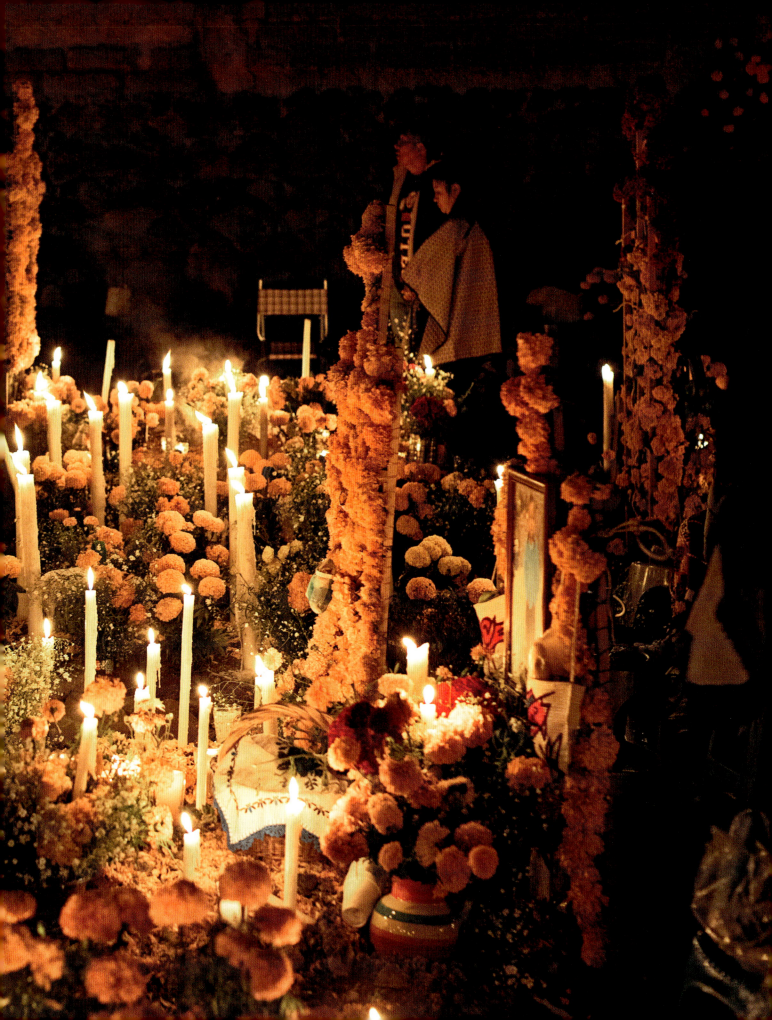

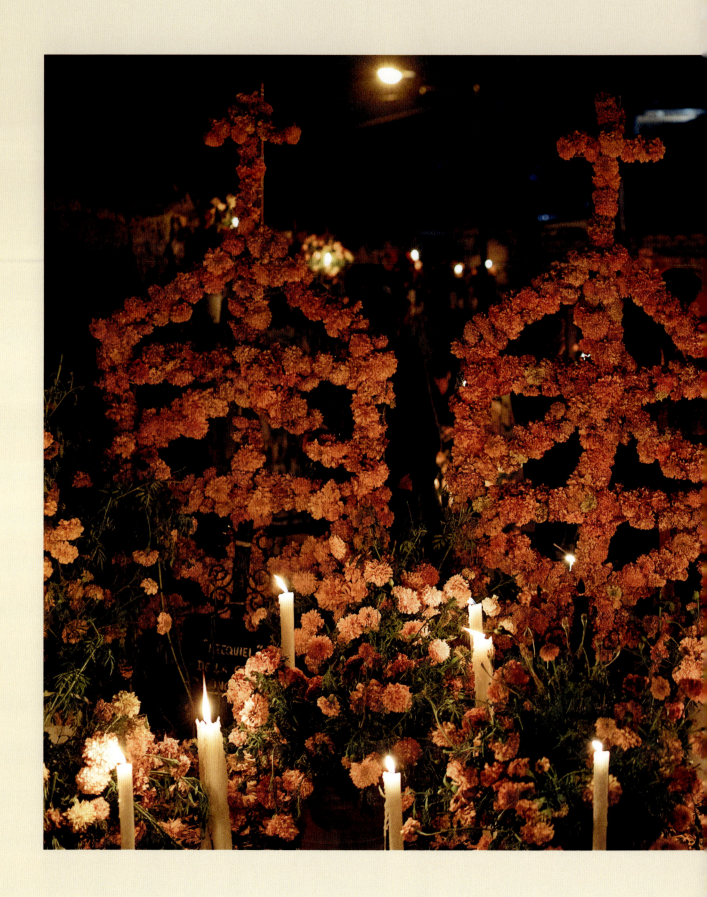

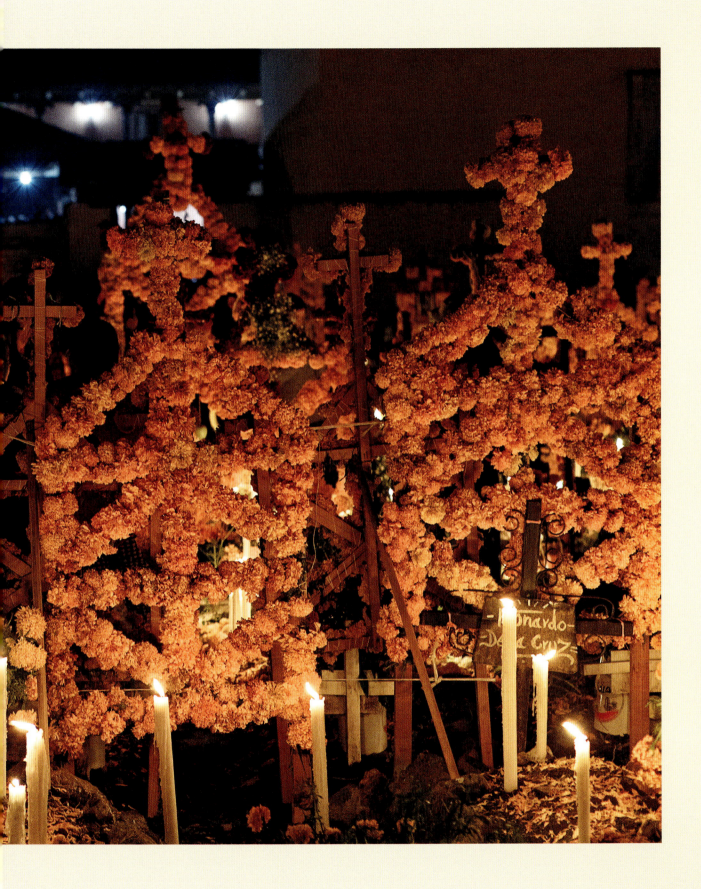

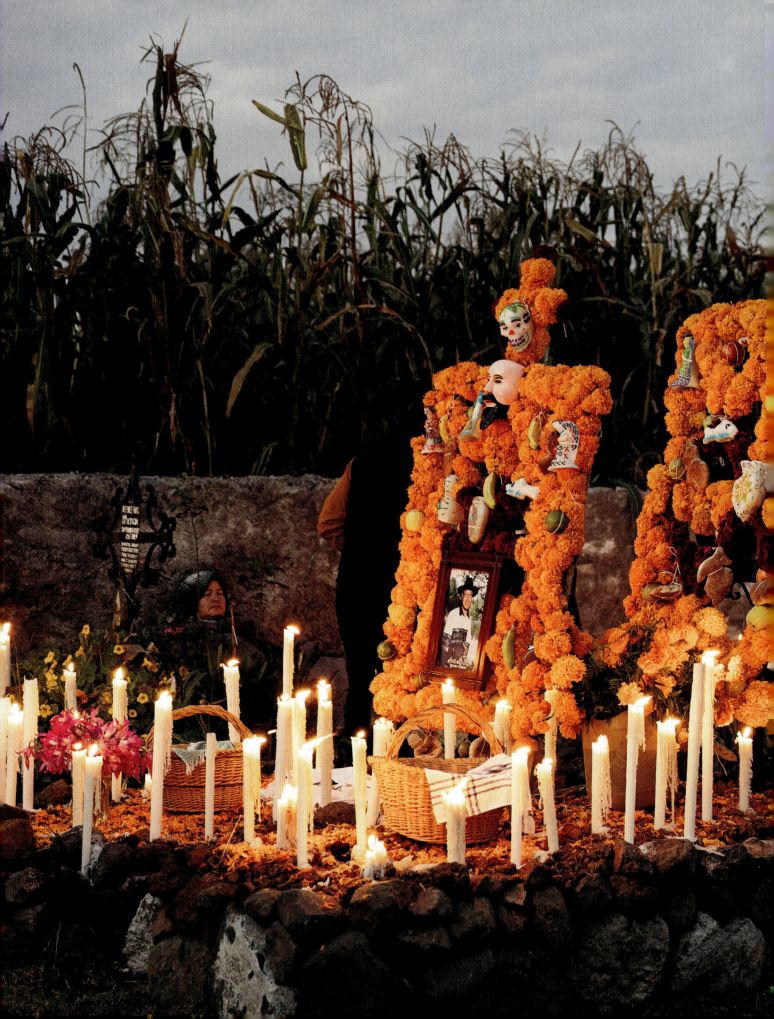

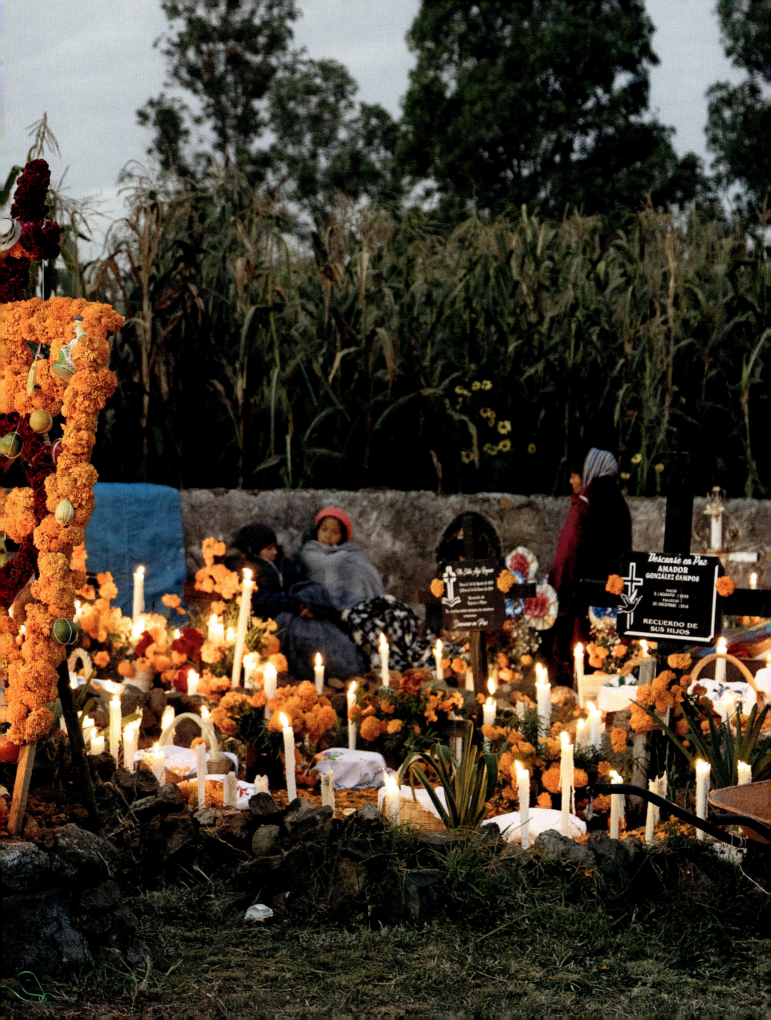

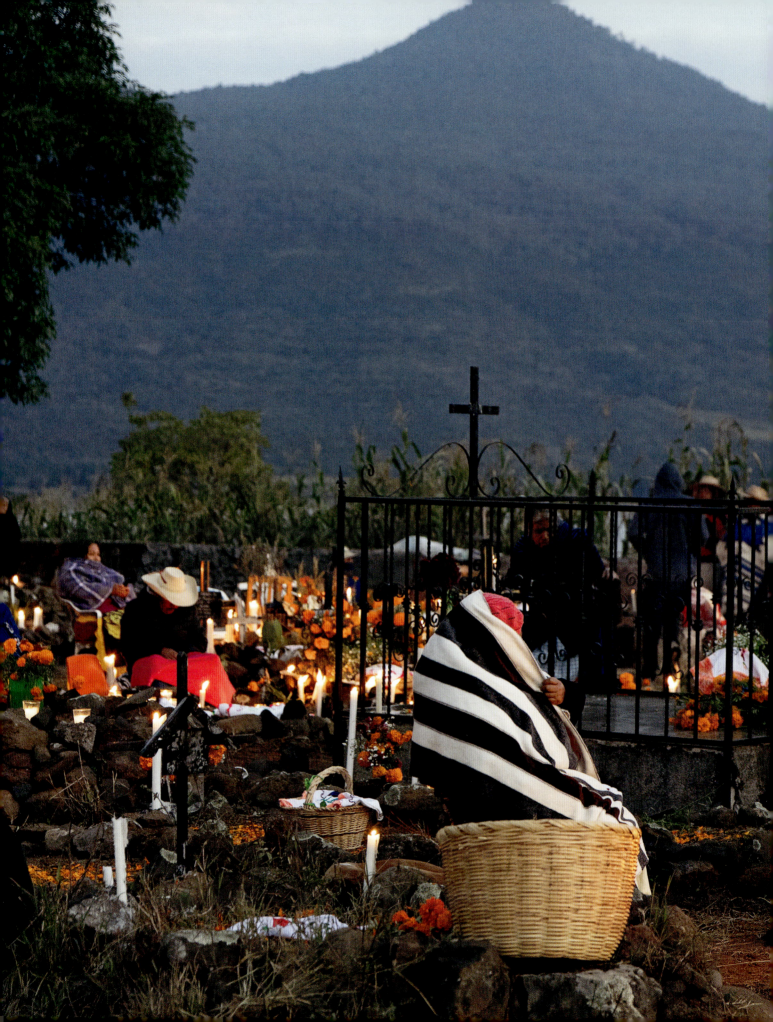

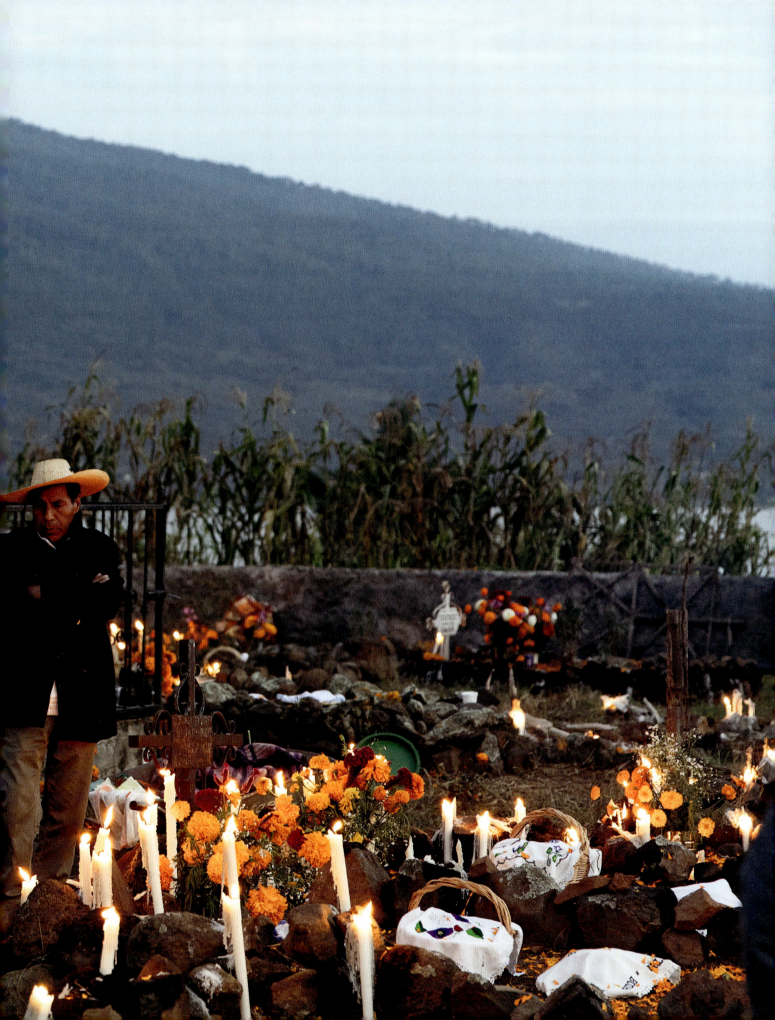

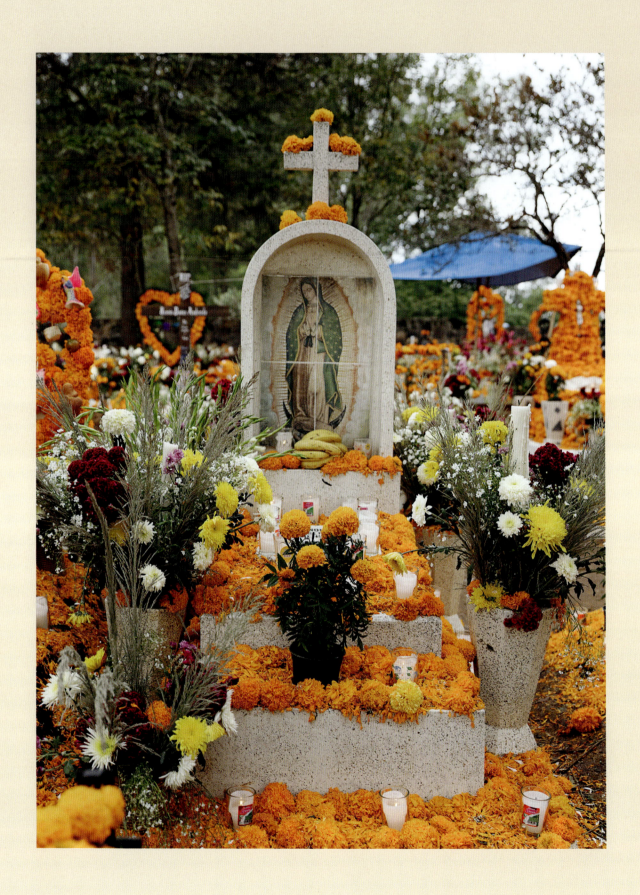

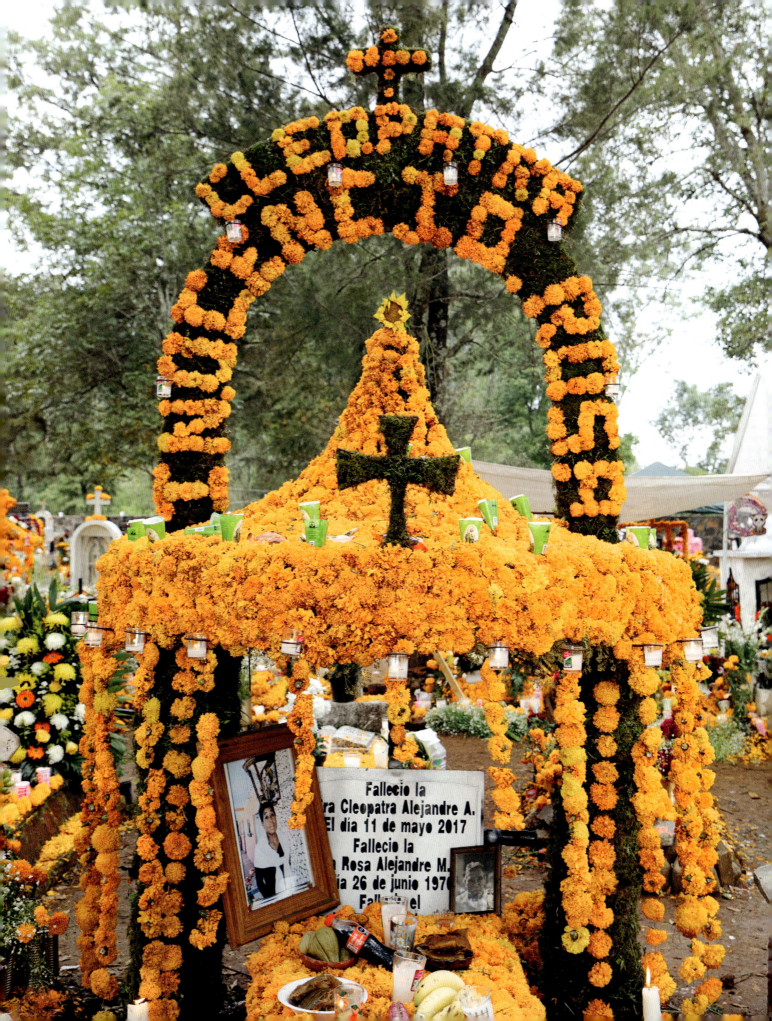

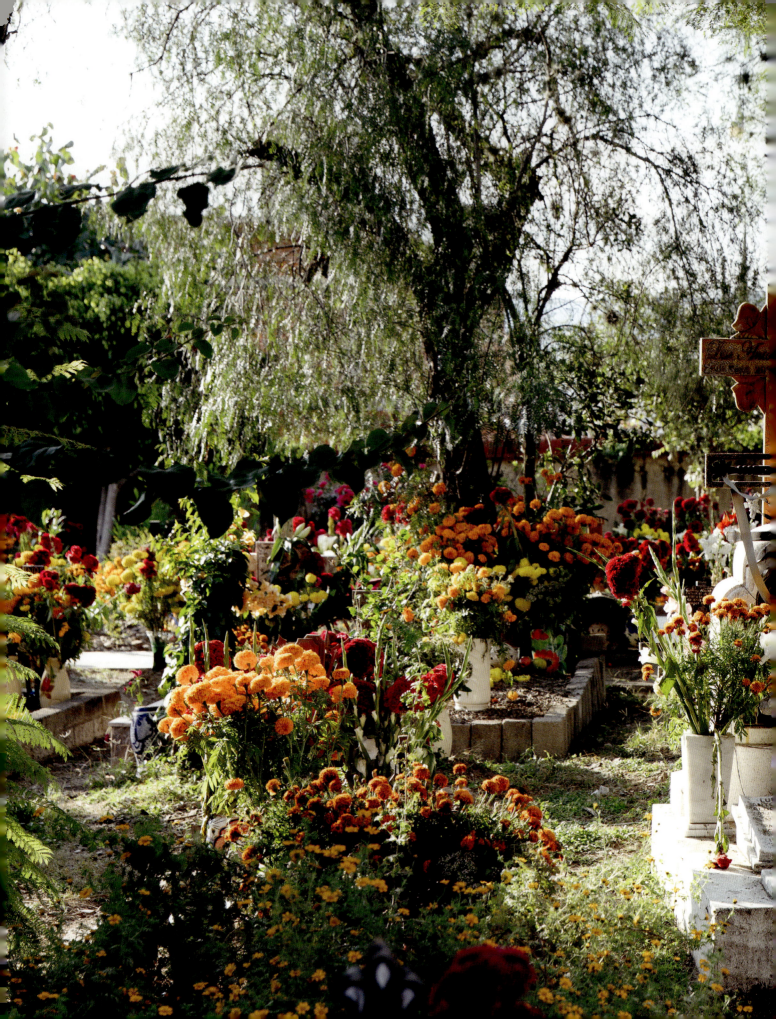

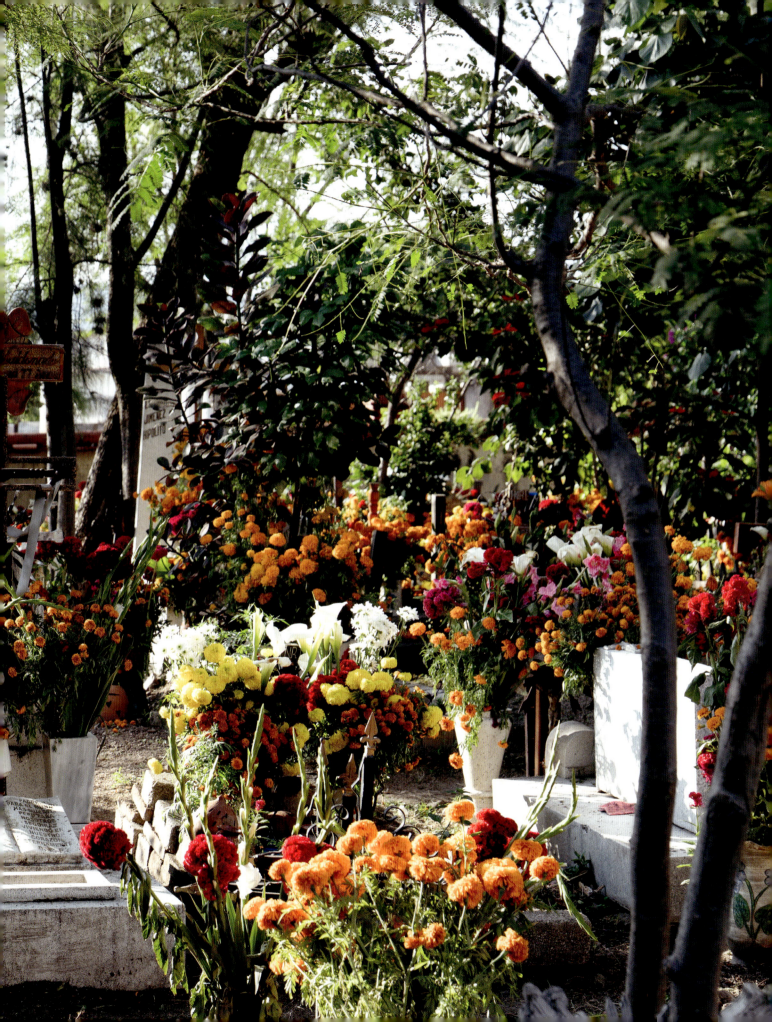

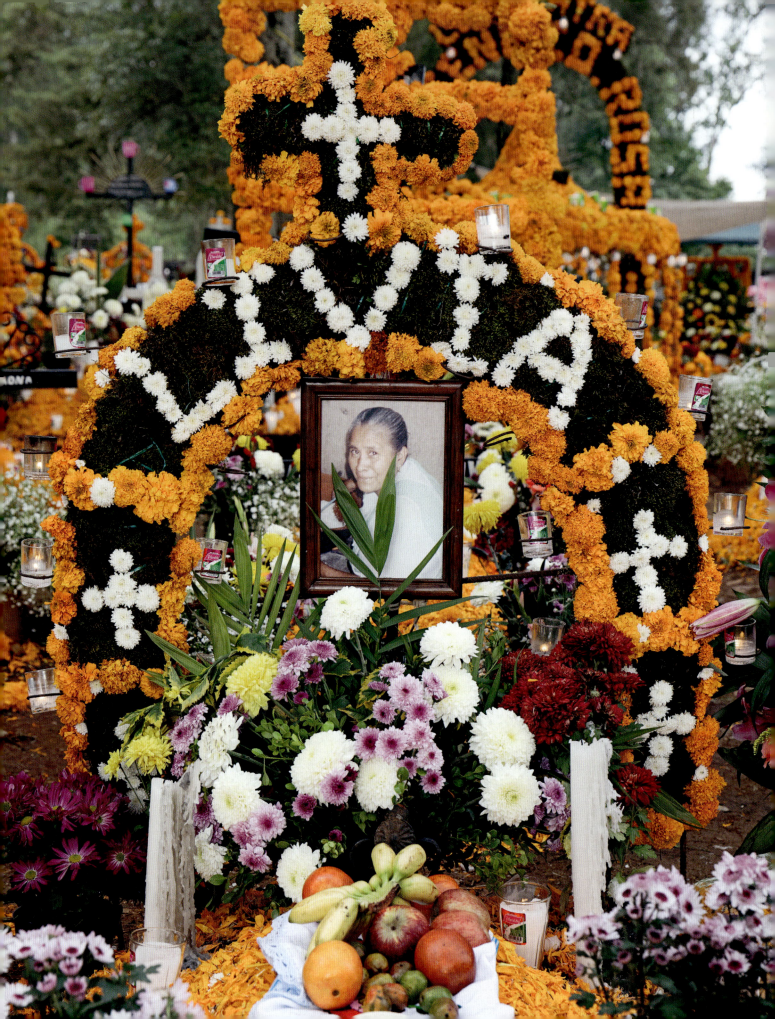

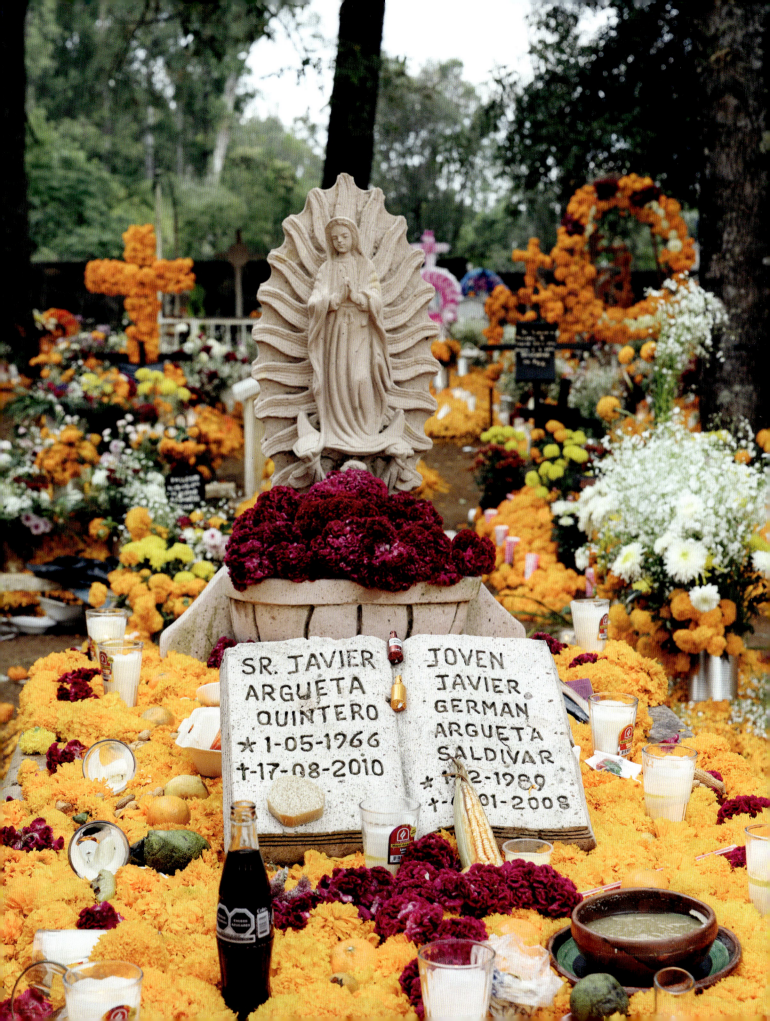

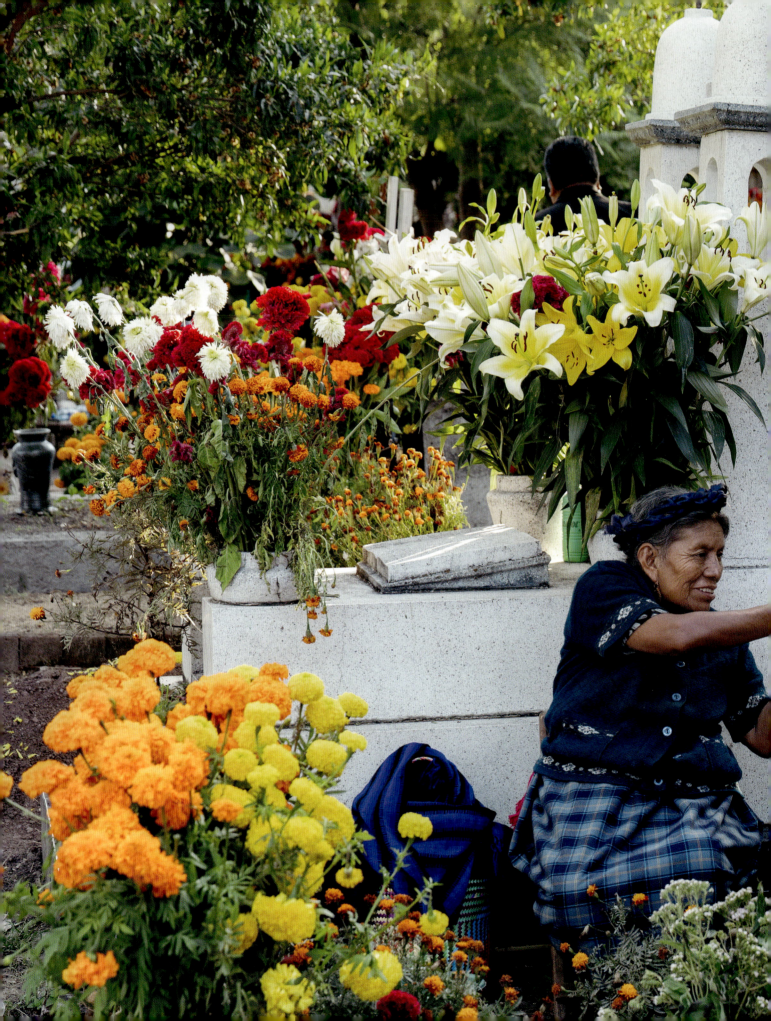

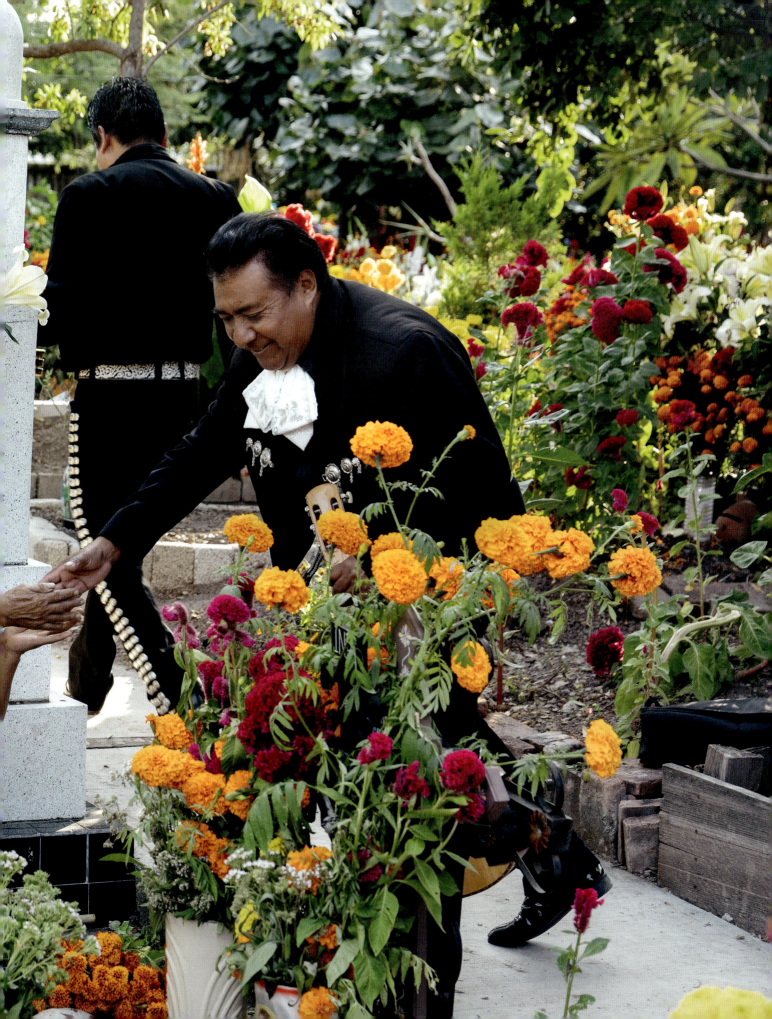

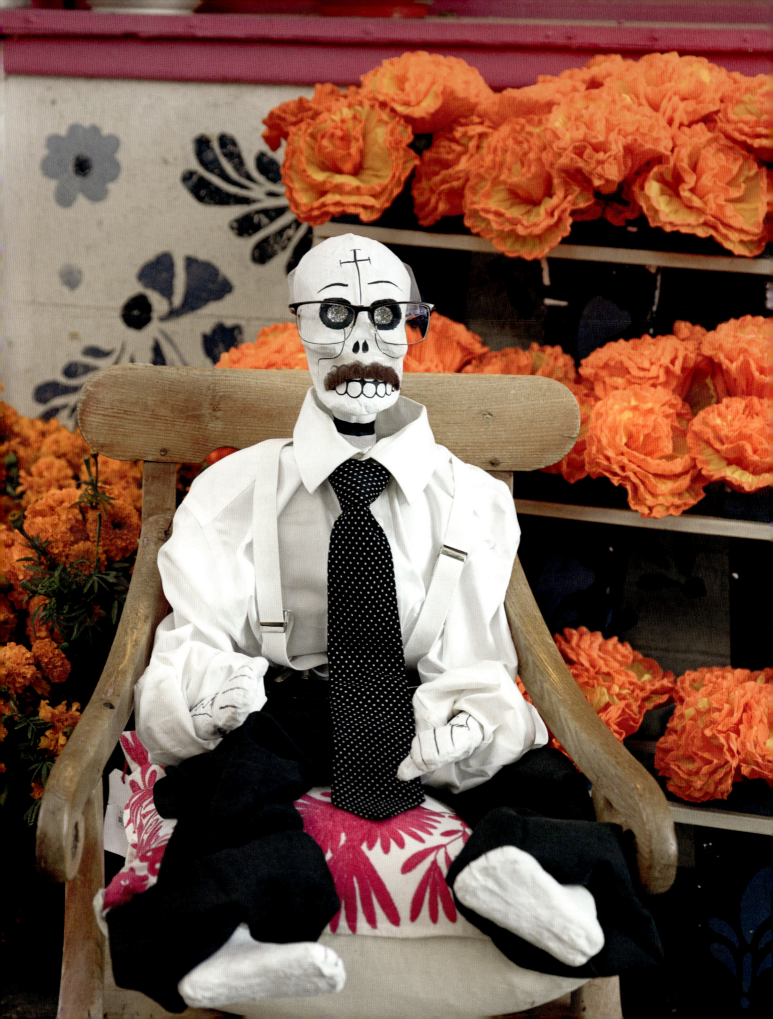

TITO SANTIAGO AND THE SKELETON

Every altar tells a unique story and grants a personal experience that nothing else can replicate. Even though I have seen many beautiful altars throughout the years, my favorite has always been my grandfather's.

During Day of the Dead, Tito Santiago would create an altar that honored the stories of our great-grandparents and ancestors. He filled each crevice with treasures from our family's past. My favorite artifacts were a wooden wall telephone from 1918 and an antique lamp from the 1870s. Even though Tito was an ophthalmologist, I think of him as a writer. In his later years, he used his free time to write a few books, including one about his father-in-law, Papá Pancho. He even saved relics that belonged to my great-grandfather, including his hat, cane, books, and typewriter. His conservation efforts came in handy one year when he surprised us by using the heirlooms to dress a papier-mâché skeleton as my Papá Pancho! It was delightful to see my great-grandfather, a lawyer and law professor, sitting at a desk, dressed in his own suit and tie, with his books and his typewriter.

I loved that Tito Santiago started this tradition because it was a clever way for the younger generations to learn more about our ancestors. Today, I remain inspired by the fact that Tito built these altars until he passed away at the age of ninety-five.

After Tito Santiago died, I decided to continue the tradition by dressing a papier-mâché skeleton in his memory. When I displayed the skeleton at my gift shop, customers got a kick out of it. And I know he would have loved it, too. I swear when I added a thick mustache and large eyeglasses to a dummy version of his skeleton, I could hear him chuckling along with me. As bizarre as it might seem to dress up a skeleton as your grandfather, I love that my culture has taught me to have a sense of humor when it comes to death. It's also comforting to know that in spite of the pain, it's okay to have a little fun in the process. Sometimes I even think of how spectacular it would be if my

future grandchildren decided to continue the tradition and dress up a papier-mâché skeleton as me!

In addition to teaching me to have a sense of humor, Tito also taught me that it is my responsibility to make sure that these family traditions continue. So no matter how tired or busy I might be, I always make sure I take the time to build a personal altar during Día de Muertos. Even though it has taken me years to learn all the traditions, I look forward to participating each time because I always learn something new about my ancestors, and I incorporate these stories and memories into my altar.

Of all the photographs I display each year, one of my favorites is of my other grandfather, Tito Carlos, and his cousin Benjamin, dressed as *charros* (Mexican cowboys) when they were little boys. The photo was taken in 1939 in Mexico City, and the photographer had to find a solution to the problem of both boys wanting to be the charro, despite the fact that there was only one costume. Luckily, since they were the same age and size, it fit both of them, allowing the photographer to take separate photographs and combine the images after developing them. Knowing that this photo was a product of proto-photoshopping makes me laugh. As I've continued to build my altar and collect family archives, I've also managed to obtain copies of photos from my great-grandparents' and grandparents' weddings. I love to sit with their images by the altar's candlelight and imagine what those celebrations would have been like.

Collecting all of these artifacts and stories has led me to wonder about generations further back in my family. Sadly, I don't know too much, but I feel fortunate to have discovered that my great-great-grandfather Francisco Fuentes Fragoso was a journalist, newspaper editor, and entrepreneur. During the early twentieth century, he was in charge of the printing press for the state of Coahuila, he was the editor of Saltillo's biweekly newspaper, *El Siglo XX*, and he created his own printing business, Imprenta Libre (free printing press), during the repressive Porfirio presidency, which censored freedom of speech and issued threats of violence directed at newspapers and reporters. Unfortunately, his machinery was confiscated by the government during the Mexican revolution because they feared what he could publish.

Eventually, Fragoso was invited by the president of Mexico, Venustiano Carranza, to move to Mexico City and lead the printing press for the federal government, for which he chose a name. Today, this public organization still exists under the same name, *Talleres*

Gráficos de la Nación, and it produces annual reports, books, magazines, newspapers, and brochures. As a journalist myself, I proudly add his picture to my altar every year and share with others that he was my great-great-grandfather, the trailblazing journalist who got his original printing press seized by the Mexican government!

In addition to photographs, I also enjoy placing personal items on my altar. For example, for my cousin Lila, I always choose to display her favorite seashell necklace.

To outsiders, these little artifacts may hold no meaning, but for me, they carry memories that transport me back in time to when my loved ones were alive.

If you decide to build an altar, I recommend gathering family memorabilia and saving trinkets each year, then displaying them on your altar to help keep the magic of your relatives alive. I admit that gathering all of these relics can feel overwhelming. So if you feel stressed about the process, remember that the goal isn't to create something perfect but rather to focus on building something meaningful for your family.

My own altar began quite simply and has become more intricate over time. Gradually, as I continue to ask more questions, I manage to learn more through the process of collecting family keepsakes and images.

After grieving the loss of Lila for so many years, I am grateful that my culture can revive my spirit by giving me an opportunity to talk about my relatives. I used to feel depressed knowing that over time Lila's memory would eventually be forgotten. But I have learned that it is my responsibility to keep her spirit alive, and I worry less about making people uncomfortable when I talk about her death.

Mostly, I feel grateful that Día de Muertos has given me an outlet to share stories about my loved ones who are no longer with us. The best part is people actually want to hear it! Of course, sometimes I shed tears during the process, but I also smile knowing that every single time I am building a visual representation of my love for my family.

This is why, no matter how busy life gets, I'm committed to honoring Tito Santiago's tradition of building an altar that tells the story of our family. And even though it took him time to prepare, I am so happy that he spent that time so I could learn about relatives like Papá Pancho.

Now that Tito Santiago is a part of my altar, I think fondly about the fact that one day my own grandchild could also learn the story of one of the greatest men I have ever known. Perhaps Tito Santiago will even make another appearance as a papier-mâché skeleton—I know he would love that!

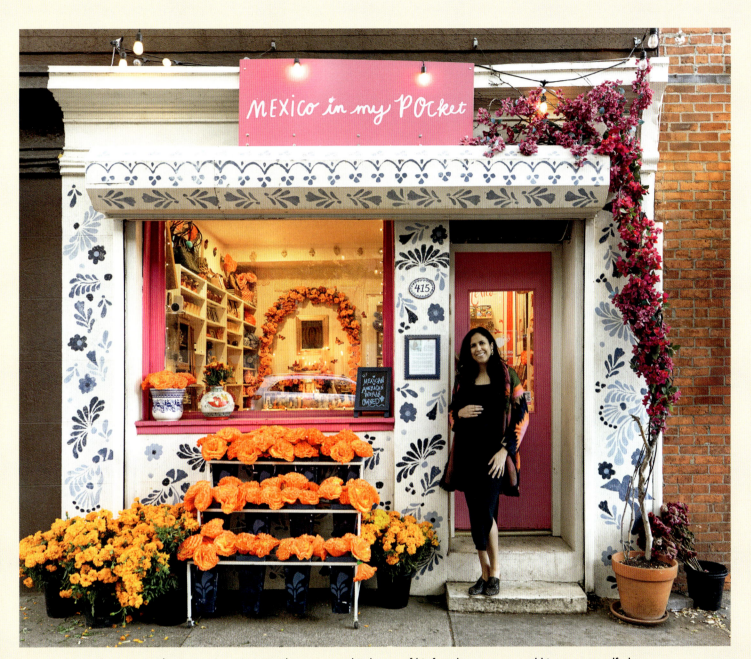
Pregnant with my son, Luca James, who we named in honor of his female ancestors and his great-grandfather.

INDEX

A
Acosta, Rumaldo, 93
Alávez, Viviana, 79
alebrijes, 74–75
altars. *See also* ofrendas
 for babies, 182
 creating your own, 178–79, 181–82, 229
 elements of, 66–67, 74–75, 84–85, 105–6, 113–14, 120–22
 ofrendas vs., 49
 seven-tier, 181
 taking down, 183
 three-tier, 179
 two-tier, 179
arches, 74
ash, on the altar, 84
Aztecs, 24–25, 28–29, 105, 121–22

B
babies, altars for, 182
bienvenida, 49
butterflies, 105–6, 204–5

C
La Calavera Garbancera, 28–29
Calle, Ramón Garcia, 130
candles, 75
Carranza, Venustiano, 228
La Catrina, 28, 29, 151, 190, 205
cemeteries, visiting, 161, 203–5
chair, empty, 84
Codex Telleriano-Remensis, 25
colors, significance of, 150–51
copal, 75
Cortés, Hernán, 25, 29

D
Day of the Dead (Día de Muertos)
 calendar for, 188–89
 colors of, 150–51
 Halloween vs., 21, 29, 150
 history of, 24–25, 28–29
 home celebrations of, 187, 201
 meaning of, 21, 23–24
 in Michoacán, 159–62, 203–5
 non-Mexicans celebrating, 24
 traditions for celebrating, 66, 201
death
 fear of, 23
 goddess of, 24–25, 29
 talking about, 45–47
 universality of, 21
Día de Muertos. *See* Day of the Dead
Díaz, Porfirio, 28, 29, 228
dirt, on the altar, 84
drinks, on the altar, 105
Durán, Diego, 25, 28

F
flowers, 84–85
food, on the altar, 105, 181
Fragoso, Francisco Fuentes, 228–29

G
Gerson, Fany, 187, 198
Guadalupana, 120
guests, welcoming, 49

H
horses, wooden, 160
hummingbirds, 105

J
Jesus, 150, 181
Juárez, Benito, 29

K
Kahlo, Frida, 24, 29, 75, 114, 122

L
Lewis, C. S., 46
Linares, Pedro, 74–75
Luna Family Farm, 85

M
mariachi bands, 162
marigolds, 84–85
Mayans, 105
Melgarejo, Arturo Ceja, 130
Miccaihuitl, 25, 28
Miccailhuitontli, 25, 28
Mictēcacihuātl, 24–25, 29
Mictlāntēcutli, 24
monarch butterflies, 106, 204–5
Morelos, José María, 203

O
ofrenda baskets, 159–60
ofrendas. *See also* altars
 altars vs., 49
 elements of, 66–67, 74–75, 84–85, 105–6, 113–14, 120–22
 meaning of, 49

P

palo santo, 106
pan de muerto, 106, 128, 130–31, 181
 with charred corn husk, 198–99
panteones, visiting, 161, 203–5
papel picado, 113, 190–92
personal items, on the altar, 113, 229
photographs, on the altar, 113, 181, 183, 228–29
Posada, José Guadalupe, 28–29

R

religious items, 114
Rivera, Diego, 29, 75, 114, 122
Rodriguez, Leo Dante, 92
rugs, 114
Ruiz, Elizabeth Santiago, 76

S

Sahagún, Bernardino de, 25
saints, 114, 181
salt, 114, 181
skeletons
 La Calavera Garbancera, 28–29
 La Catrina, 28, 29, 151, 190, 205
 dressing up, 227–28
 meaning of, 29, 66, 114
Stephens, John Lloyd, 120–21
sugar skulls, 120–21, 194–96

T

tablecloth, for the altar, 121
Tellez, Hugo Cesar Juarez, 130–31

V

La Virgen de Guadalupe, 28, 114, 181

W

water, on the altar, 121, 181
Wilcox, Sarahli, 187, 190, 194

X

Xoloitzcuintle (Mexican spirit dog), 122, 160

ACKNOWLEDGMENTS

Richard, from Boston College to Columbia Journalism School to living in New York City, the last thirteen years with you by my side have been filled with countless adventures. You have stuck with me through thick and thin, and you have always encouraged me to solo-travel to Mexico, launch my own business, and write this book. Thank you for staying up late with me when I needed to meet a deadline. You are the best life partner I could have ever asked for, and I love you with all my heart.

Luca, my little miracle, you were the best news I received while writing this book. Traveling to Oaxaca together (you were in my belly!) inspired me to take this book to the next level for future generations. I can't wait to teach you Spanish and celebrate Día de Muertos with you. I love you more than you will ever know.

Mom and Dad, this book would not have been possible without your dedication and commitment to teaching us about our Mexican culture at home. From teaching me Spanish, to making homemade Mexican meals, and taking us on beautiful vacations all over the country—my love for being Mexican started at a very young age because of you. Thank you for your unconditional love and sacrifice.

Christine Chitnis, I can't thank you enough for believing in this book and for introducing me to the right people to make it happen. As if that wasn't enough, I am so grateful that you also said yes to photographing this project. Your editorial eye and dedication to detail are unmatched and beautifully reflected in each of these pages. Thanks to women like you, who open doors for other women, more diverse stories are getting told. I promise to pay it forward.

Alison Fargis, thank you for fiercely believing in this project from day one. I won the lottery gaining you as an agent and am so grateful for your commitment to represent minority voices and stories in the publishing world.

Jenny Wapner, I'll never forget the first day we met and how passionate you were about helping me shed light on Day of the Dead in an authentic and respectful way. I am so grateful that you believed in this book and took a chance on it. Thanks to editors like yourself, who care deeply about cultural reporting, the world is gaining access to a more genuine perspective. I feel so lucky to say that "Mexico's Day of the Dead" is a Jenny Wapner book.

Maria Reynoso, mi hermanita and right hand, thank you for taking care of the shop—no questions asked—when I needed to travel and pull all-nighters for last minute deadlines. You might not realize it, but your encouragement and support along the way is one of the reasons this book exists.

Sam González and Ruben Vásquez, thank you for accompanying us during our travels and for helping us access an authentic look at Día de Muertos celebrations. Without your guidance, we would not have been able to capture the interviews and photographs that we did.

Deborah López García, Sandra Trujillo Juarez, Liliana Ruiz López, Jose Carlos Matadamas, Julissa Vásquez Jiménez, and Rey David Vásquez Jiménez, I can't thank you enough for always being there for me when I had questions or needed clarification about a particular Day of the Dead topic. Thanks to you, I was able to give readers a more nuanced and accurate look at these indigenous celebrations.

Cecilia Iñiguez, thank you for allowing us to spend time with your family during Día de Muertos in Cuanajo. Thanks to you, I was able to gain a more authentic perspective and greater insight into the history of these indigenous traditions.

Fany Gerson and Sarahli Wilcox, I am so grateful for your contributions to this book. Thanks to you, we were able to share Day of the Dead recipes and traditions with readers at home who may never get the chance to travel to Mexico.

Lizzie Allen, Mónica Lara, and Natalia Auza, thank you for understanding my unique vision for this project. I appreciate your patience as we went back and forth to ensure that the designs accurately reflected the beauty of this indigenous custom. I am forever grateful for your expertise and dedication to perfect each unique detail.

The Hardie Grant team—Clancy Drake, Natalie Lundgren, Carolyn Insley, Louise Newlands, and Liz Correll—thank you for all the hours you poured into creating and promoting this beautiful project. I feel so lucky to be a part of the Hardie Grant family.

Lastly, I hope this book inspires Mexicans, of all generations, to never lose sight of their ancestral roots and to always be in awe of our beautiful culture.

BIBLIOGRAPHY

Artes de México. 2002. *Día de muertos: Serenidad ritual / Day of the Dead: Ritual Serenity* (Artes de México #62, bilingual ed.). Mexico City: Artes de México.

Beimler, R.R., and J. Greenleigh. 1991. *The Days of the Dead / Los Días de Muertos: Mexico's Festival of Communion with the Departed / Un festival de comunión con los muertos en México*. 1st ed. San Francisco, CA: Collins Publishers.

Carmichael, E., and C. Sayer. 1992. *The Skeleton at the Feast: The Day of the Dead in Mexico*. New York, NY: University of Texas Press.

Chávez Balderas, X., L. Cue, and others. 2009. *Muerte Azteca-Mexica* (Artes de México #96, bilingual ed.). Mexico City: Artes de México.

Defibaugh, D., and W.S. Albro. 2007. *Day of the Dead: Día de Muertos*. Rochester, NY: University of Texas Press.

El Universal, n.d. "¿Quién fue Mictecacihuatl, la llamada Señora de la Muerte y Reina del Mictlán en el Mundo Mexica?" *El Universal*. https://www.eluniversal.com.mx/cultura/quien-fue-mictecacihuatl-la-llamada-senora-de-la-muerte-y-reina-del-mictlan-en-el-mundo-mexica/.

Embajada de México en el Vaticano. n.d. "Cartas del embajador: Así era Porfirio Díaz." https://embamex.sre.gob.mx/vaticano/index.php/noticias/416-cartas-del-embajador-asi-era-porfirio-diaz.

Glasstire. 2019. "José Guadalupe Posada and Diego Rivera Fashion Catrina: From Sellout to National Icon (and Back Again)." *Glasstire*. November 2, 2019. https://glasstire.com/2019/11/02/jose-guadalupe-posada-and-diego-rivera-fashion-catrina-from-sellout-to-national-icon-and-back-again/.

Gobierno de México. n.d. *Mictlán, un relato sobre la muerte* [Libro electrónico]. https://www.gob.mx/inpi/articulos/mictlan-un-relato-sobre-la-muerte-libro-electronico?idiom=es.

Instituto de México en Washington, D.C. n.d. *El Camino a Mictlán*. https://instituteofmexicodc.org/wp-content/uploads/2020/10/EL-CAMINO-A-MICTLAN-BANNER-converted.pdf.

Instituto Nacional de Antropología e Historia (INAH). n.d. *Mictlantecuhtli, Señor del Inframundo*. https://www.inah.gob.mx/foto-del-dia/mictlantecuhtli-senor-del-inframundo.

National Geographic Español. n.d. "¿Qué es un catrín? Del porfiriato a la lotería." *National Geographic Español*. https://www.ngenespanol.com/el-mundo/que-es-un-catrin-porfiriato-loteria/.

Posada, J.G., and J. Rothenstein, eds. 1989. J.G. *Posada: Messenger of Mortality*. London: Redstone Press.

Stephens, J.L. 1843. *Incidents of Travel in Yucatan*. 2 vols. New York: Harper Bros.

Vanguardia. n.d. "Relatos y retratos de Saltillo: Francisco Fuentes Fragoso, periodista, impresor y promotor." *Vanguardia*. https://vanguardia.com.mx/coahuila/saltillo/relatos-y-retratos-de-saltillo-francisco-fuentes-fragoso-periodista-impresor-y-promotor-BSVG3573112.

Villoro, J., M. López, H. Bonilla, M. Gali, and R. Barajas, eds. n.d. *Posada: A Century of Skeletons*.

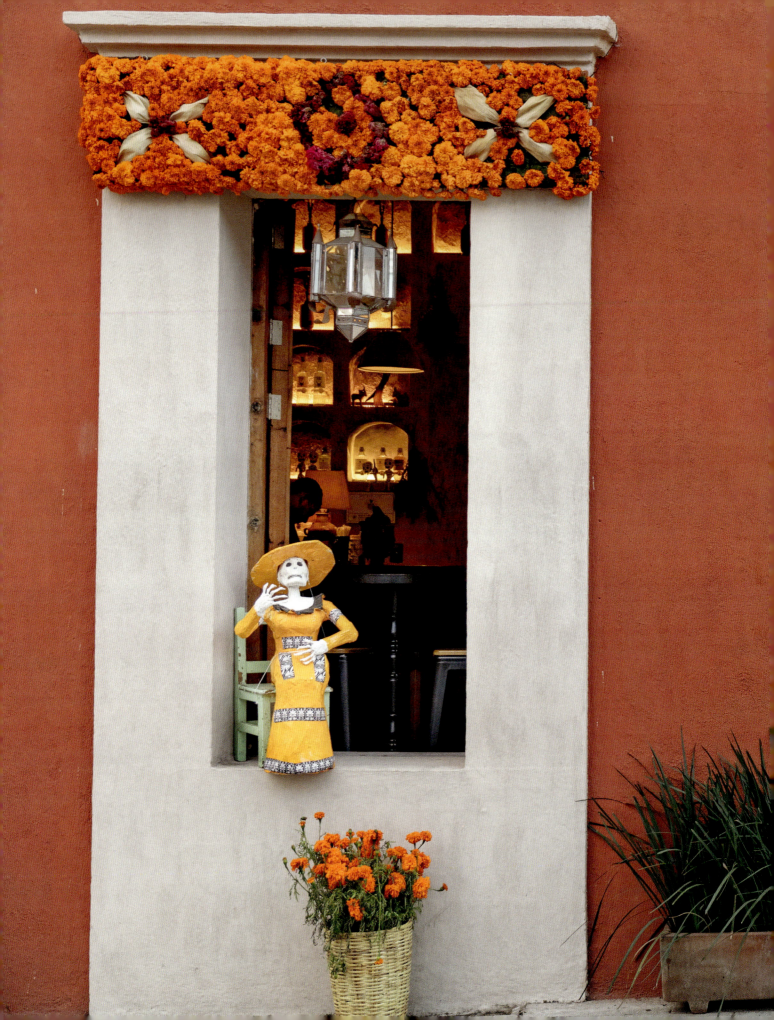

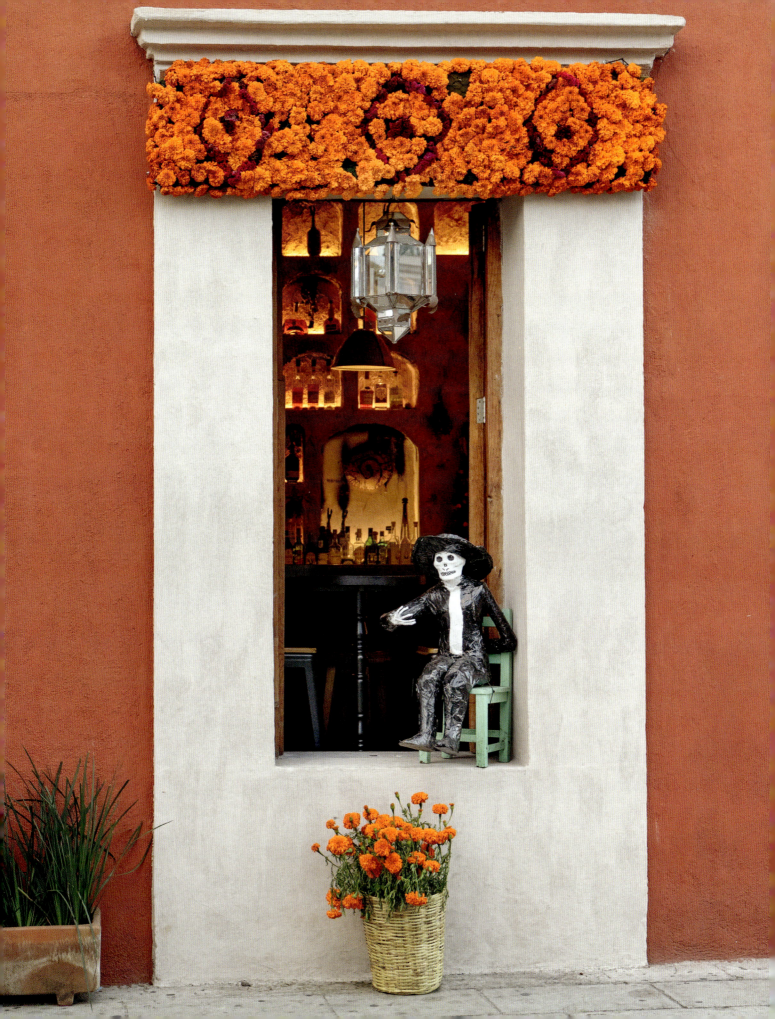

Hardie Grant

NORTH AMERICA

Hardie Grant North America
2912 Telegraph Ave
Berkeley, CA 94705
hardiegrant.com

Copyright © 2025 by Luisa Navarro
Photographs Copyright © 2025 by Christine Chitnis
Illustrations Copyright © 2025 by Goodish Studio
Photographs pages 191-193, 195, 197 copyright © 2025 by Sarahli Wilcox
All rights reserved. No part of this book may be reproduced in any form without written permission from the publisher. Published in the United States by Hardie Grant North America, an imprint of Hardie Grant Publishing Pty Ltd.

Library of Congress Cataloging-in-Publication Data is available upon request.
ISBN: 9781958417591
ISBN: 9781958417607 (eBook)
Printed in China
Design by Lizzie Allen
Cover design by Goodish Studio
First Edition